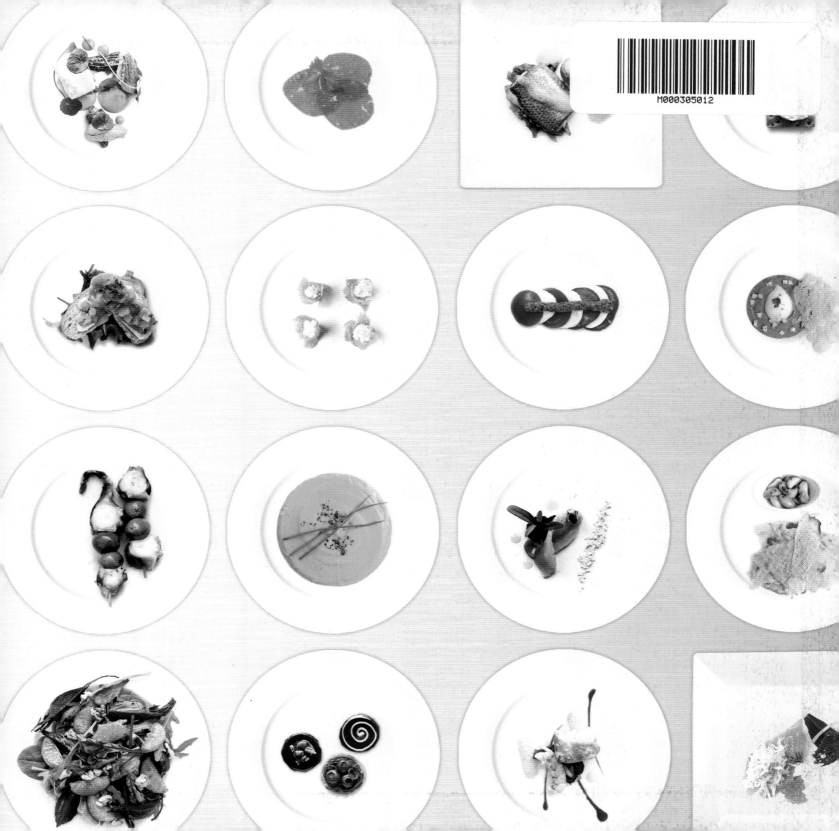

FOOD & ART
STYLING IDEAS

First published in the United States of America by Rockport Publishers, a member of Quayside Publishing Group
100 Cummings Center
Suite 406-L
Beverly, Massachusetts 01915-6101
Telephone: (978) 282-9590
Fax: (978) 283-2742
www.rockpub.com

ISBN: 978-1-59253-859-1

Digital edition published in 2014
eISBN: 978-1-61058-940-6

10 9 8 7 6 5 4 3 2 1

Design: Grip Design
Art direction: Kelly Kaminski, Kevin McConkey
Cover and interior design: Jenn McHale, Camay Ho

Printed in China

FOOD & ART STYLING IDEAS

MOUTHWATERING FOOD PRESENTATIONS FROM CHEFS,
PHOTOGRAPHERS & BLOGGERS FROM AROUND THE GLOBE

WRITTEN & CURATED BY
ARI BENDERSKY

DESIGNED BY
GRIP × CHICAGO

Rockport Publishers
100 Cummings Center, Suite 406L
Beverly, MA 01915

rockpub.com • rockpaperink.com

THE
MENU

WE ALL NEED FOOD TO SURVIVE, **but we should all, at some point in our lives, have the opportunity to experience truly gorgeous food that not only nourishes us physically, but also inspires us visually, emotionally, and creatively.** Whether plates are prepared through molecular gastronomy in the foremost restaurants around the globe or through simple, rustic methods in your own kitchen, beauty can lie within any preparation. As a society connected through social media, more and more people take and share photos of their food, further connecting us all through the love of the perfect bite. As a food writer and culinary explorer, I have had the privilege of feasting on wonderful dishes by some of the world's most renowned and respected chefs. Having the honor to gather the gorgeous images found on the following pages further fueled my desire to share the beauty that can be discovered through food.

For this collection, **we reached out to photographers, stylists, and gourmands around the globe,** both professional and amateur. People couldn't have been more thrilled to share their visual experiences with us and eventually with you to help inspire your next photo shoot, whether for yourself or a commercial endeavor. Photos came in from all over the United States as well as far-flung places like Kuwait, Estonia, Australia, Costa Rica, England and beyond, showing how similar ingredients can produce wildly different, yet equally delicious, results.

The following chapters showcase food in haute preparations as well as in its natural, organic state. From indulgent platings featuring juicy burgers piled high with melted cheese or sweet cakes *oozing* with chocolate sauce to healthy preparations of salads, vegetables, or grilled fish, *1,000 Food Art & Styling*

Ideas can help stimulate your creative juices and show you just how much fun taking photos of food truly can be. Spend time browsing the pages as you jump from Land to Sea, explore the use of Color, turn things up with Heat, or tell a story through Narrative. No matter how you thought of food before, you are surely bound to experience it in a new light and a truly altogether different flavor profile.

Get ready to have a heightened, sensorial experience and no matter how you let these photos inspire you, be sure you enjoy each and every savory shot. **ONE WARNING: Don't flip through these pages on an empty stomach as you may go on a dining binge.** And if you do, don't say we didn't warn you . . . the following pages contain serious drool-worthy images. **Enjoy!**

ARI BENDERSKY

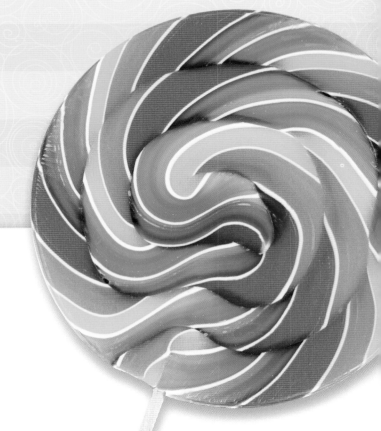

COLOR

BRIGHT / BOLD / PLAYFUL

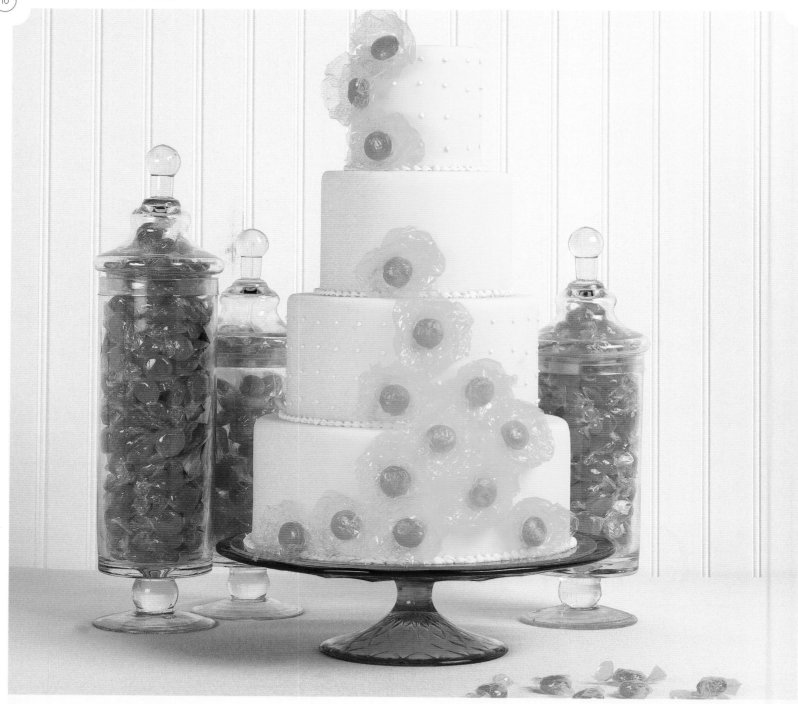

DAVE BRADLEY
USA

0001

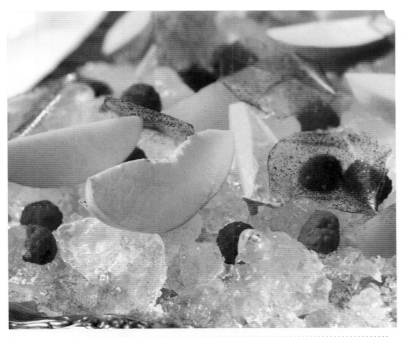

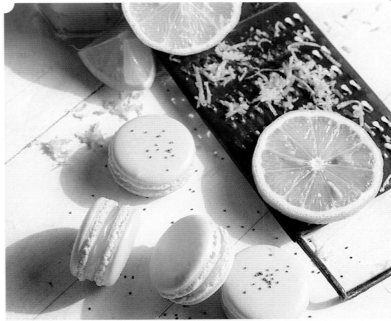

HEATHER SPERLING
USA
0002

HEATHER VAN GAALE
USA
0003

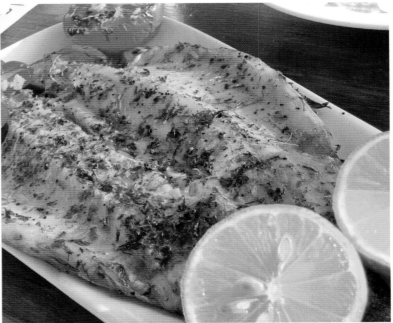

JUSTIN B. PARIS
USA
0004

KATE RIESENBERG
USA
0005

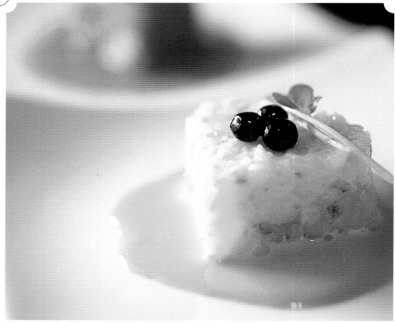

SCOTT ERB AND DONNA DUFAULT
USA

0006

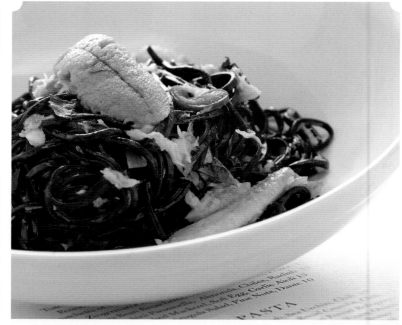

ERIC KLEINBERG
USA

0007

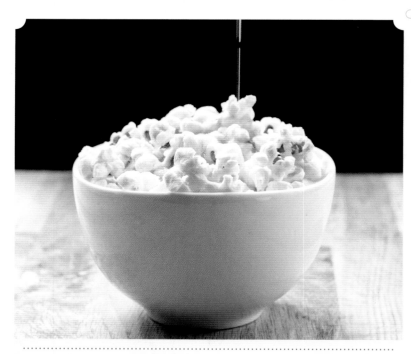

MOLLY MCMAHON
USA

0008

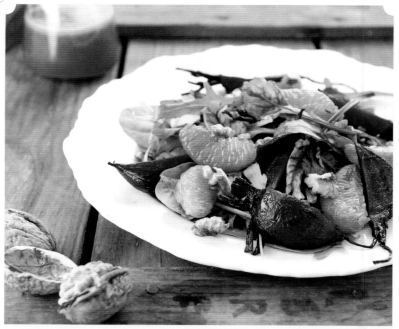

NADINE SHAW
AUSTRALIA

0009

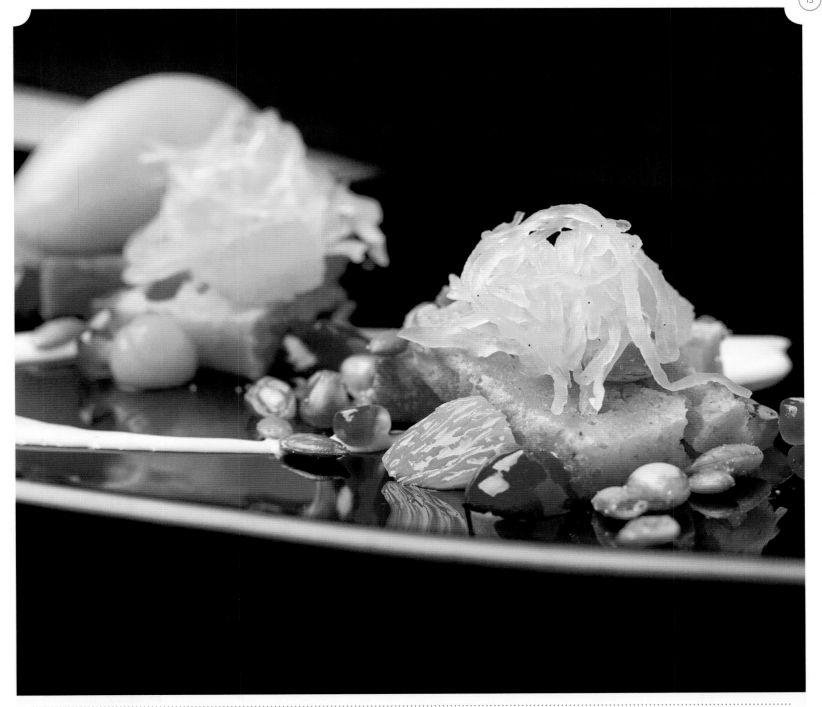

ERIC KLEINBERG
USA

0010

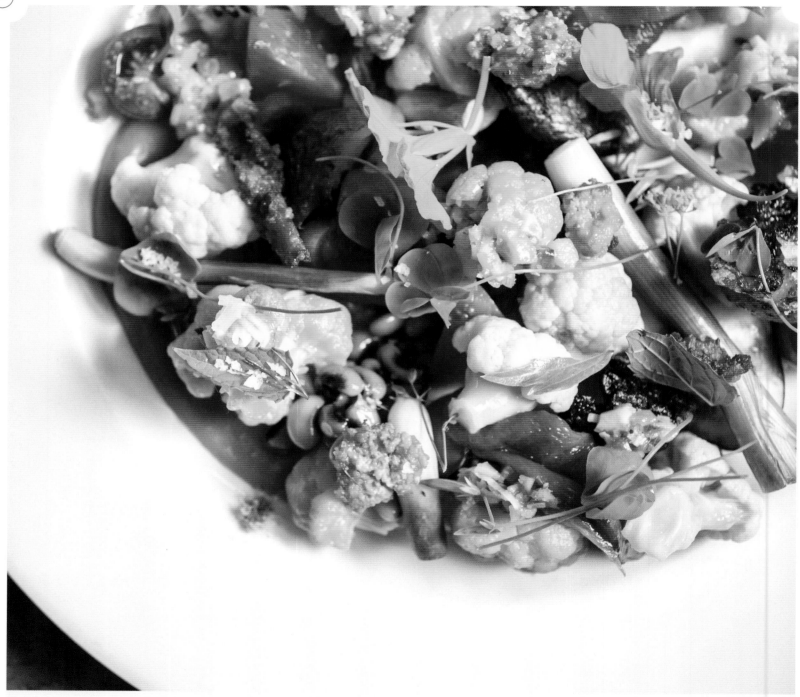

GALDONES PHOTOGRAPHY
USA

0011

ELISABETTA REDAELLI
ITALY
0012

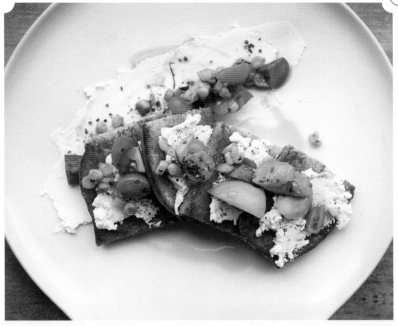

ERIC KLEINBERG
USA
0013

EZEQUIEL BECERRA
COSTA RICA
0014

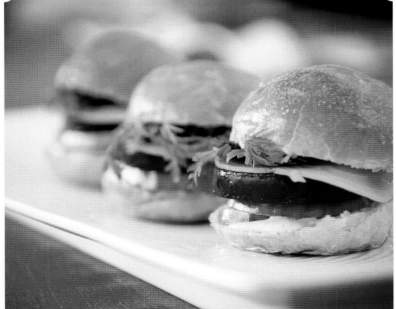

CARA AND SCOTT NAVA
USA
0015

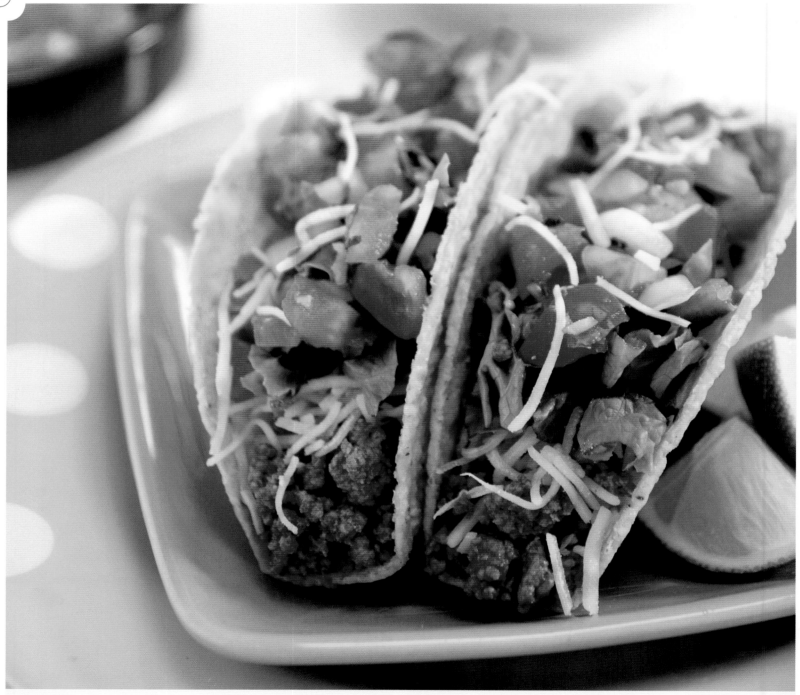

GRIP
USA

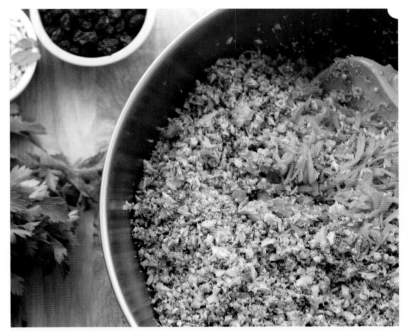

MOLLY MCMAHON
USA

0017

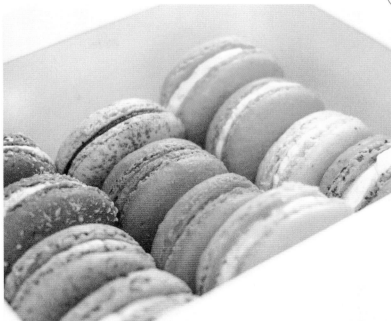

TY LETTAU
USA

0018

TY LETTAU
USA

0019

TY LETTAU
USA

0020

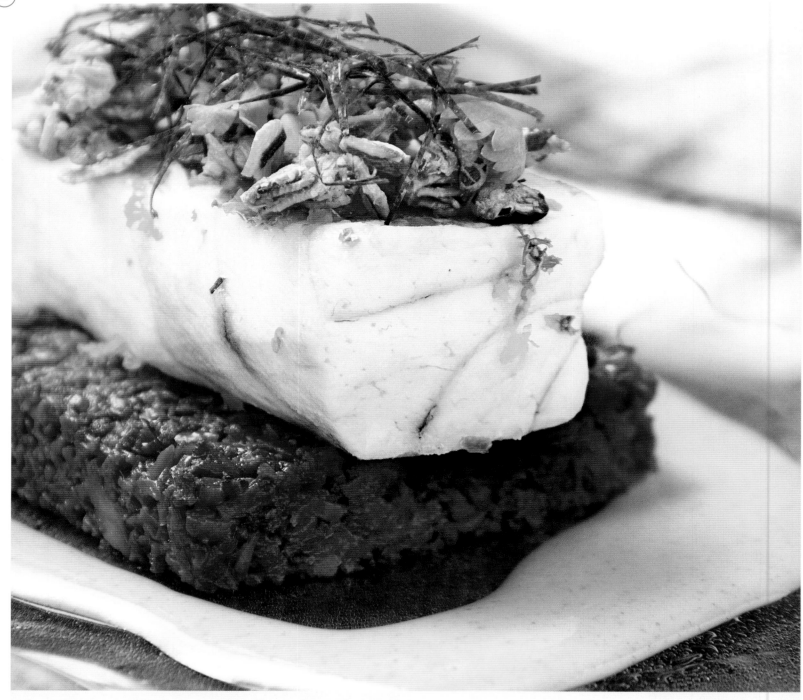

ERIC KLEINBERG
USA

0021

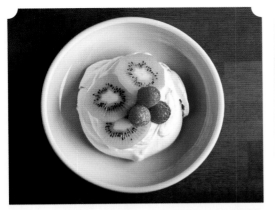

TUAN H. BUI
USA
0022

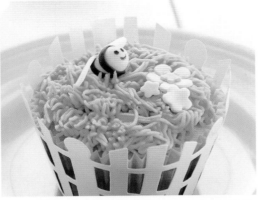

NADINE SHAW
AUSTRALIA
0023

HEATHER SPERLING
USA
0024

GLENN SCOTT
USA
0025

PARAGON MARKETING
COMMUNICATIONS KUWAIT
0026

TUAN H. BUI
USA
0027

TUAN H. BUI
USA
0028

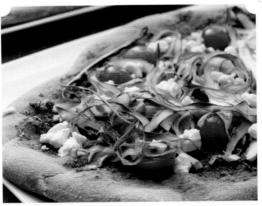

MOLLY MCMAHON
USA
0029

AZITA HOUSHIAR
USA
0030

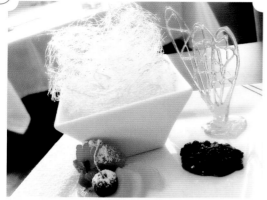

PARAGON MARKETING
COMMUNICATIONS KUWAIT **0031**

ELISABETTA REDAELLI **0032**
ITALY

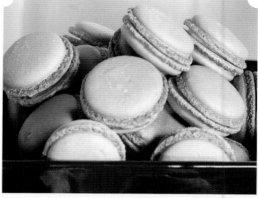

TUAN H. BUI **0033**
USA

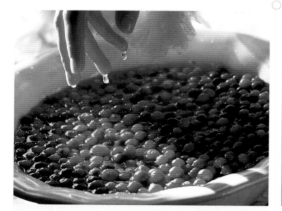

RUTH HUIMERIND **0034**
ESTONIA

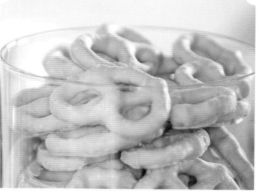

TUAN H. BUI **0035**
USA

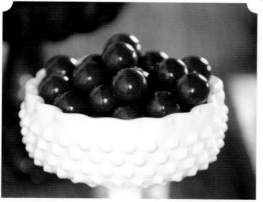

RUTH HUIMERIND **0036**
ESTONIA

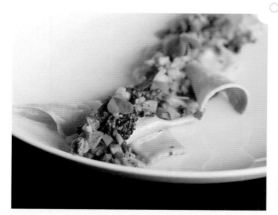

HEATHER SPERLING **0037**
USA

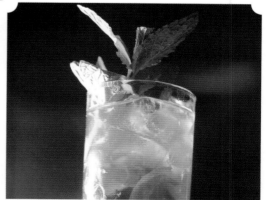

TUAN H. BUI **0038**
USA

TUAN H. BUI **0039**
USA

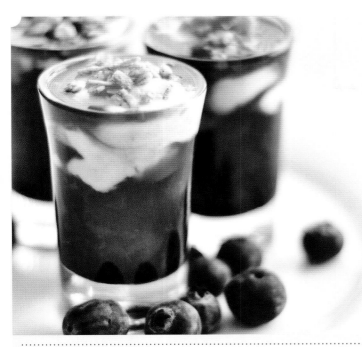

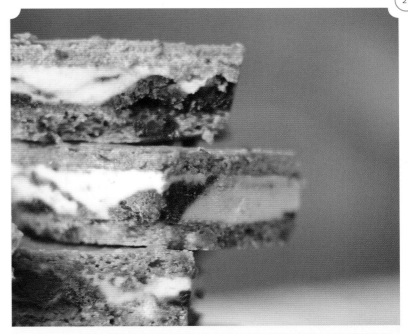

NICOLE ZARATE
USA
0040

SHERI SILVER
USA
0041

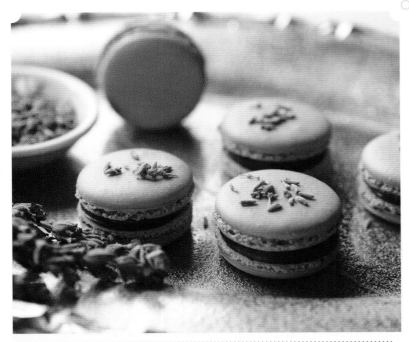

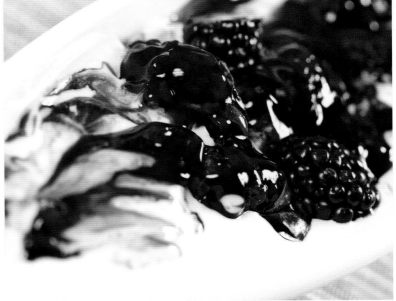

HEATHER VAN GAALE
USA
0042

PARAGON MARKETING COMMUNICATIONS
KUWAIT
0043

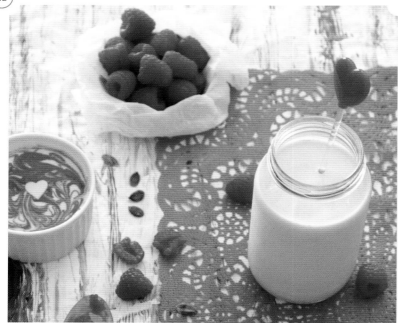

ELISABETTA REDAELLI
ITALY

0044

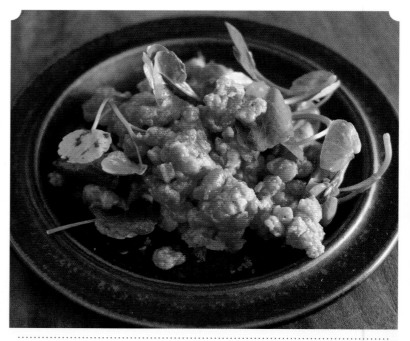

TY LETTAU
USA

0045

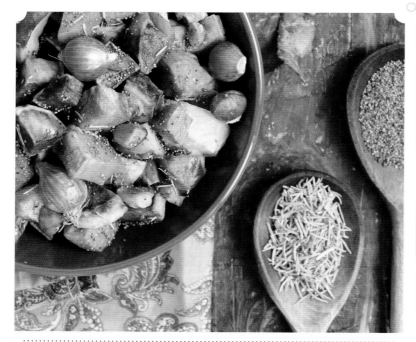

ELISABETTA REDAELLI
ITALY

0046

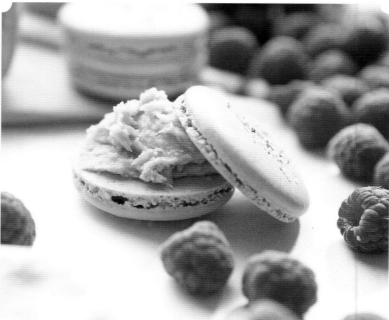

HEATHER VAN GAALE
USA

0047

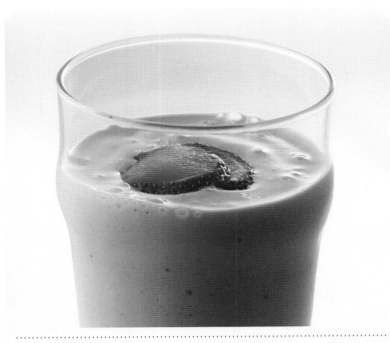

PARAGON MARKETING COMMUNICATIONS
KUWAIT
0048

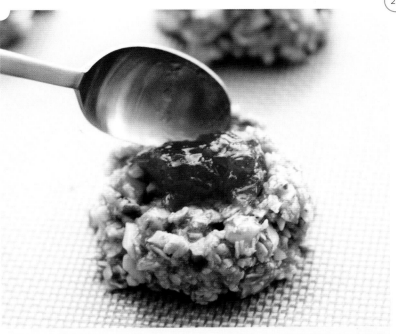

MOLLY MCMAHON
USA
0049

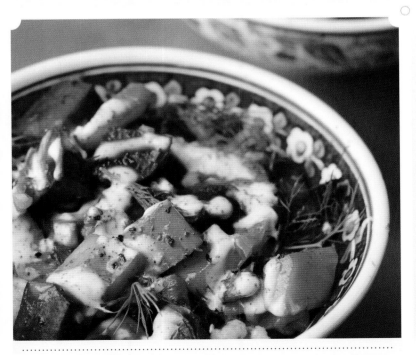

HEATHER SPERLING
USA
0050

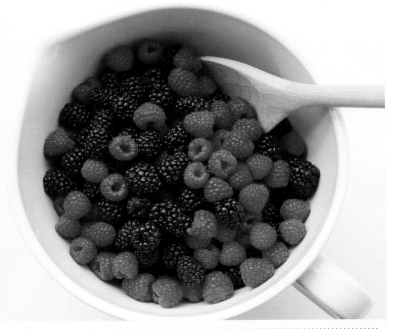

MOLLY MCMAHON
USA
0051

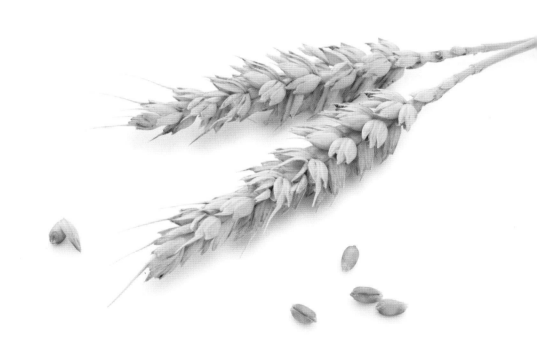

AU NATURAL

ORGANIC / ARTISAN / FRESH / PURE

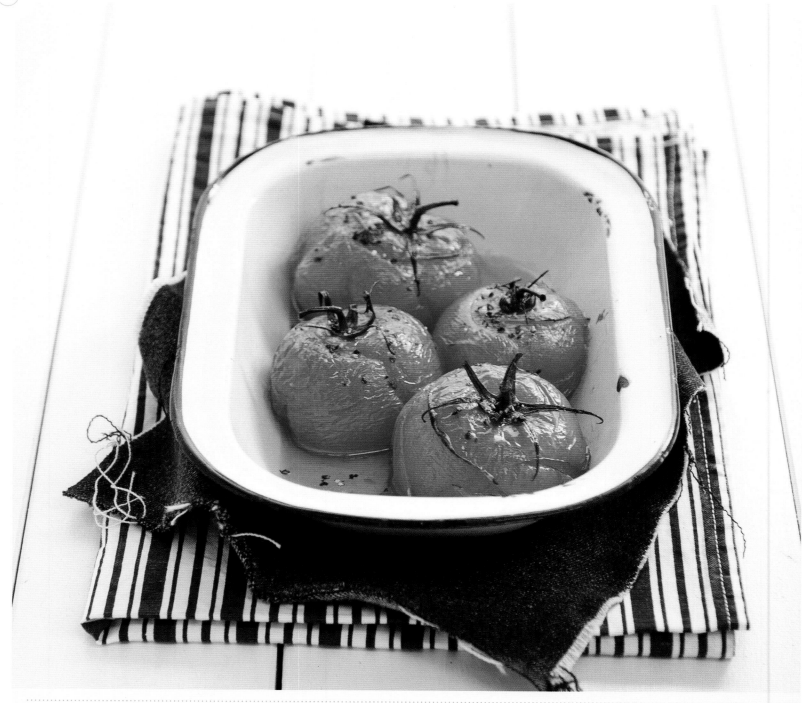

NADINE SHAW
AUSTRALIA

0052

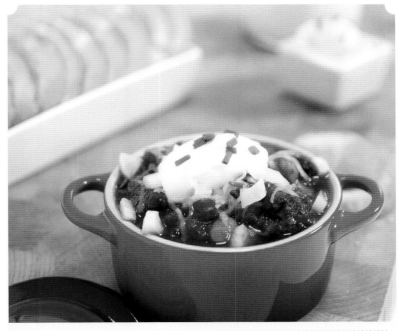

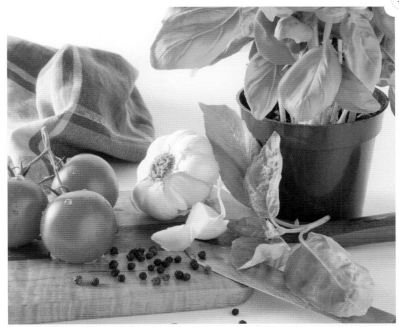

GRIP
USA
0053

SCOTT ERB AND DONNA DUFAULT
USA
0054

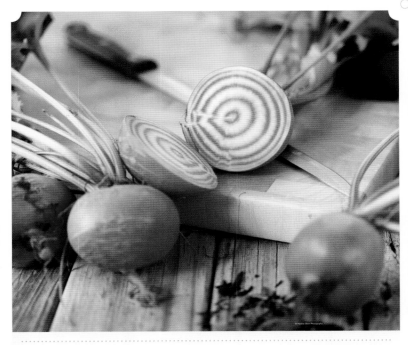

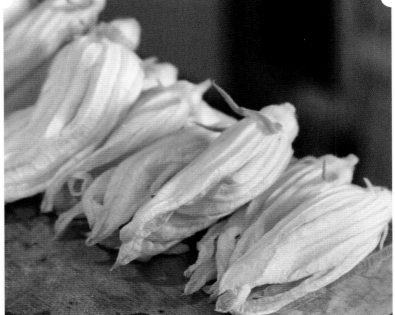

NADINE SHAW
AUSTRALIA
0055

HEATHER SPERLING
USA
0056

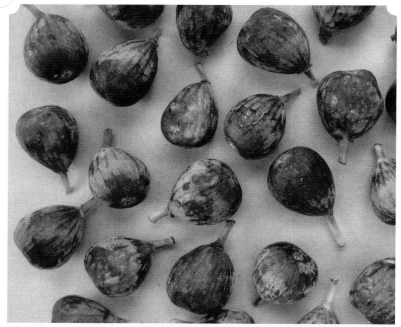

AZITA HOUSHIAR
USA

0057

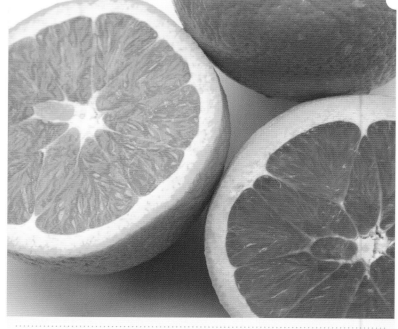

MOLLY MCMAHON
USA

0058

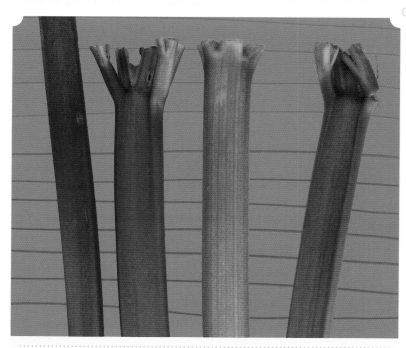

AZITA HOUSHIAR

0059

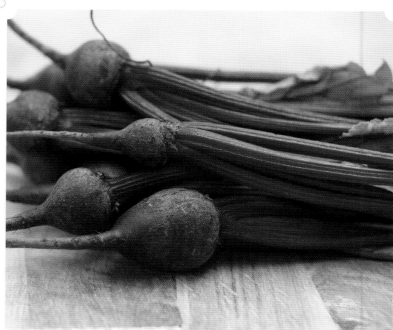

MOLLY MCMAHON
USA

0060

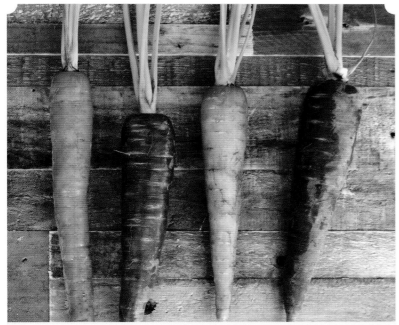

REGAN BARONI
USA

0061

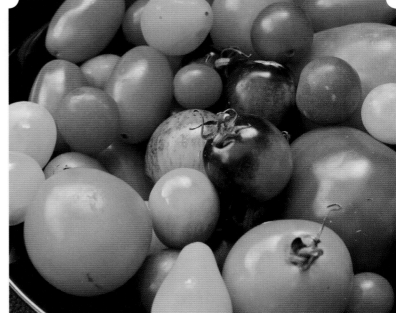

BERNADINE ROLNICKI
USA

0062

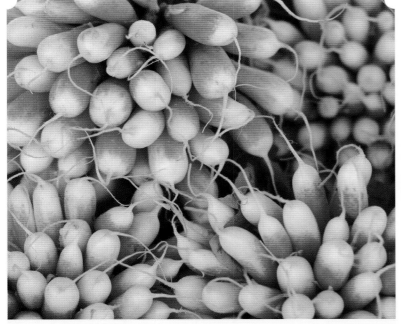

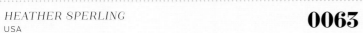

HEATHER SPERLING
USA

0063

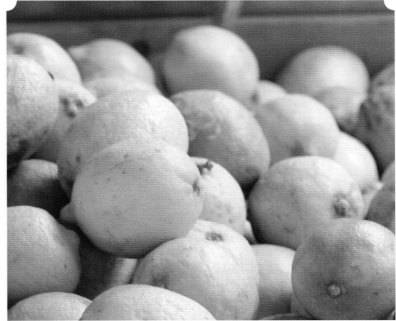

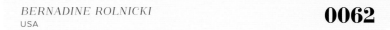

HEATHER SPERLING
USA

0064

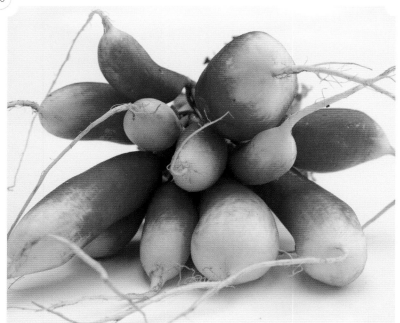

MOLLY MCMAHON
USA
0065

NICOLE ZARATE
USA
0066

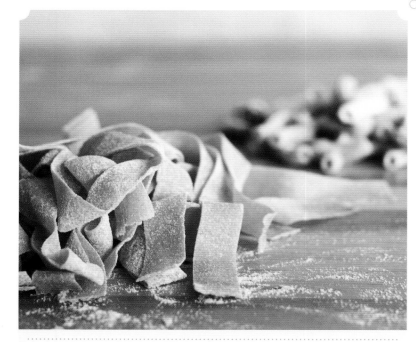

HEATHER SPERLING
USA
0067

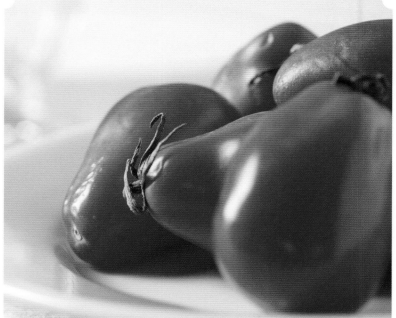

MICHELLE DEITER
USA
0068

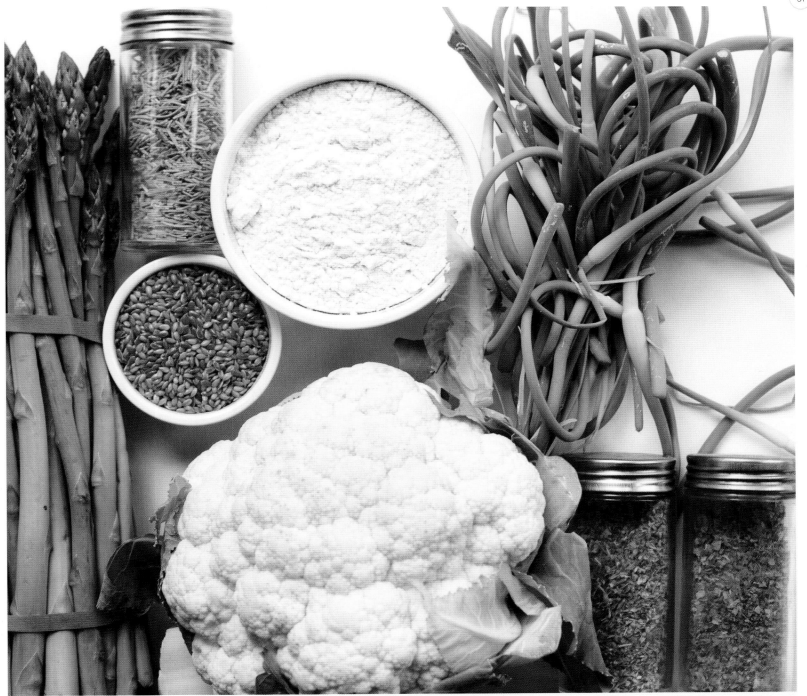

MOLLY MCMAHON
USA

0069

GEORGIOS DETSIS
GREECE

0070

HEATHER SPERLING
USA

0071

CARLOS RIBEIRO
PORTUGAL

0072

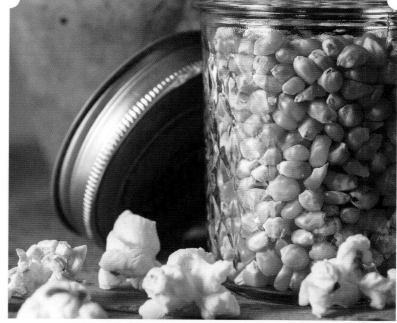

MICHELLE DEITER
USA

0073

MOLLY MCMAHON
USA
0074

MOLLY MCMAHON
USA
0075

MOLLY MCMAHON
USA
0076

MOLLY MCMAHON
USA
0077

MOLLY MCMAHON
USA
0078

MOLLY MCMAHON
USA
0079

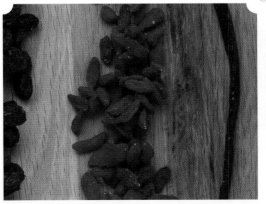

MOLLY MCMAHON
USA
0080

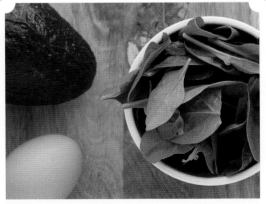

MOLLY MCMAHON
USA
0081

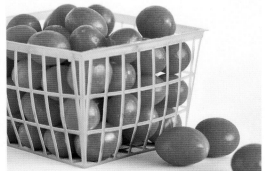

NICOLE ZARATE
USA
0082

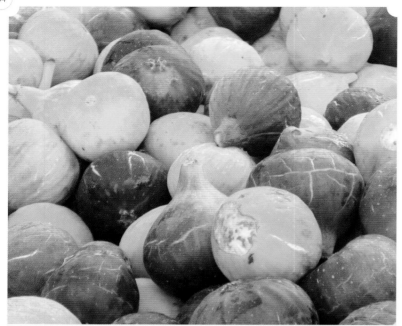

KATE RIESENBERG
USA
0083

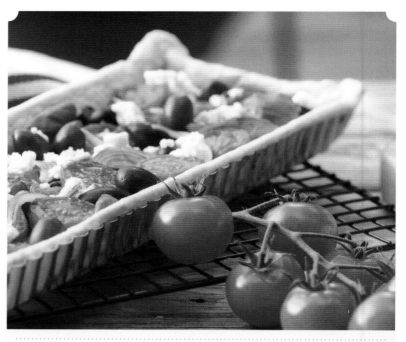

NADINE SHAW
AUSTRALIA
0084

KATE RIESENBERG
USA
0085

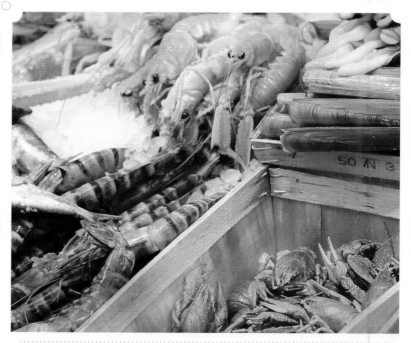

HEATHER SPERLING
USA
0086

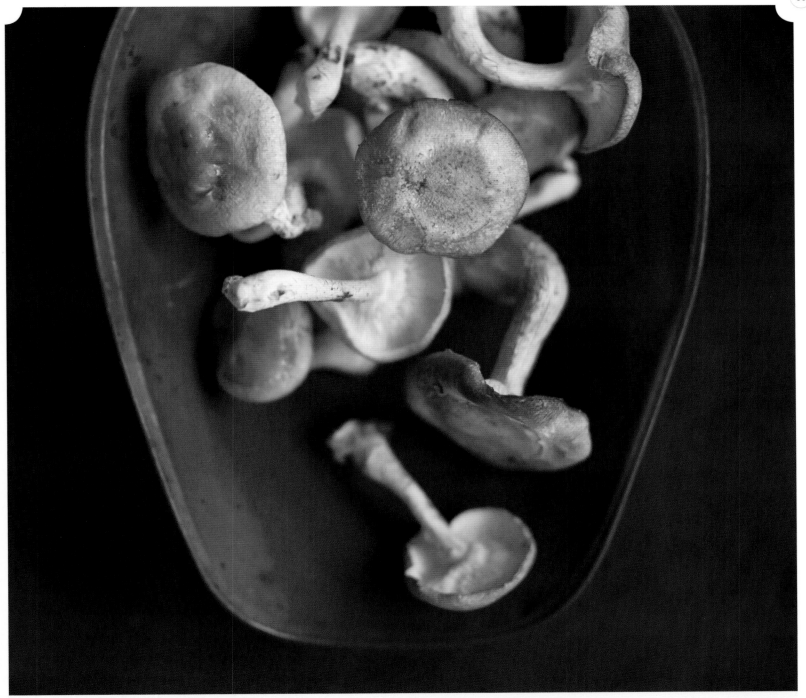

JUSTIN B. PARIS
USA

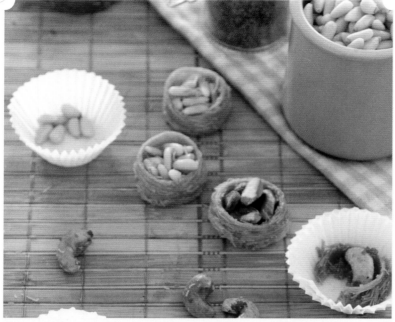

ELISABETTA REDAELLI
ITALY

0088

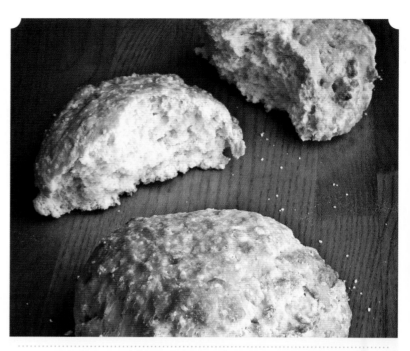

SCOTT ERB AND DONNA DUFAULT
USA

0089

SCOTT ERB AND DONNA DUFAULT
USA

0090

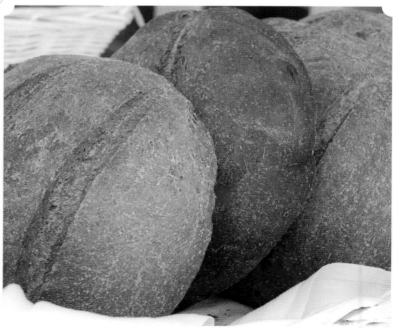

GEORGIOS DETSIS
GREECE

0091

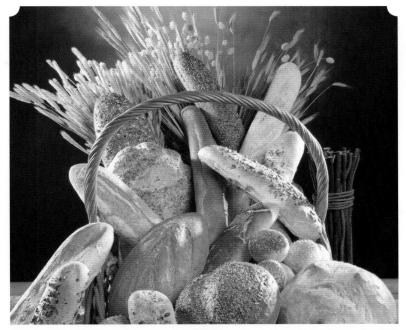

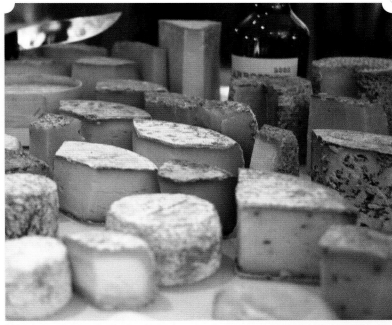

PARAGON MARKETING COMMUNICATIONS
KUWAIT

0092

TY LETTAU
USA

0093

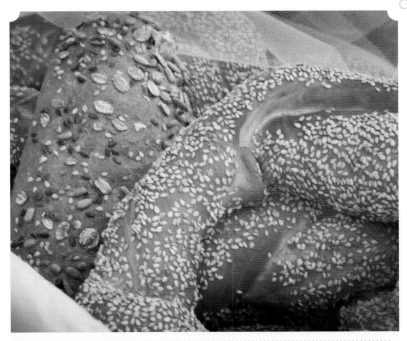

GEORGIOS DETSIS
GREECE

0094

KATE RIESENBERG
USA

0095

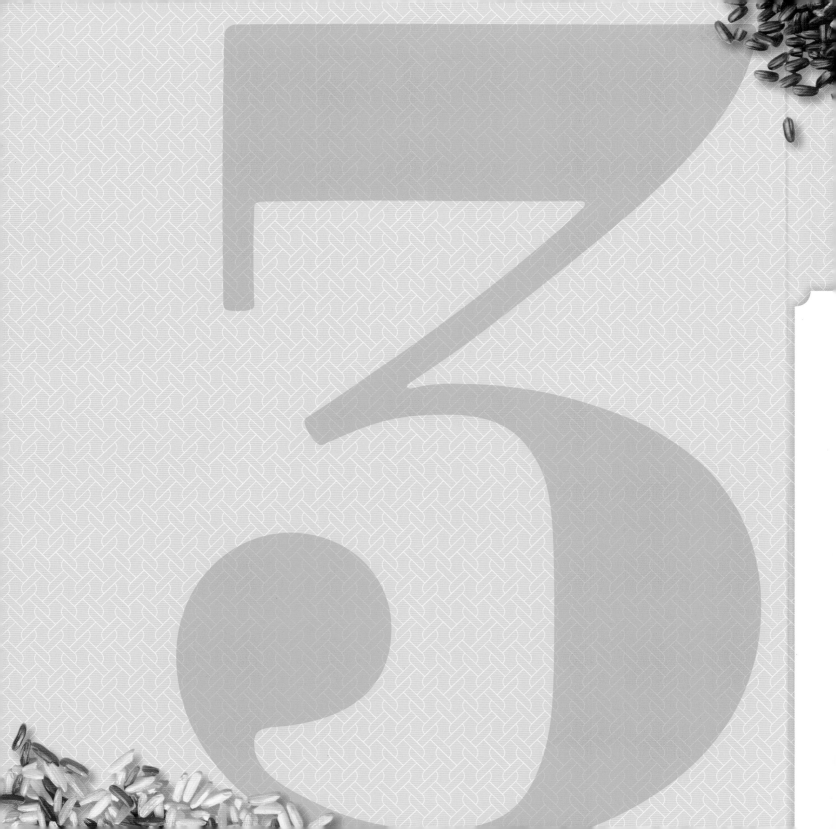

GLOBAL

TRAVEL / IMPORTED / EXOTIC / ETHNIC / DIVERSE

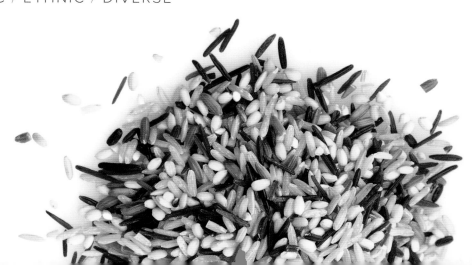

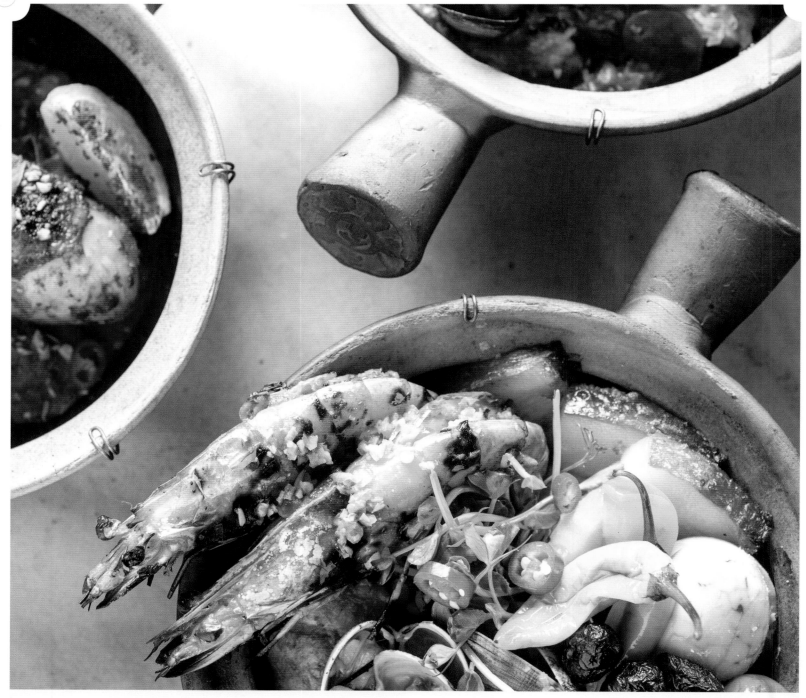

GALDONES PHOTOGRAPHY
USA

0096

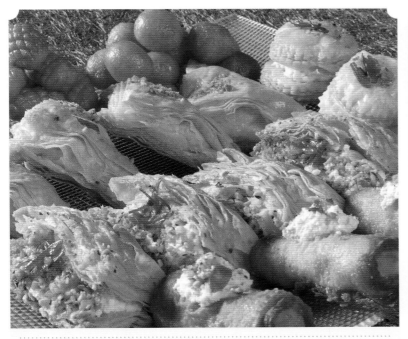

PARAGON MARKETING COMMUNICATIONS
KUWAIT

0097

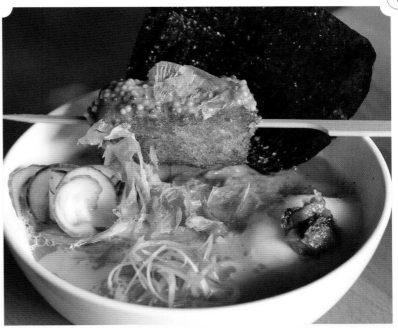

HEATHER SPERLING
USA

0098

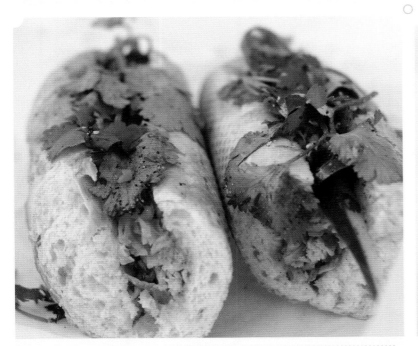

HEATHER SPERLING
USA

0099

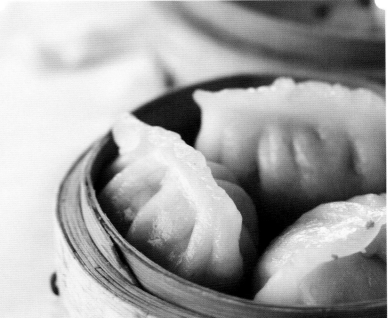

HEATHER SPERLING
USA

0100

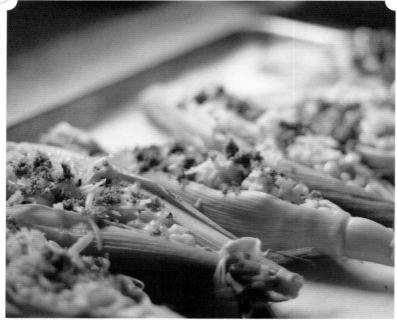

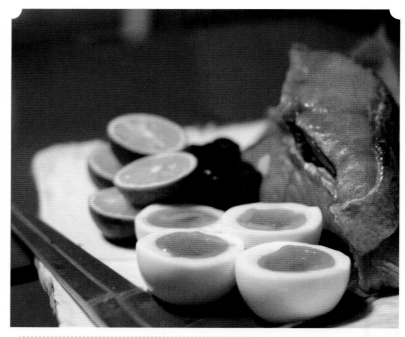

SHERI SILVER
USA **0101**

HEATHER SPERLING
USA **0102**

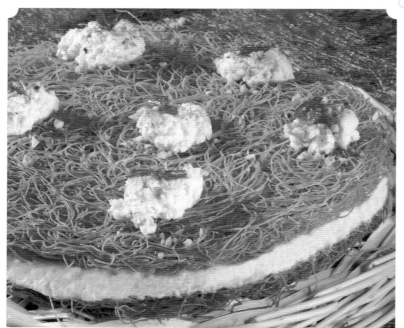

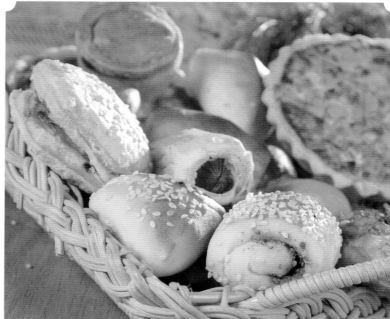

PARAGON MARKETING COMMUNICATIONS
KUWAIT **0103**

PARAGON MARKETING COMMUNICATIONS
KUWAIT **0104**

HEATHER SPERLING
USA

0105

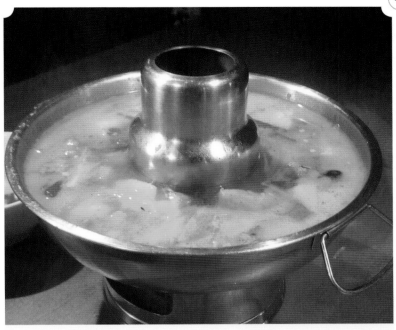

JACQUI WEDEWER
USA

0106

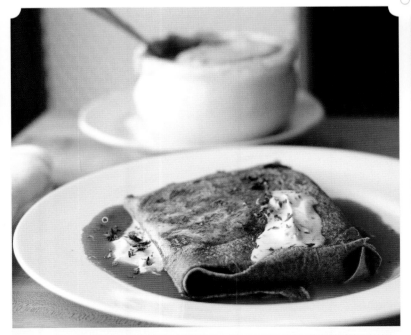

HEATHER SPERLING
USA

0107

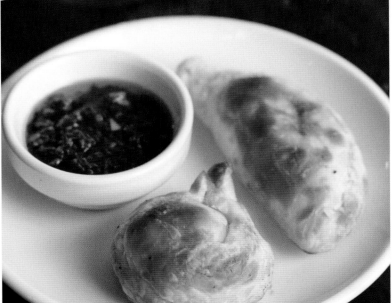

HEATHER SPERLING
USA

0108

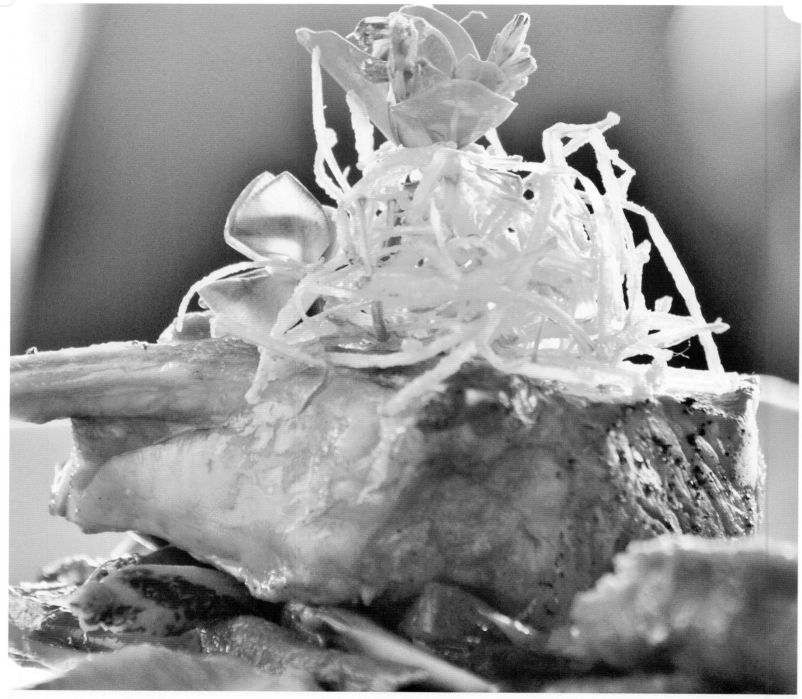

DWAYNE KNIGHT
BARBADOS

0109

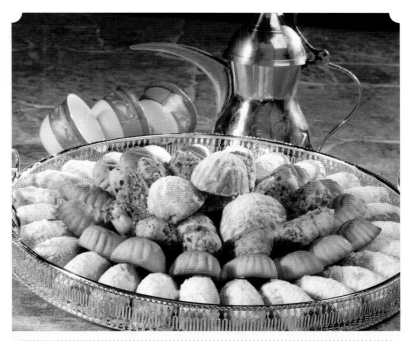

PARAGON MARKETING COMMUNICATIONS
KUWAIT
0110

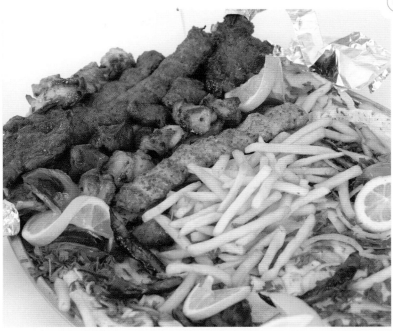

PARAGON MARKETING COMMUNICATIONS
KUWAIT
0111

HEATHER SPERLING
USA
0112

PARAGON MARKETING COMMUNICATIONS
KUWAIT
0113

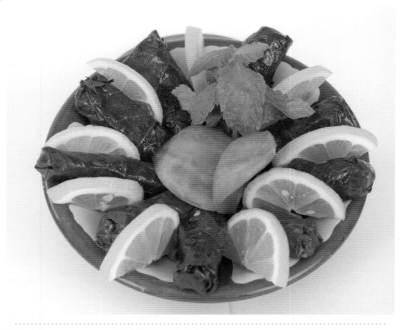

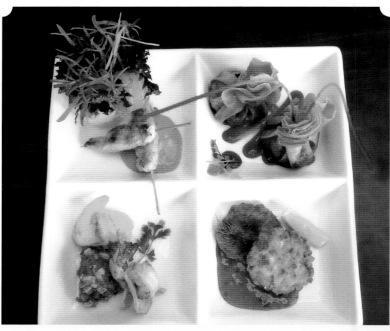

PARAGON MARKETING COMMUNICATIONS
KUWAIT
0114

PARAGON MARKETING COMMUNICATIONS
KUWAIT
0115

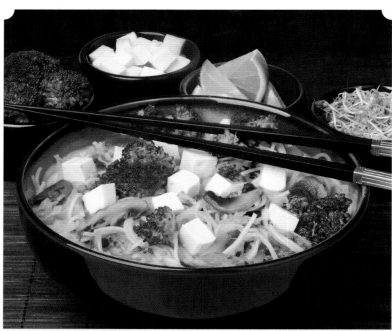

ANDREW HICKEY
USA
0116

KATE RIESENBERG
USA
0117

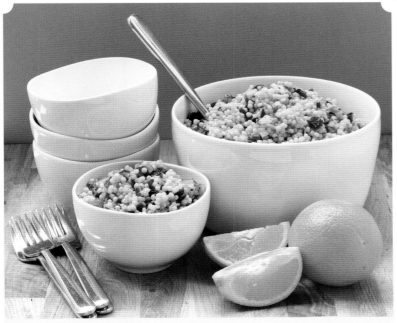

MOLLY MCMAHON
USA

0118

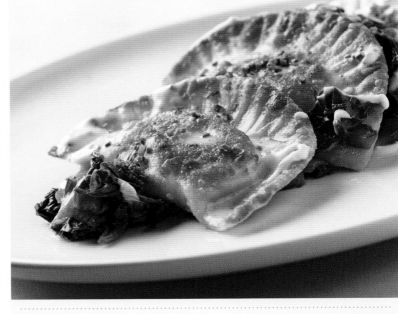

ERIC KLEINBERG
USA

0119

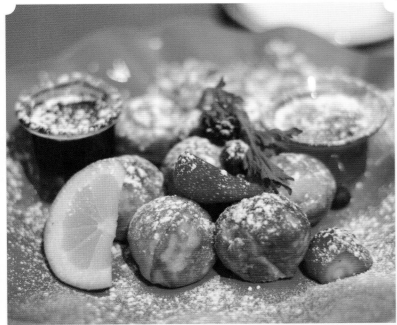

ANDREW HICKEY
USA

0120

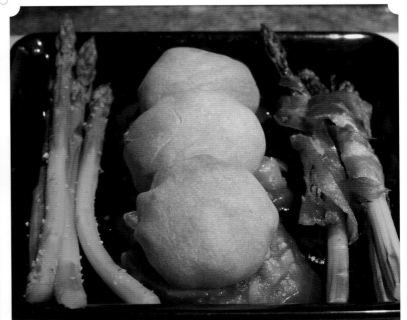

BERNADINE ROLNICKI
USA

0121

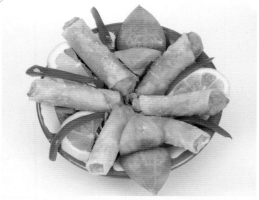

PARAGON MARKETING
COMMUNICATIONS KUWAIT **0122**

ANDREW HICKEY
USA **0123**

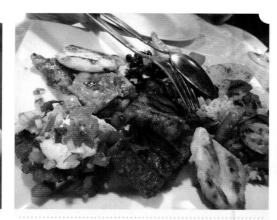

ANDREW HICKEY
USA **0124**

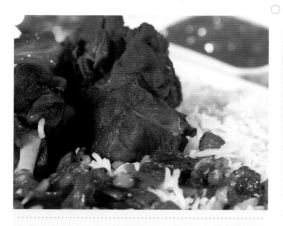

PARAGON MARKETING
COMMUNICATIONS KUWAIT **0125**

PARAGON MARKETING
COMMUNICATIONS KUWAIT **0126**

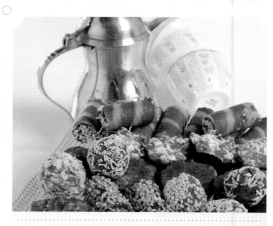

PARAGON MARKETING
COMMUNICATIONS KUWAIT **0127**

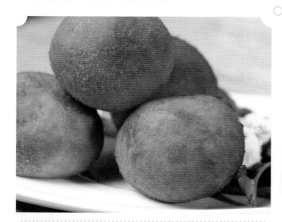

PARAGON MARKETING
COMMUNICATIONS KUWAIT **0128**

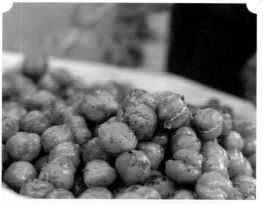

MICHELLE DEITER
USA **0129**

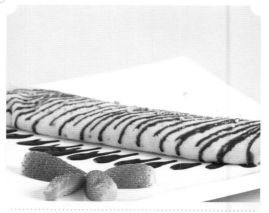

PARAGON MARKETING
COMMUNICATIONS KUWAIT **0130**

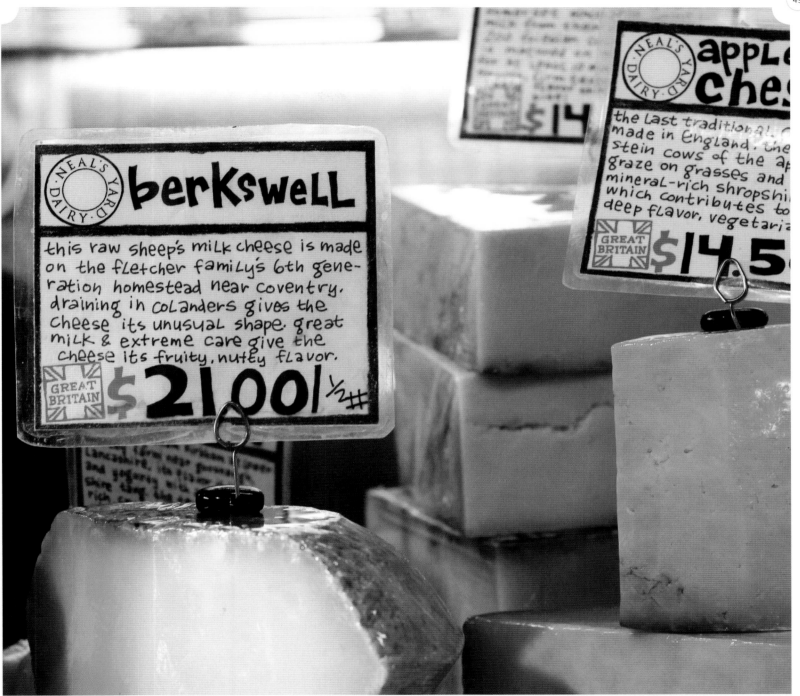

berKsweLL

NEAL'S YARD DAIRY

this raw sheep's miLk cheese is made on the fLetcher famiLy's 6th gene-ration homestead near coventry. draining in coLanders gives the cheese its unusual shape. great miLk & extreme care give the cheese its fruity, nutey flavor.

GREAT BRITAIN $21.00/½#

appLe
ches

NEAL'S YARD DAIRY

the Last traditional made in England, the stein cows of the ap graze on grasses and mineral-rich shropshi which contributes to deep flavor, vegetaria

GREAT BRITAIN $14.5

HEATHER SPERLING
USA

0131

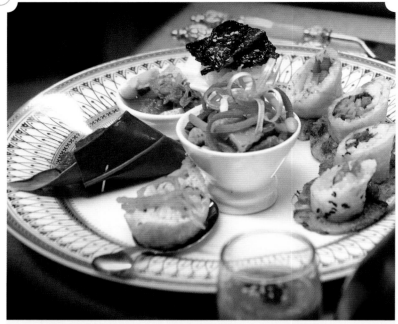

RACHEL DE MARTE
USA
0132

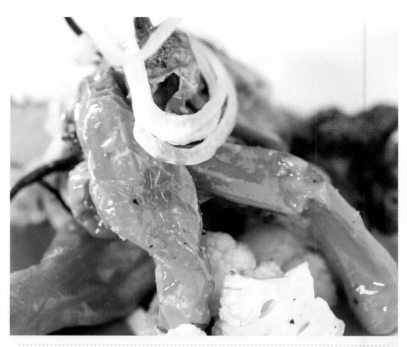

GALDONES PHOTOGRAPHY
USA
0133

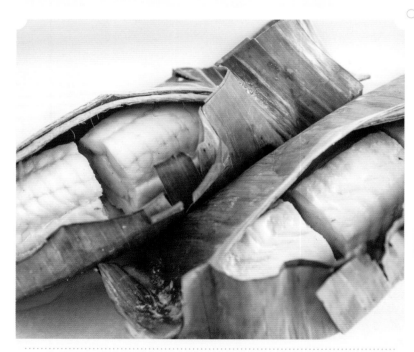

GALDONES PHOTOGRAPHY
USA
0134

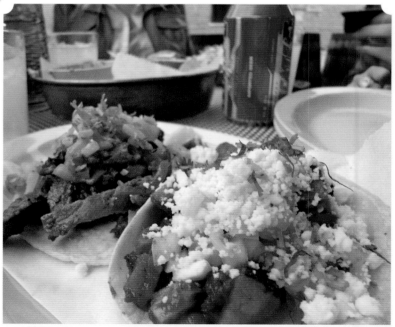

ELLIE MEYER
USA
0135

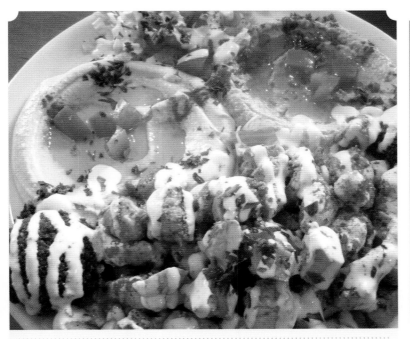

KATE RIESENBERG
USA

0136

AZITA HOUSHIAR
USA

0137

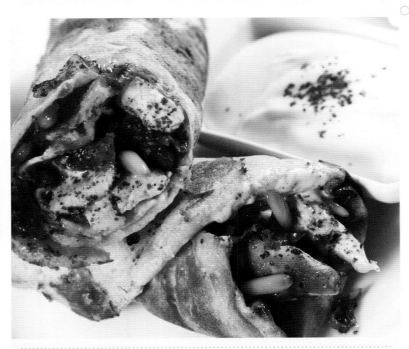

PARAGON MARKETING COMMUNICATIONS
KUWAIT

0138

KATE RIESENBERG
USA

0139

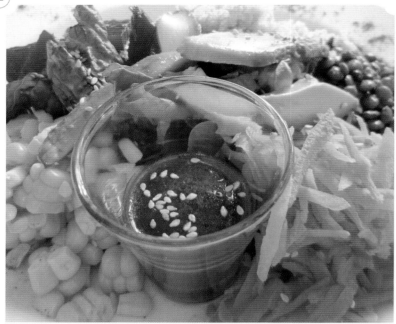

KATE RIESENBERG
USA

0140

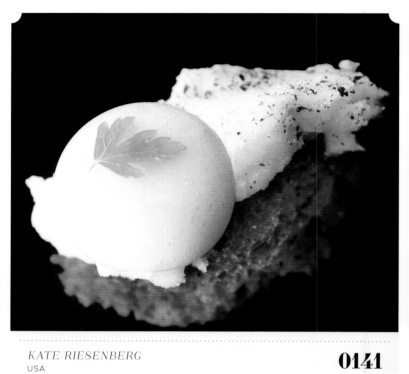

KATE RIESENBERG
USA

0141

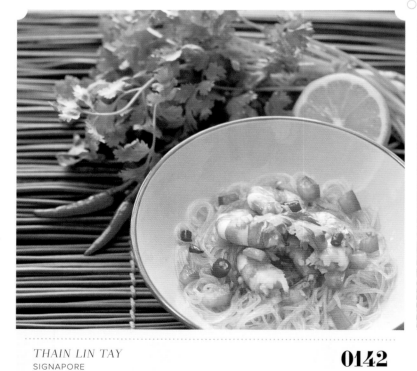

THAIN LIN TAY
SIGNAPORE

0142

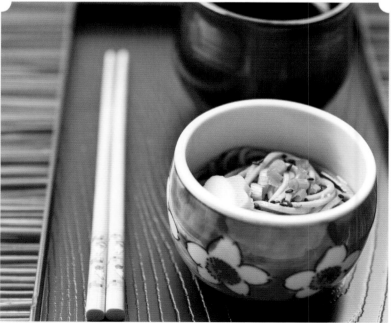

THAIN LIN TAY
SIGNAPORE

0143

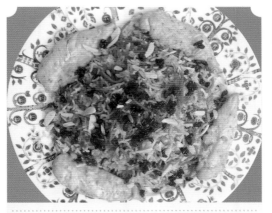

AZITA HOUSHIAR
USA
0144

ANDRES DANGOND
USA
0145

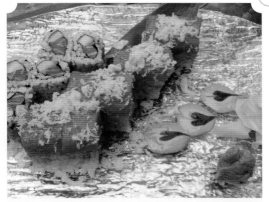

KATE RIESENBERG
USA
0146

HEATHER SPERLING
USA
0147

GEORGIOS DETSIS
GREECE
0148

PARAGON MARKETING
COMMUNICATIONS KUWAIT
0149

PARAGON MARKETING
COMMUNICATIONS KUWAIT
0150

PARAGON MARKETING
COMMUNICATIONS KUWAIT
0151

HEATHER SPERLING
USA
0152

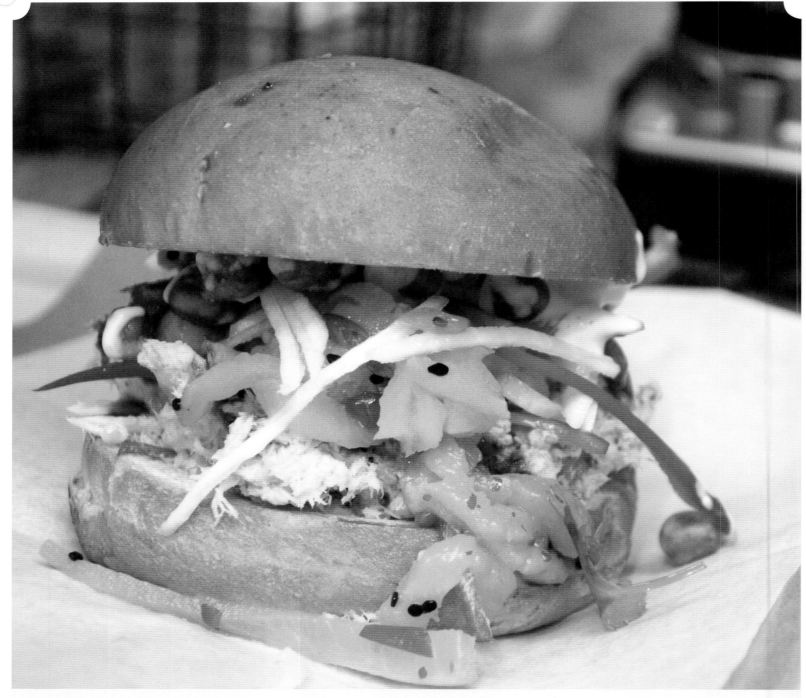

ANDREW HICKEY
USA

0153

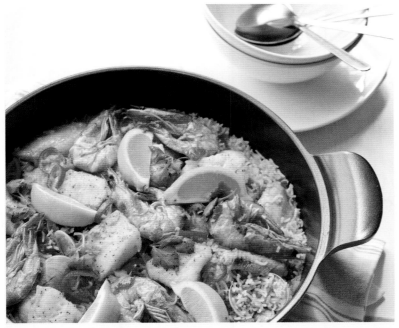

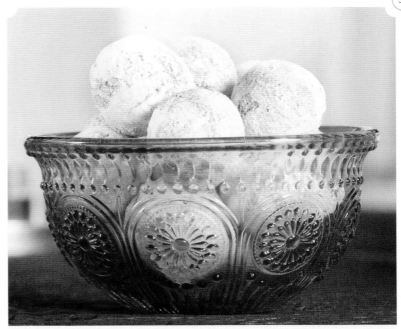

THAIN LIN TAY
SIGNAPORE
0154

TUAN H. BUI
USA
0155

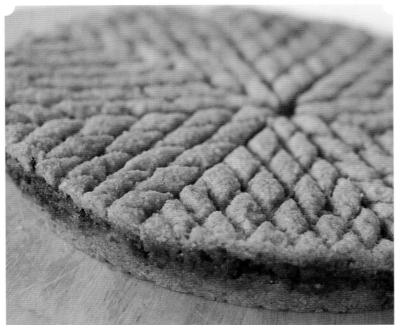

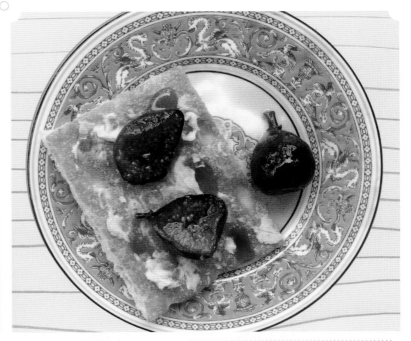

GEORGIOS DETSIS
GREECE
0156

AZITA HOUSHIAR
USA
0157

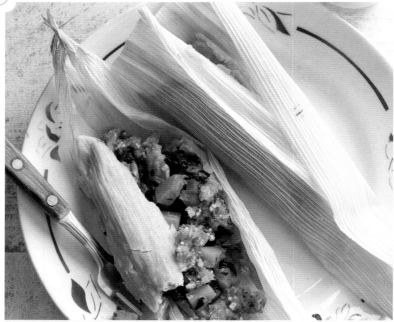

SARA REMINGTON
USA

0158

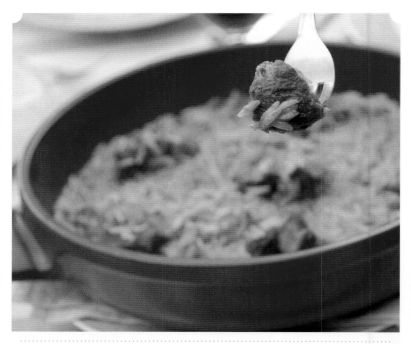

GEORGIOS DETSIS
GREECE

0159

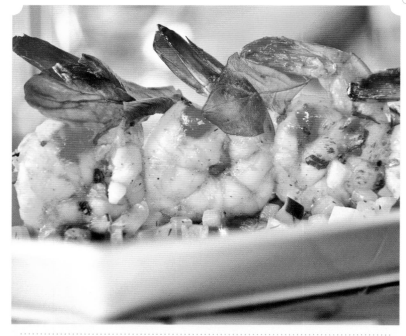

DWAYNE KNIGHT
BARBADOS

0160

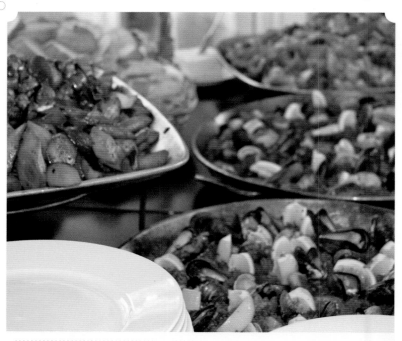

BRIAN POREA
USA

0161

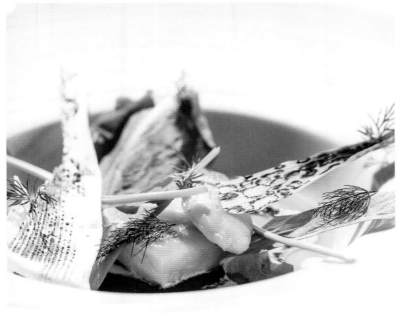

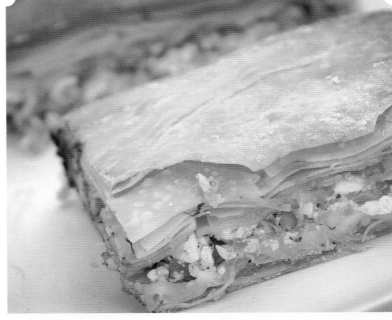

GALDONES PHOTOGRAPHY
USA

0162

GEORGIOS DETSIS
GREECE

0163

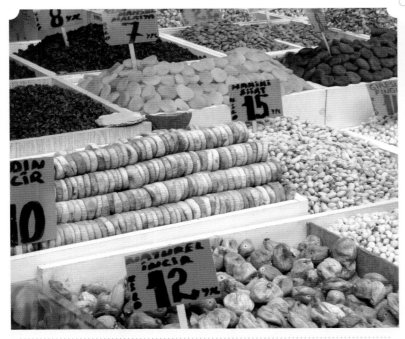

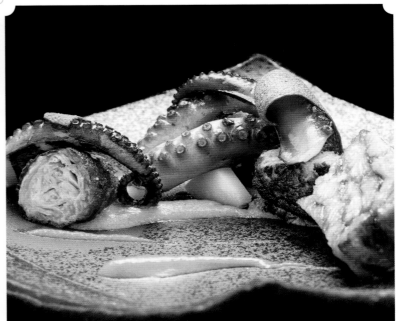

BRIAN POREA
USA

0164

ERIC KLEINBERG
USA

0165

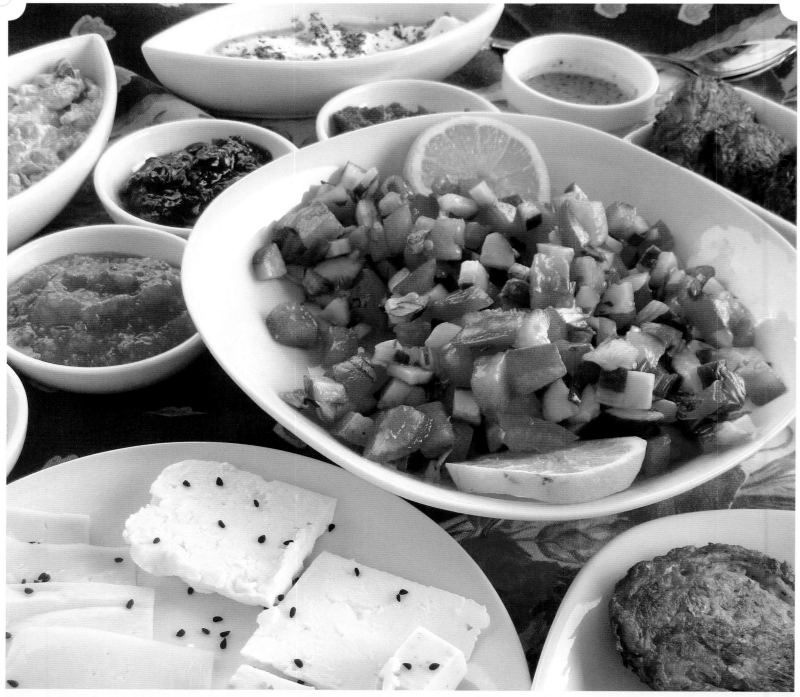

KATE RIESENBERG
USA

0166

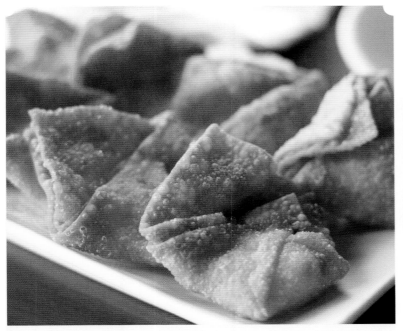

DENNIS LEE
USA
0167

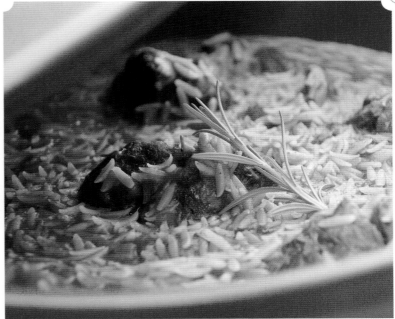

GEORGIOS DETSIS
GREECE
0168

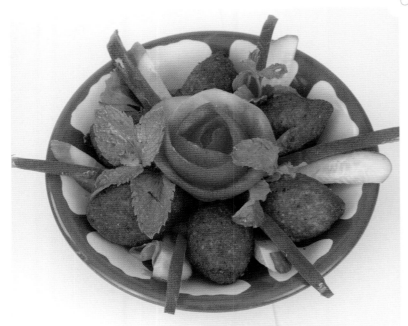

PARAGON MARKETING COMMUNICATIONS
KUWAIT
0169

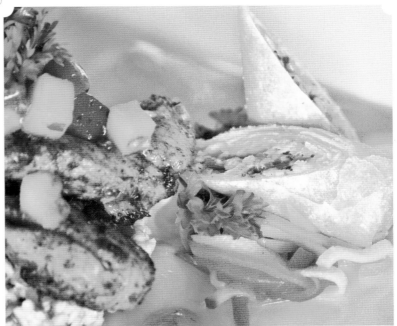

DWAYNE KNIGHT
BARBADOS
0170

WATCH IT

SKINNY / CLEAN / LOW-CAL / LIGHT / SLIM

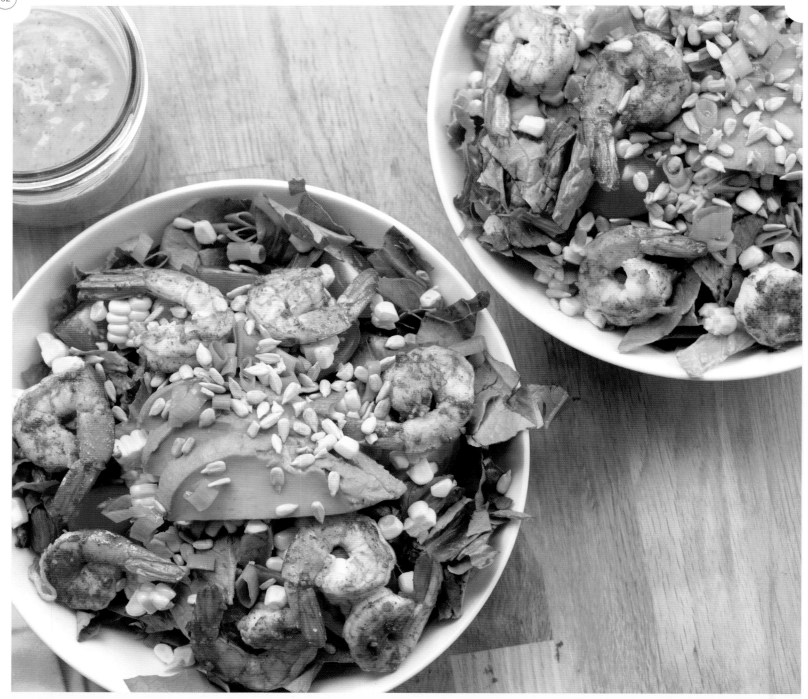

MOLLY MCMAHON
USA

0171

GALDONES PHOTOGRAPHY
USA
0172

PARAGON MARKETING
COMMUNICATIONS KUWAIT
0173

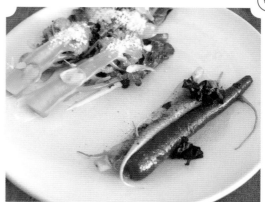

TY LETTAU
USA
0174

MOLLY MCMAHON
USA
0175

RONNIE SAINI
USA
0176

HEATHER SPERLING
USA
0177

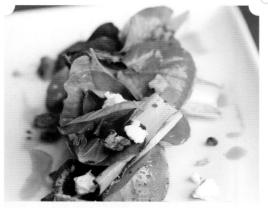

HEATHER SPERLING
USA
0178

HEATHER SPERLING
USA
0179

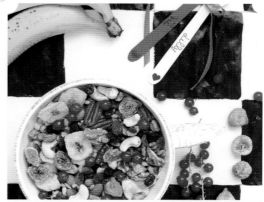

ELISABETTA REDAELLI
ITALY
0180

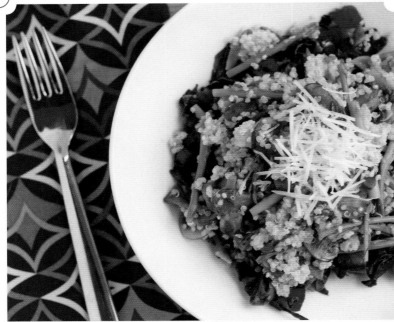

MOLLY MCMAHON
USA

0181

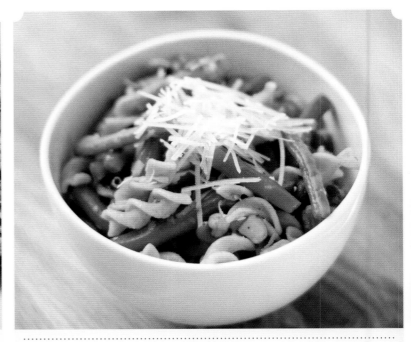

MOLLY MCMAHON
USA

0182

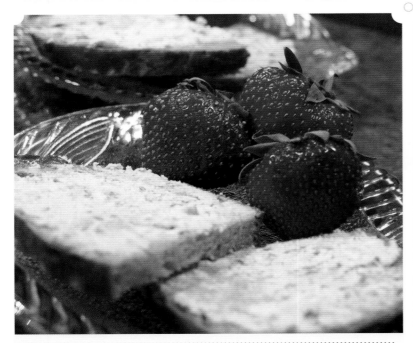

BERNADINE ROLNICKI
USA

0183

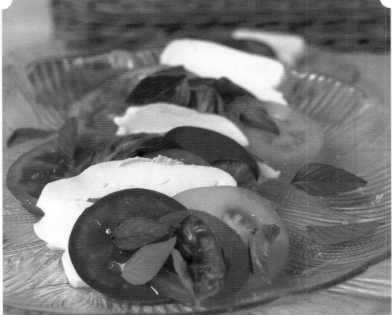

BERNADINE ROLNICKI
USA

0184

ANDRES DANGOND
USA

0185

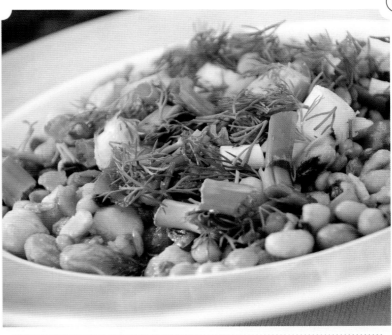

GEORGIOS DETSIS
GREECE

0186

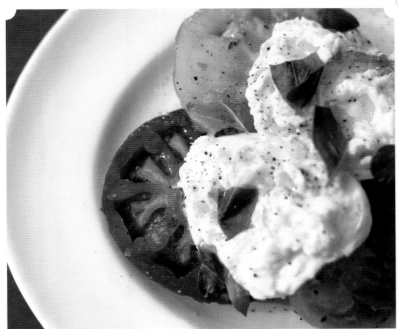

KARI SKAFLEN
USA

0187

GEORGIOS DETSIS
GREECE

0188

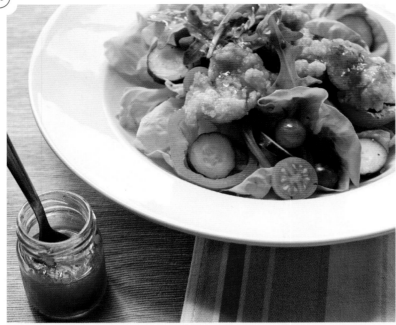

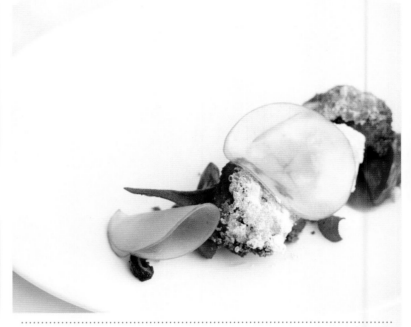

THAIN LIN TAY
SIGNAPORE

0189

HEATHER SPERLING
USA

0190

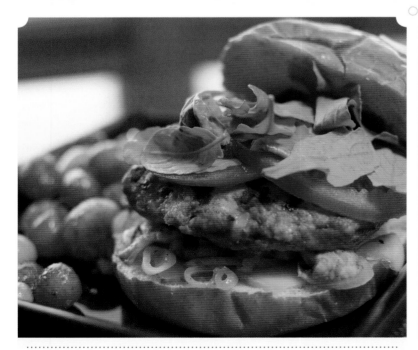

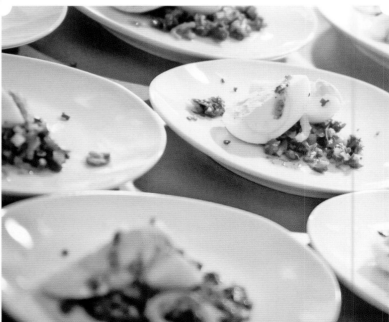

BERNADINE ROLNICKI
USA

0191

CARA AND SCOTT NAVA
USA

0192

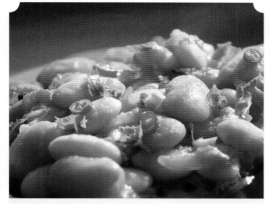

GEORGIOS DETSIS
GREECE
0193

KATE RIESENBERG
USA
0194

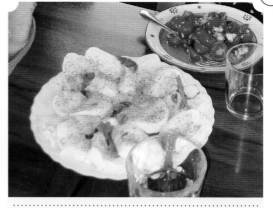

KATE RIESENBERG
USA
0195

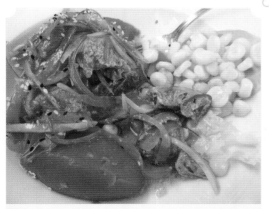

KATE RIESENBERG
USA
0196

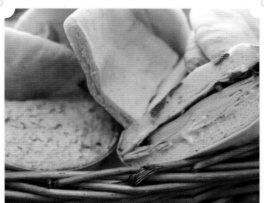

DENNIS LEE
USA
0197

LAUREN PODOLSKY
USA
0198

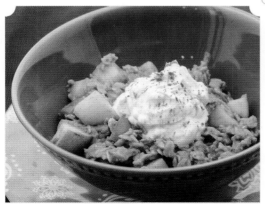

LAUREN PODOLSKY
USA
0199

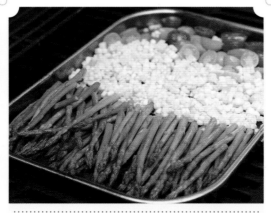

MOLLY MCMAHON
USA
0200

HEATHER SPERLING
USA
0201

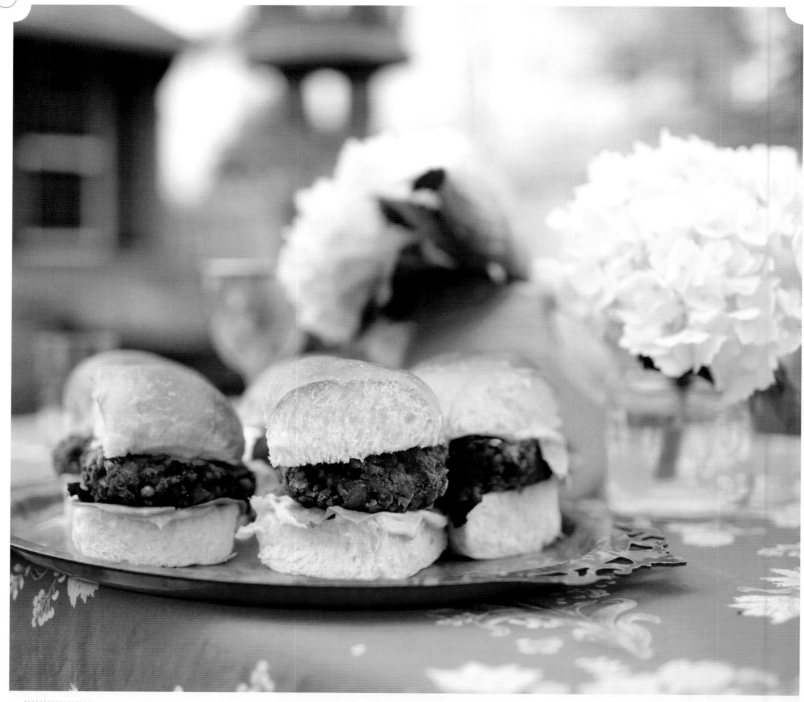

MARTA SASINOWSKA
USA

0202

HEATHER CROSBY
USA
0203

ERIC KLEINBERG
USA
0204

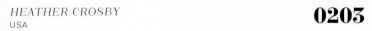

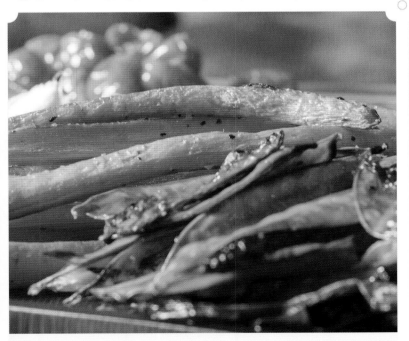

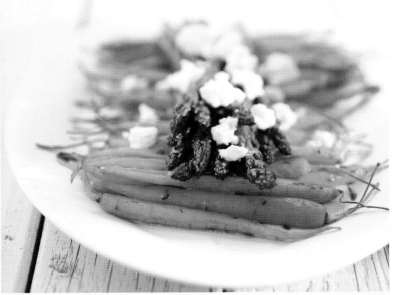

MICHELLE DEITER
USA
0205

NADINE SHAW
AUSTRALIA
0206

GRIP
USA

0207

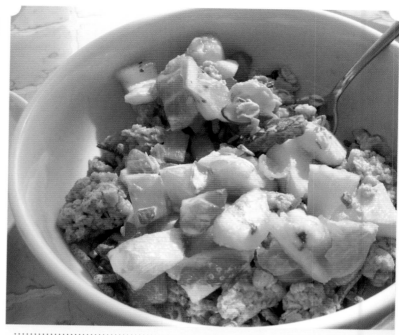

KATE RIESENBERG
USA

0208

REGAN BARONI
USA

0209

PARAGON MARKETING COMMUNICATIONS
KUWAIT

0210

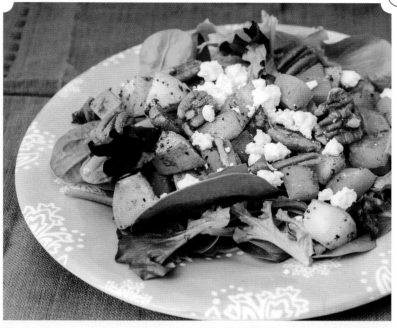

MOLLY MCMAHON
USA

0211

LAUREN PODOLSKY
USA

0212

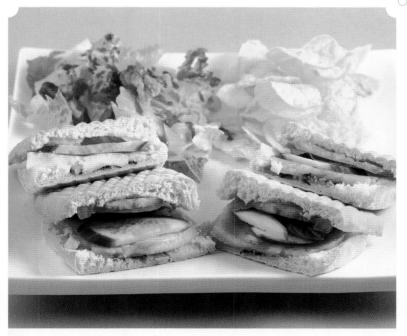

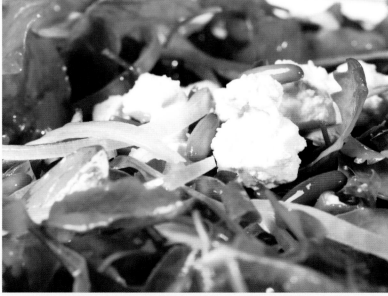

PARAGON MARKETING COMMUNICATIONS
KUWAIT

0213

PARAGON MARKETING COMMUNICATIONS
KUWAIT

0214

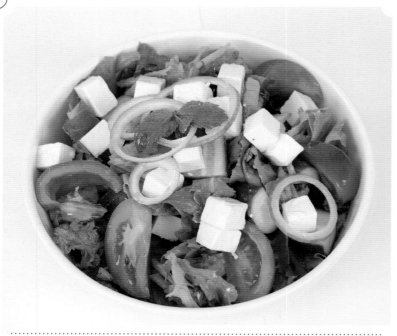

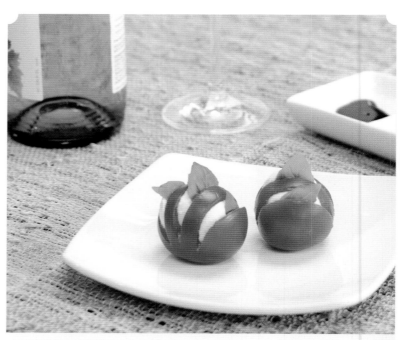

PARAGON MARKETING COMMUNICATIONS **0215**
KUWAIT

RONNIE SAINI **0216**
USA

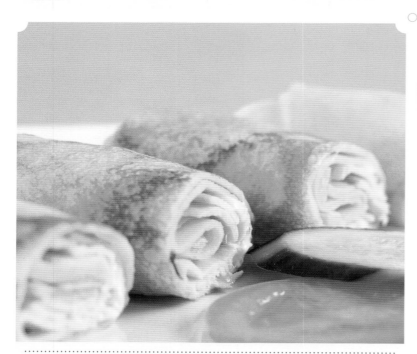

PARAGON MARKETING COMMUNICATIONS **0217**
KUWAIT

SCOTT ERB AND DONNA DUFAULT **0218**
USA

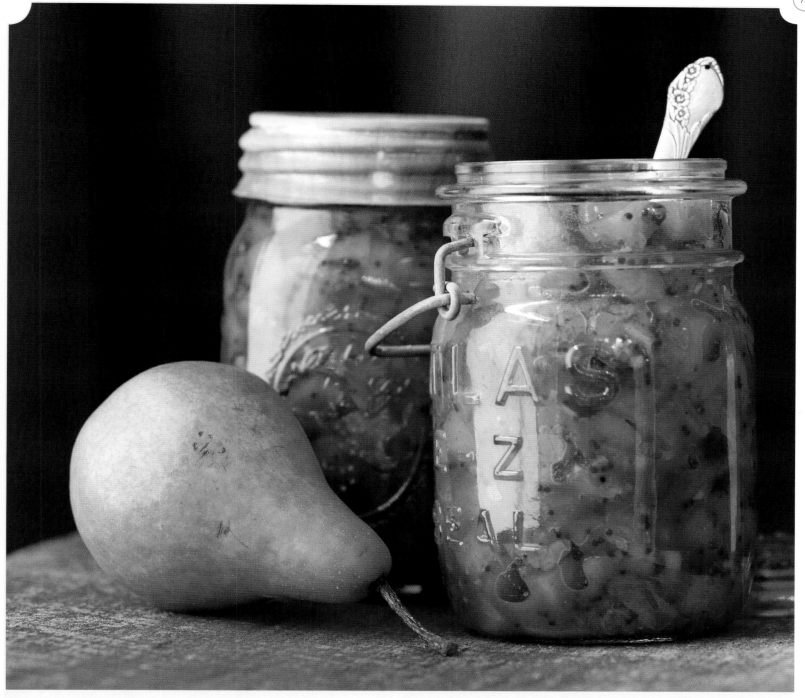

GLENN SCOTT
USA

0219

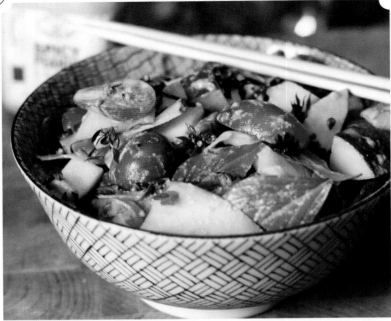

HEATHER SPERLING
USA

0220

HEATHER SPERLING
USA

0221

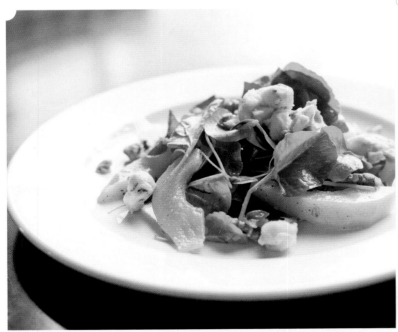

TUAN H. BUI
USA

0222

HEATHER SPERLING
USA

0223

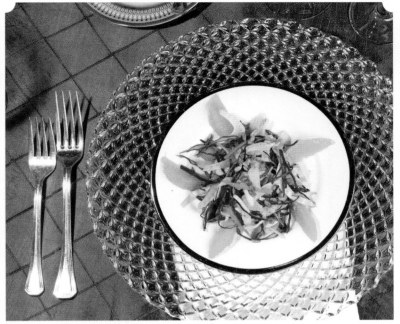

TUAN H. BUI
USA

0224

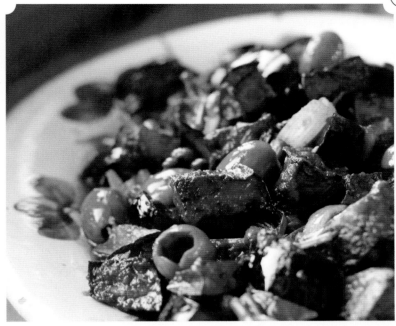

HEATHER SPERLING
USA

0225

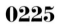

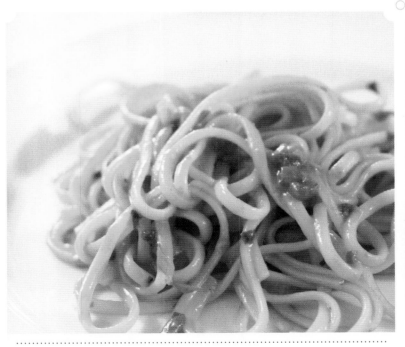

HEATHER SPERLING
USA

0226

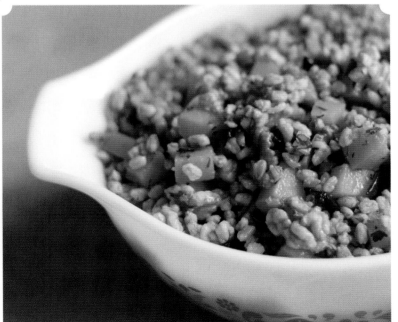

SHERI SILVER
USA

0227

INDULGE

RICH / SWEET / SAVORY / GLAZED / FRIED

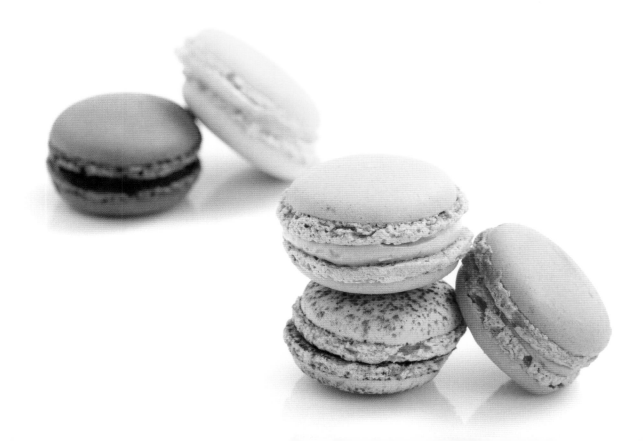

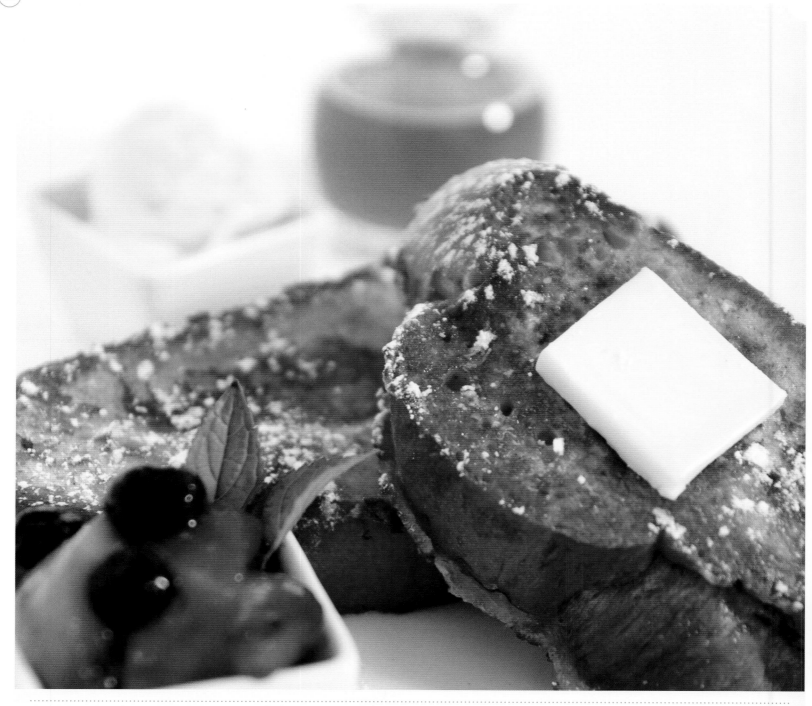

GRIP
USA

0228

NADINE SHAW
AUSTRALIA
0229

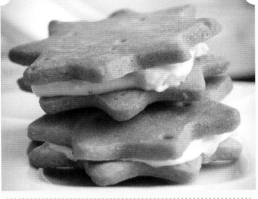

LAURA SANT
USA
0230

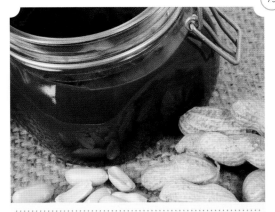

CARLOS RIBEIRO
PORTUGAL
0231

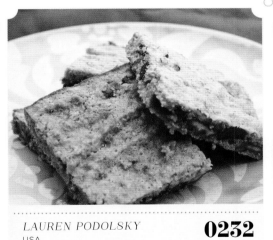

LAUREN PODOLSKY
USA
0232

HEATHER SPERLING
USA
0233

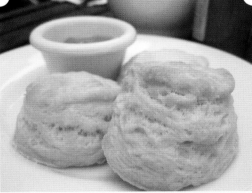

ELLIE MEYER
USA
0234

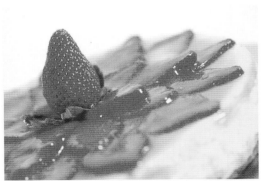

PARAGON MARKETING
COMMUNICATIONS KUWAIT
0235

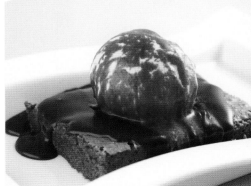

PARAGON MARKETING
COMMUNICATIONS KUWAIT
0236

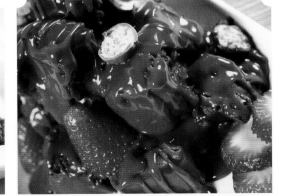

PARAGON MARKETING
COMMUNICATIONS KUWAIT
0237

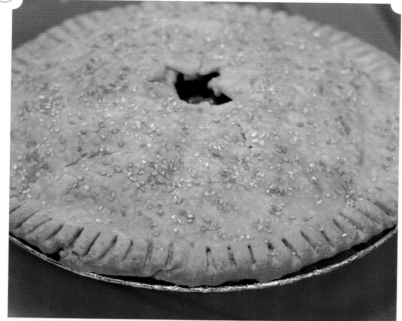

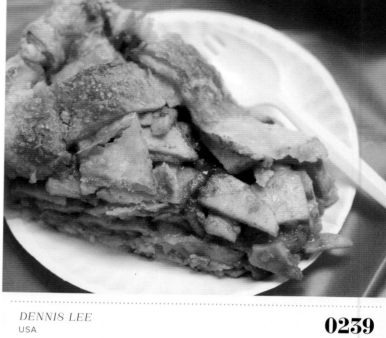

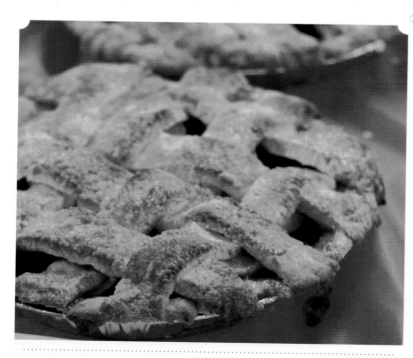

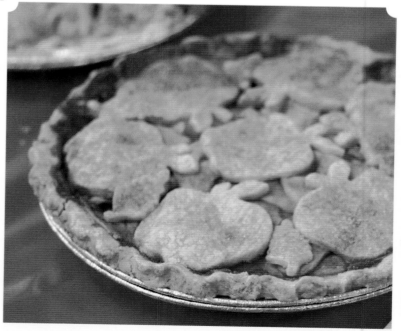

TUAN H. BUI
USA
0242

JUSTIN B. PARIS
USA
0243

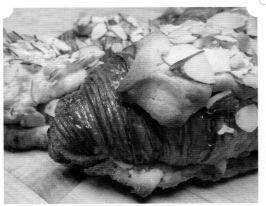

KATE RIESENBERG
USA
0244

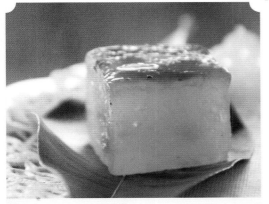

GEORGIOS DETSIS
GREECE
0245

GEORGIOS DETSIS
GREECE
0246

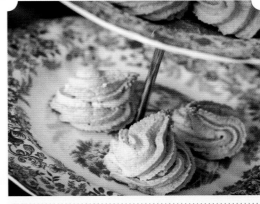

GEORGIOS DETSIS
GREECE
0247

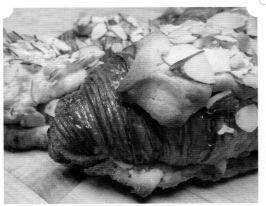

ANDREW HICKEY
USA
0248

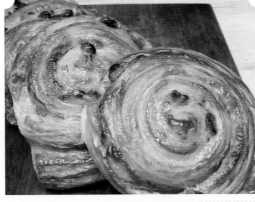

ANDREW HICKEY
USA
0249

ANDREW HICKEY
USA
0250

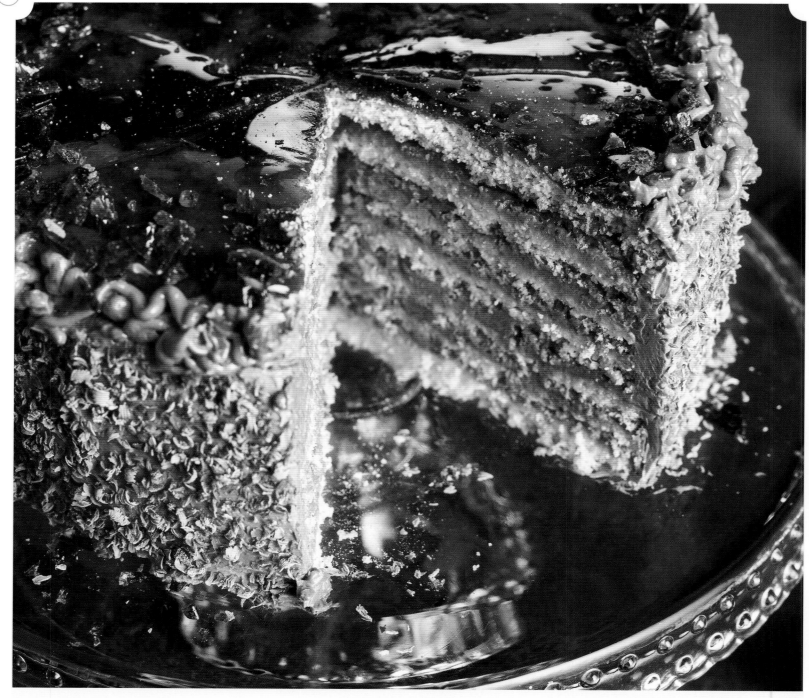

JUSTIN B. PARIS
USA

0251

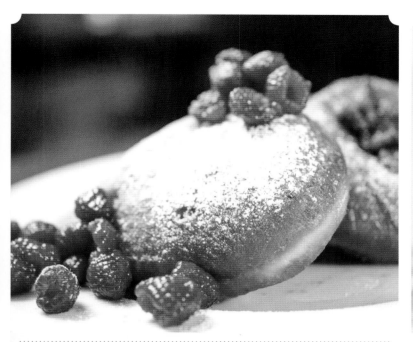

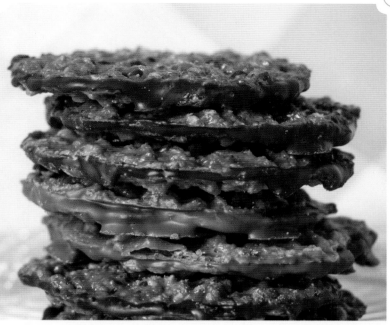

GALDONES PHOTOGRAPHY
USA
0252

MICHELLE DEITER
USA
0253

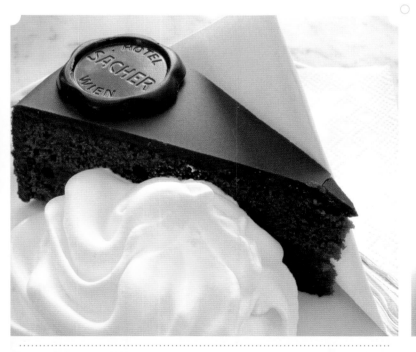

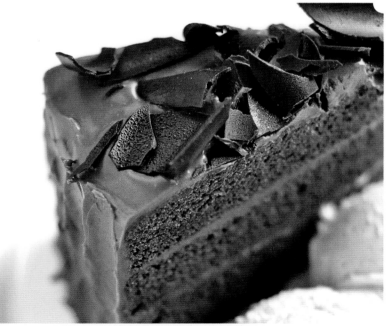

KATE RIESENBERG
USA
0254

NICOLE ZARATE
USA
0255

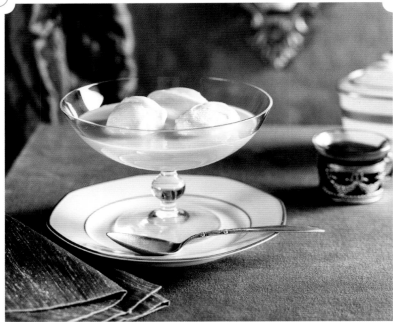

JUSTIN B. PARIS
USA

0256

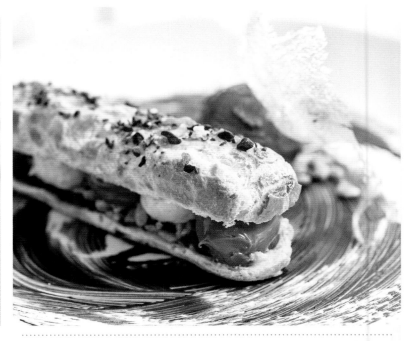

GALDONES PHOTOGRAPHY
USA

0257

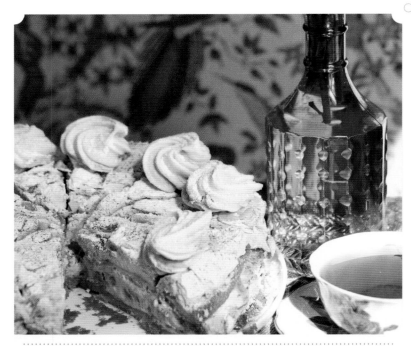

RUTH HUIMERIND
ESTONIA

0258

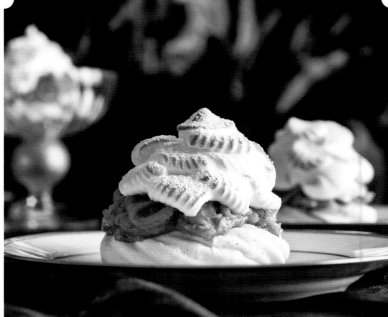

JUSTIN B. PARIS
USA

0259

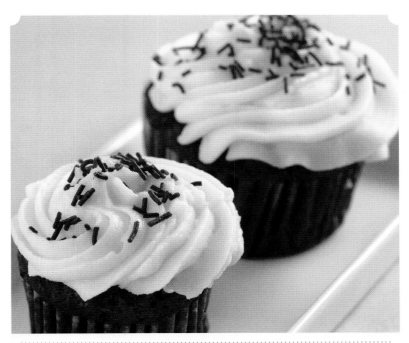

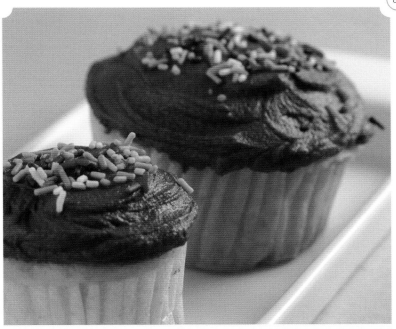

PARAGON MARKETING COMMUNICATIONS
KUWAIT
0260

PARAGON MARKETING COMMUNICATIONS
KUWAIT
0261

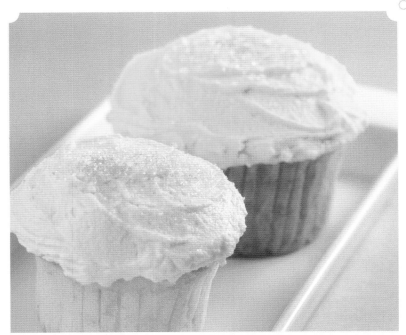

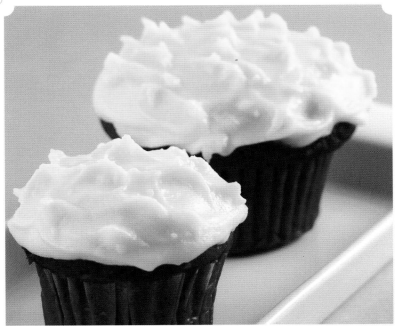

PARAGON MARKETING COMMUNICATIONS
KUWAIT
0262

PARAGON MARKETING COMMUNICATIONS
KUWAIT
0263

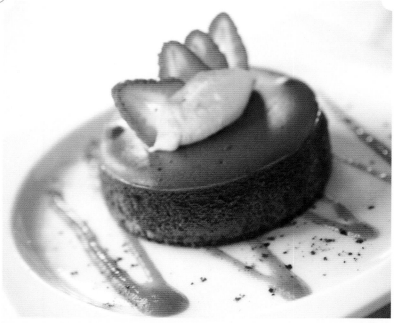

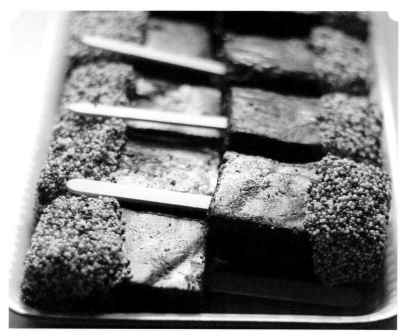

CARA AND SCOTT NAVA
USA

0264

SHERI SILVER
USA

0265

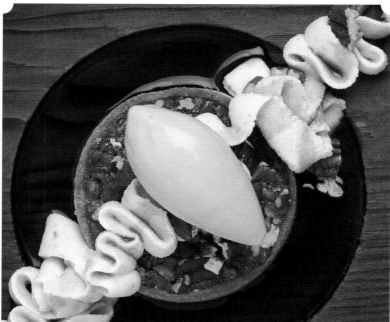

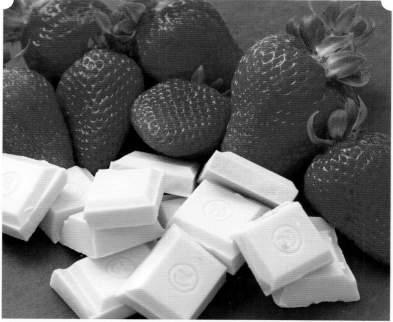

ERIC KLEINBERG
USA

0266

MOLLY MCMAHON
USA

0267

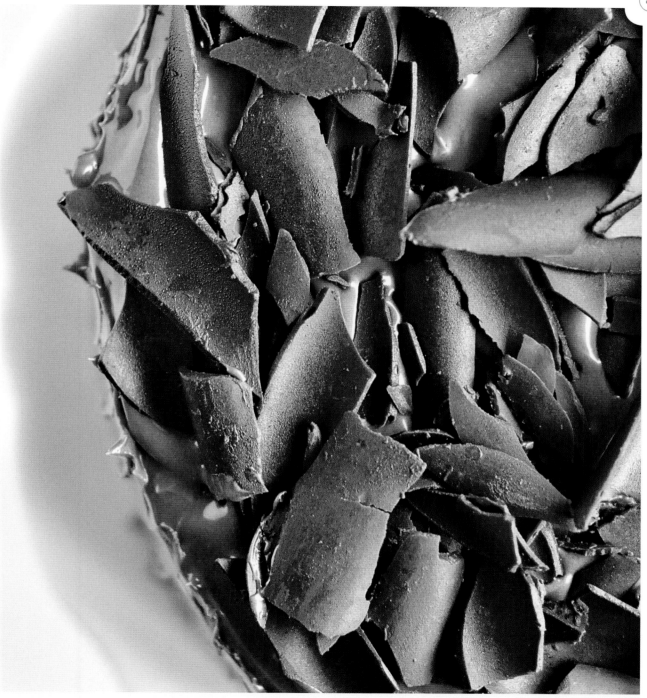

NICOLE ZARATE
USA

0268

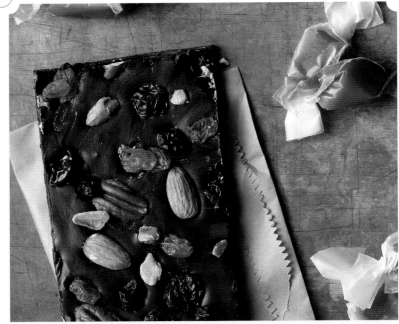

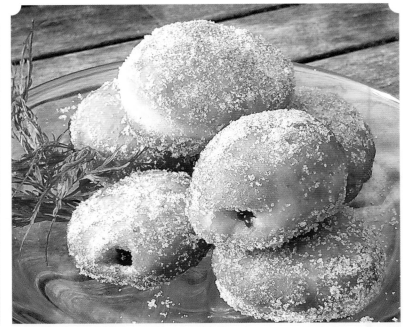

JUSTIN B. PARIS
USA

0269

ALYSA SLAY
USA

0270

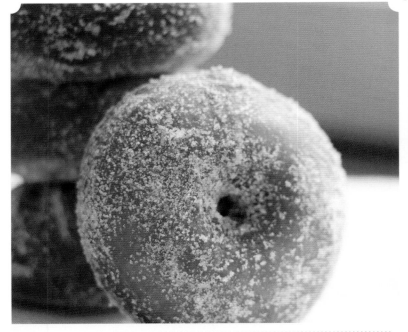

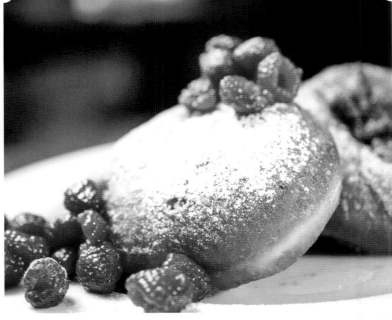

SHERI SILVER
USA

0271

GALDONES PHOTOGRAPHY
USA

0272

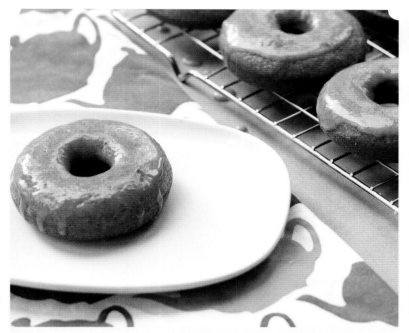

MOLLY MCMAHON
USA

0273

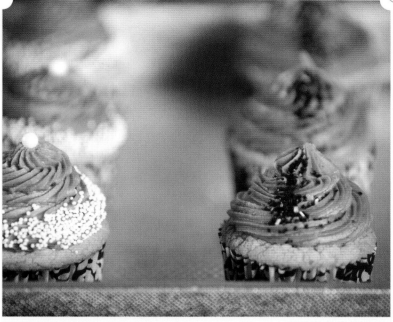

TUAN H. BUI
USA

0274

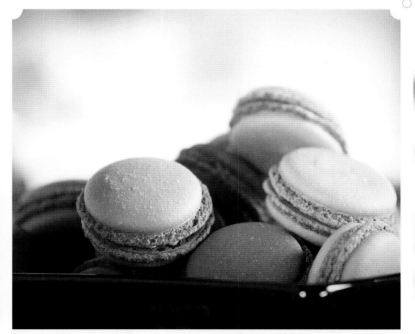

TUAN H. BUI
USA

0275

GALDONES PHOTOGRAPHY
USA

0276

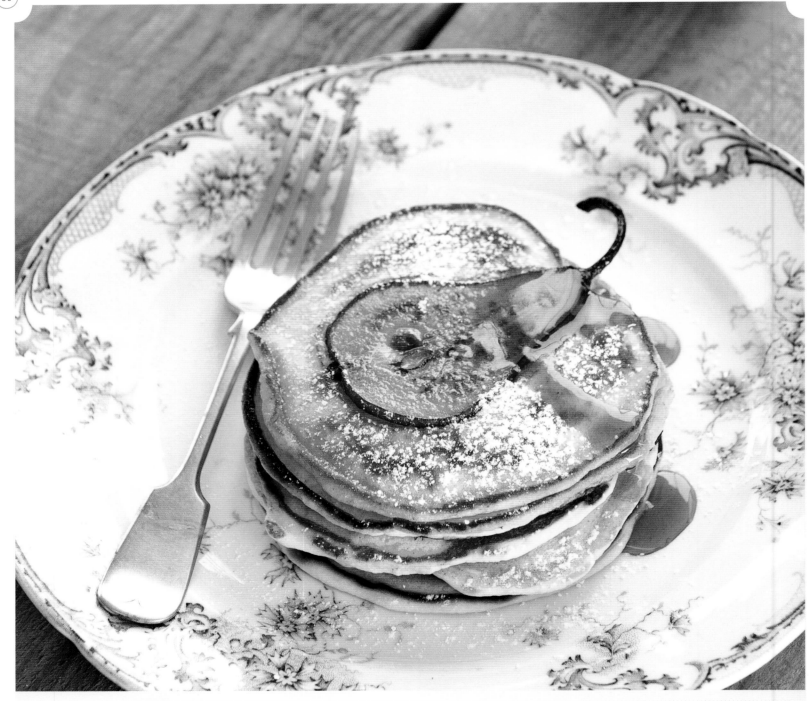

NADINE SHAW
AUSTRALIA

0277

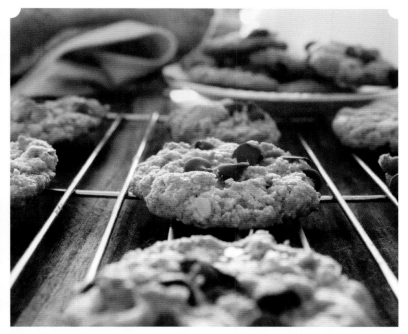

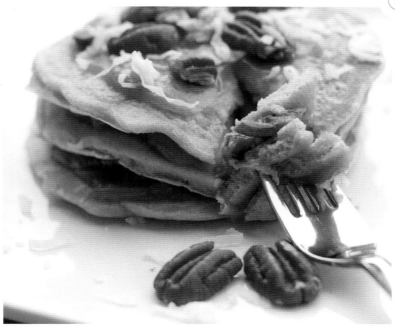

HEATHER CROSBY
USA

0278

MOLLY MCMAHON
USA

0279

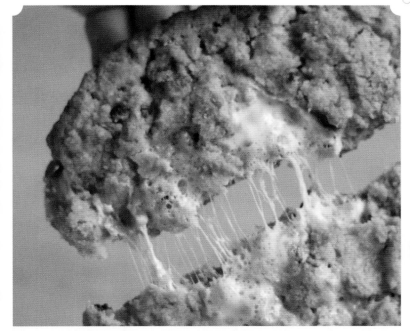

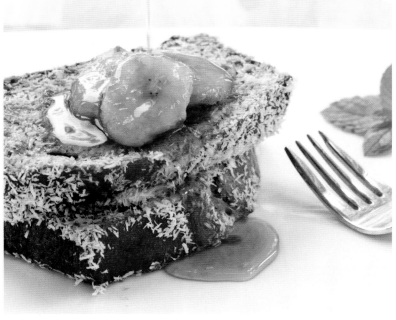

SHERI SILVER
USA

0280

MOLLY MCMAHON
USA

0281

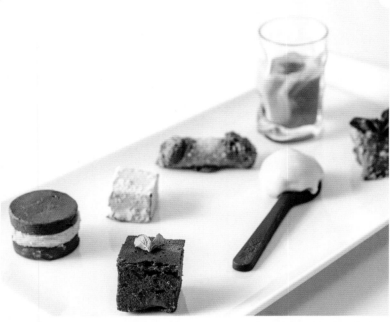

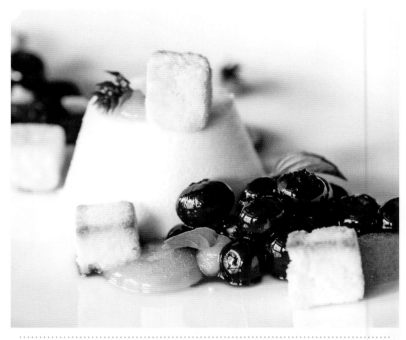

GALDONES PHOTOGRAPHY
USA

0282

GALDONES PHOTOGRAPHY
USA

0283

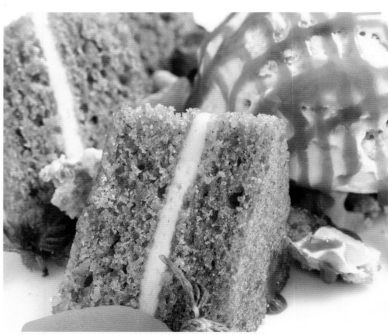

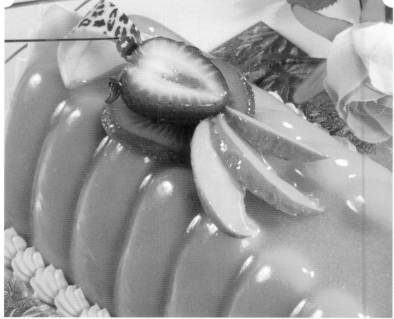

ERIC KLEINBERG
USA

0284

PARAGON MARKETING COMMUNICATIONS
KUWAIT

0285

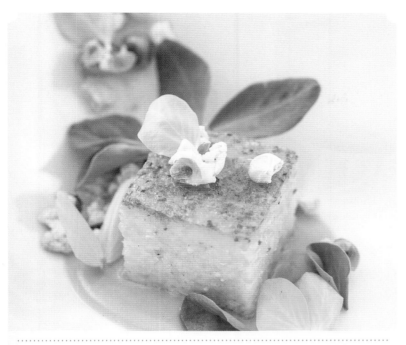

GALDONES PHOTOGRAPHY
USA

0286

GALDONES PHOTOGRAPHY
USA

0287

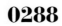

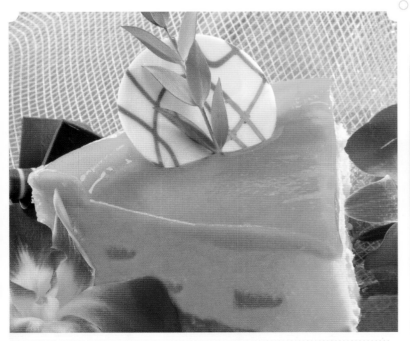

PARAGON MARKETING COMMUNICATIONS
KUWAIT

0288

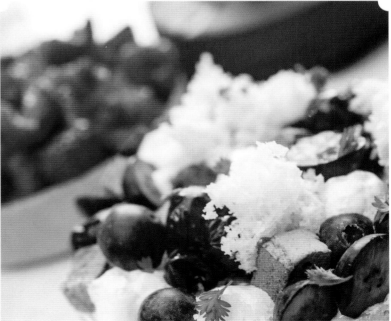

GALDONES PHOTOGRAPHY
USA

0289

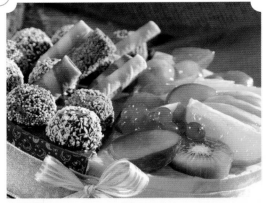

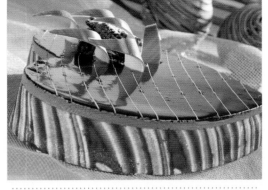

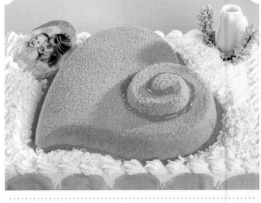

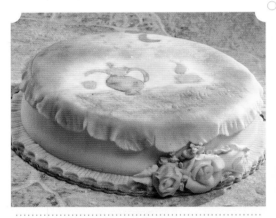

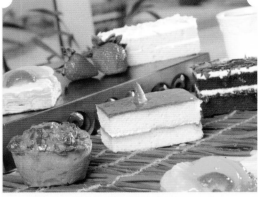

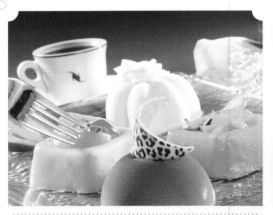

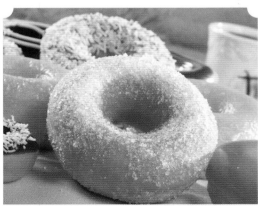

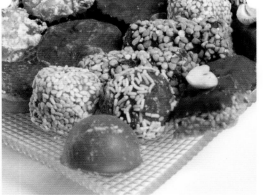

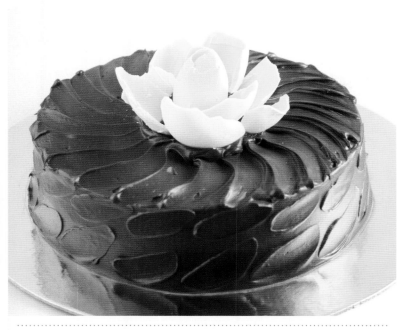

PARAGON MARKETING COMMUNICATIONS
KUWAIT

0299

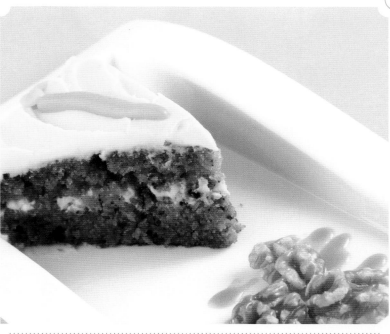

PARAGON MARKETING COMMUNICATIONS
KUWAIT

0300

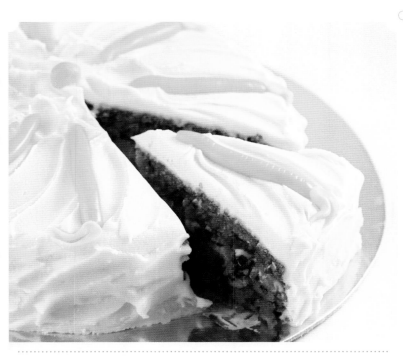

PARAGON MARKETING COMMUNICATIONS
KUWAIT

0301

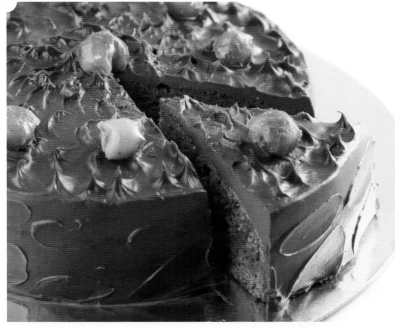

PARAGON MARKETING COMMUNICATIONS
KUWAIT

0302

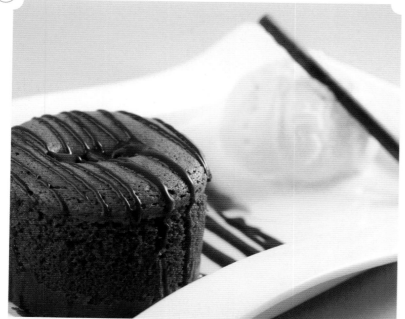

PARAGON MARKETING COMMUNICATIONS
KUWAIT

0303

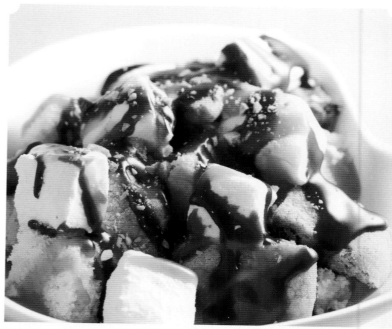

PARAGON MARKETING COMMUNICATIONS
KUWAIT

0304

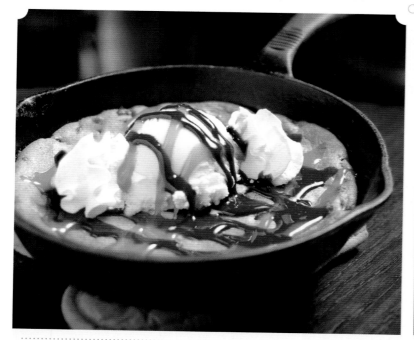

GRIP
USA

0305

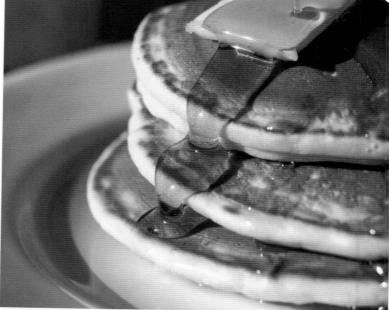

MICHELLE DEITER
USA

0306

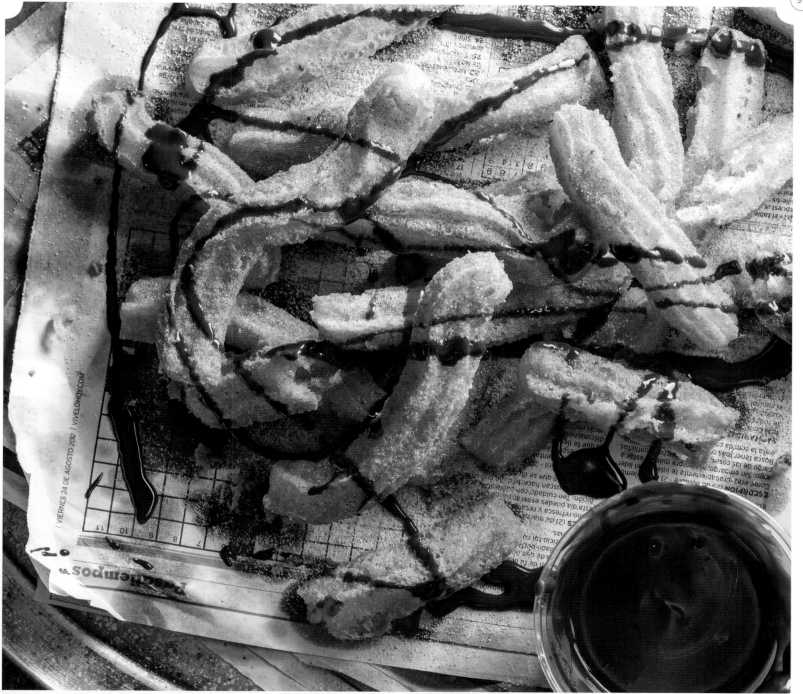

JUSTIN B. PARIS
USA

0307

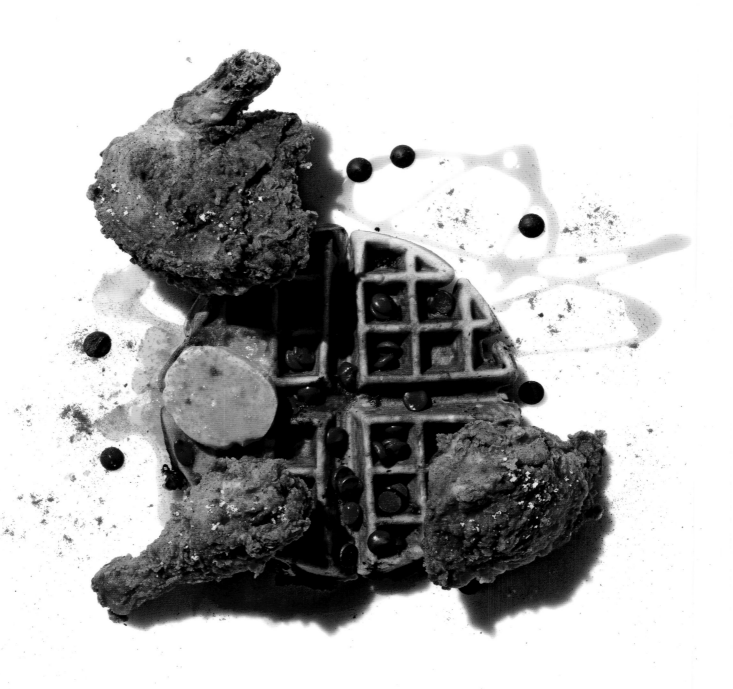

DAVE BRADLEY
USA

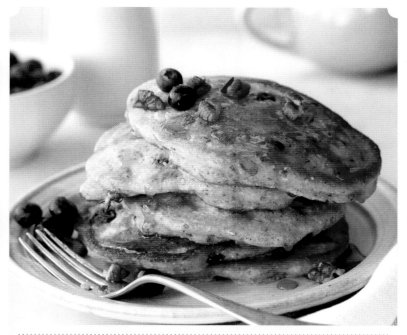

SARA REMINGTON
USA

0309

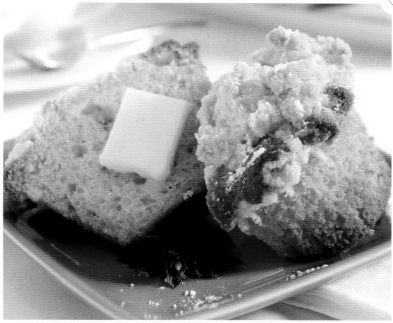

GRIP
USA

0310

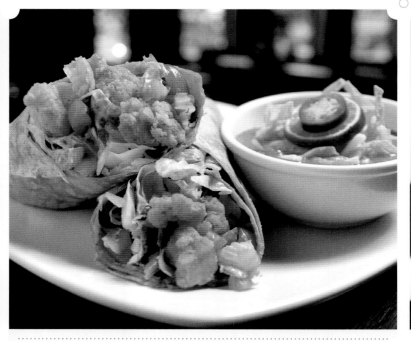

GRIP
USA

0311

PARAGON MARKETING COMMUNICATIONS
KUWAIT

0312

ERIC KLEINBERG
USA

0313

GRIP
USA

0314

DENNIS LEE
USA

0315

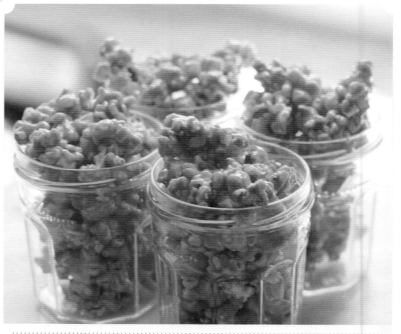

SHERI SILVER
USA

0316

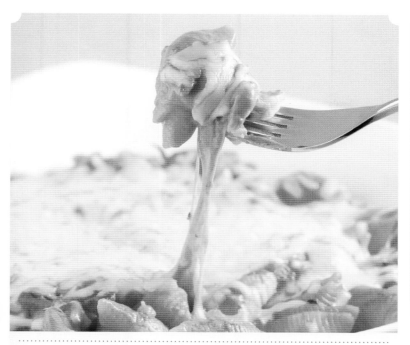

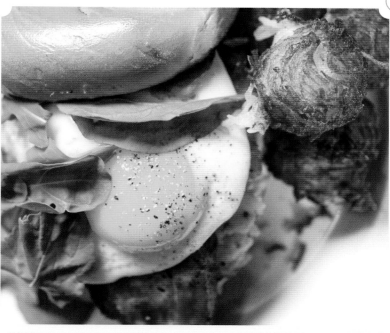

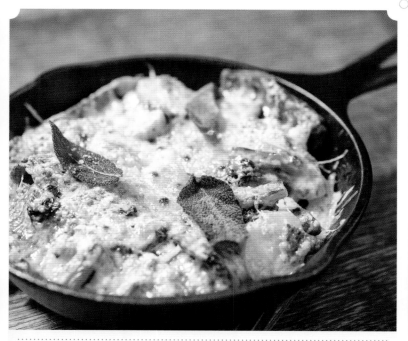

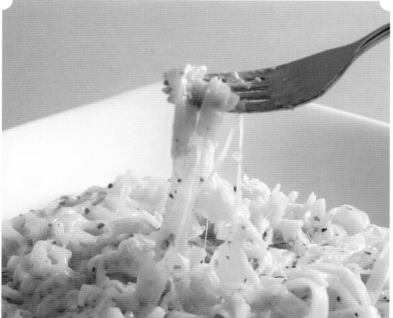

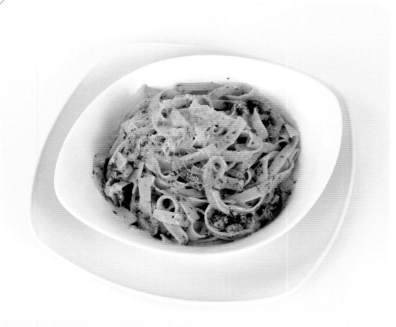

0321

0322

0323

0324

PARAGON MARKETING COMMUNICATIONS
KUWAIT
0325

PARAGON MARKETING COMMUNICATIONS
KUWAIT
0326

PARAGON MARKETING COMMUNICATIONS
KUWAIT
0327

PARAGON MARKETING COMMUNICATIONS
KUWAIT
0328

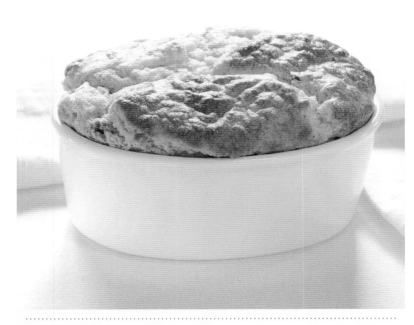

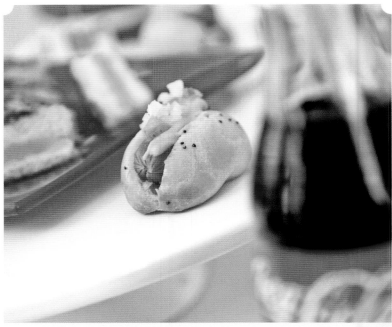

GEORGIOS DETSIS
GREECE

0329

CARA AND SCOTT NAVA
USA

0330

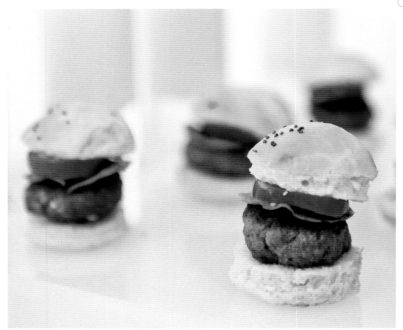

CARA AND SCOTT NAVA
USA

0331

EZEQUIEL BECERRA
COSTA RICA

0332

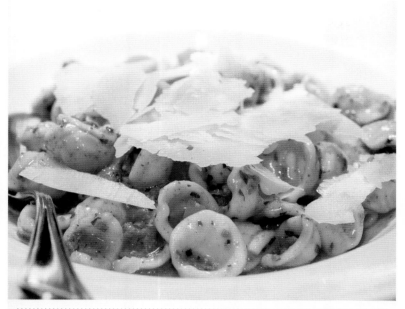

KARI SKAFLEN
USA
0333

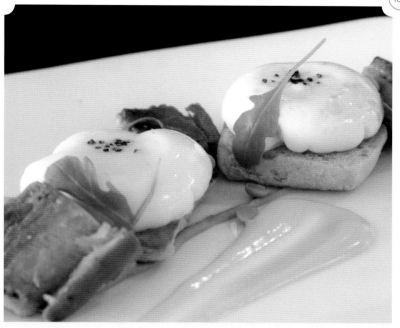

ANDREW HICKEY
USA
0334

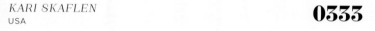

KATE RIESENBERG
USA
0335

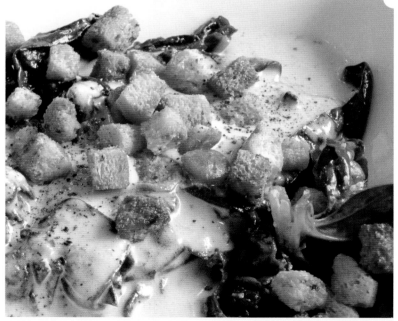

KATE RIESENBERG
USA
0336

ANTHONY TAHLIER
USA

0337

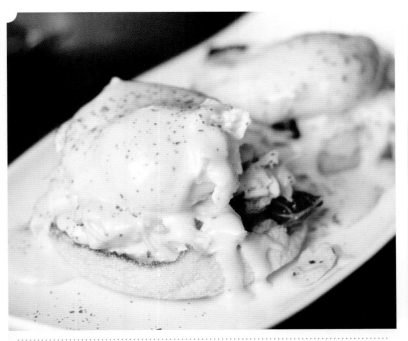

HEATHER SPERLING
USA
0338

HEATHER SPERLING
USA
0339

HEATHER SPERLING
USA
0340

HEATHER SPERLING
USA
0341

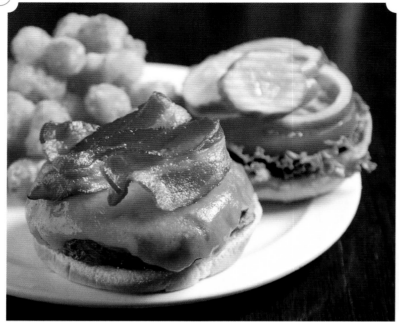

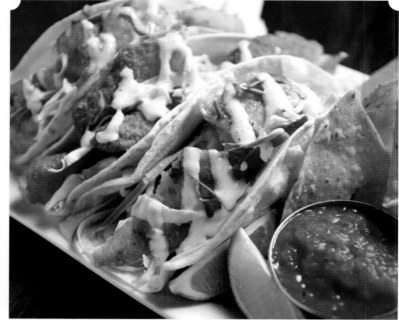

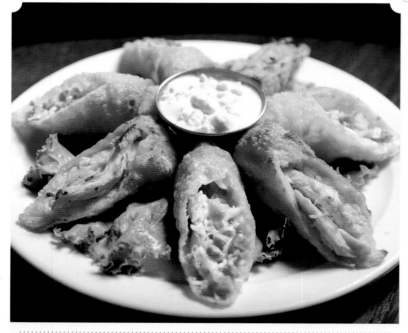

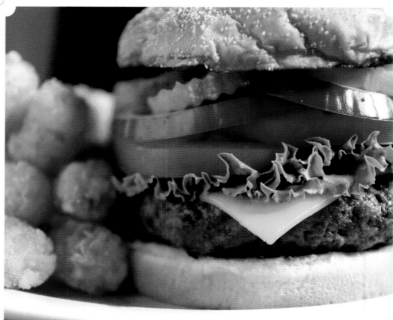

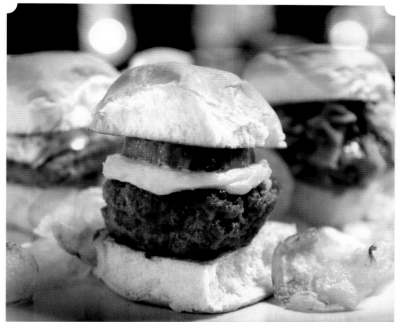

GRIP
USA
0346

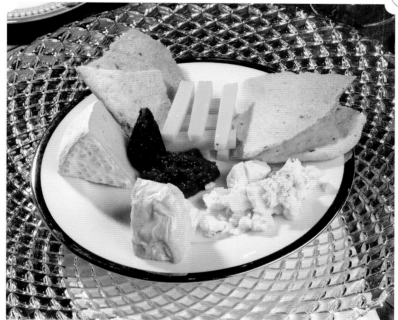

TUAN H. BUI
USA
0347

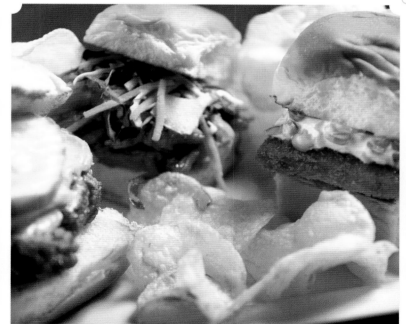

GRIP
USA
0348

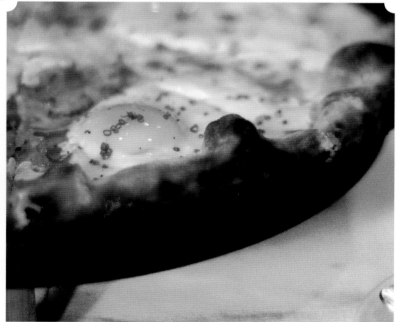

ANDREW HICKEY
USA
0349

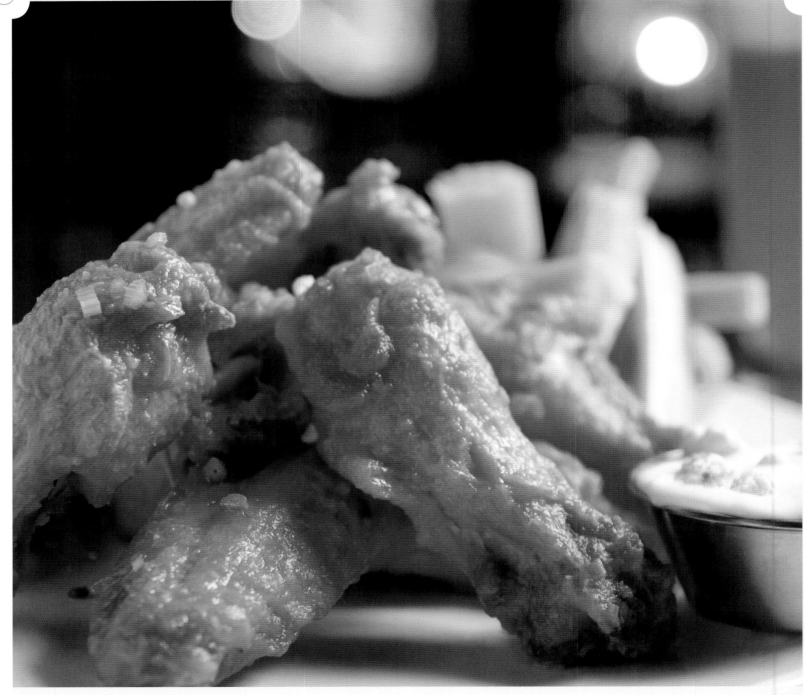

GRIP

USA

0350

GEORGIOS DETSIS
USA
0351

CARA AND SCOTT NAVA
USA
0352

BRANDON FREITAS
USA
0353

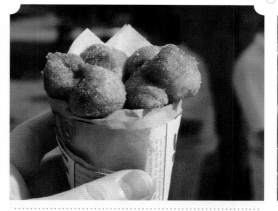

ANDREW HICKEY
USA
0354

BRANDON FREITAS
USA
0355

BRANDON FREITAS
USA
0356

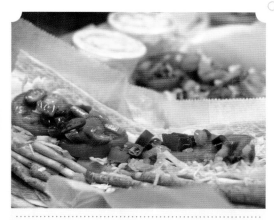

DENNIS LEE
USA
0357

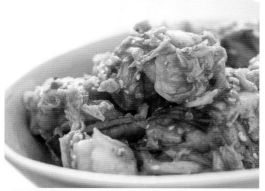

GALDONES PHOTOGRAPHY
USA
0358

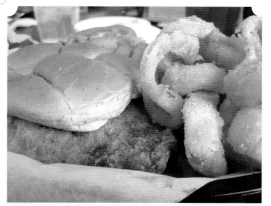

ELLIE MEYER
USA
0359

CHILL

REFRESH / QUENCH / FREEZE

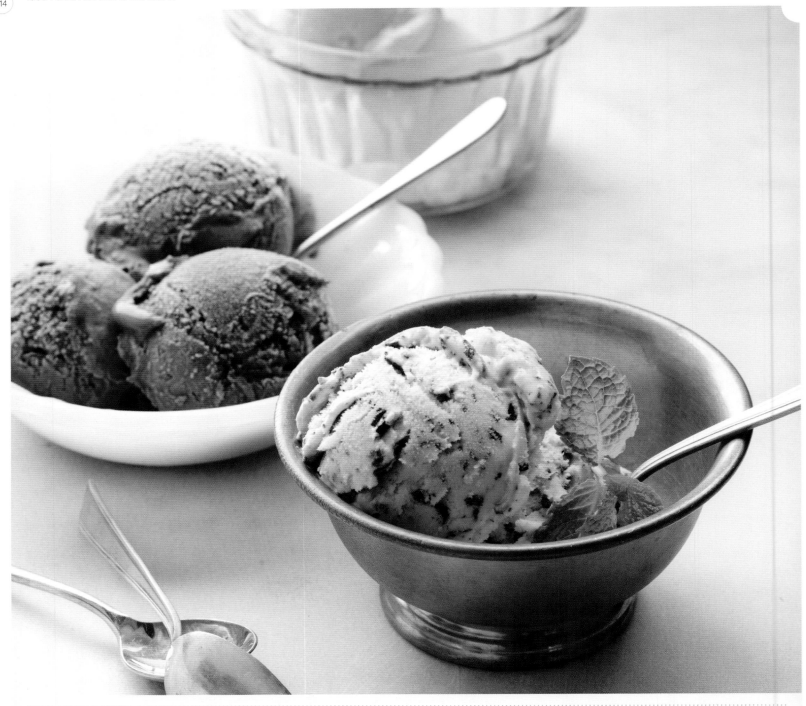

SARA REMINGTON
USA

0360

PARAGON MARKETING COMMUNICATIONS KUWAIT **0361**

HEATHER SPERLING USA **0362**

PARAGON MARKETING COMMUNICATIONS KUWAIT **0363**

BRANDON FREITAS USA **0364**

PARAGON MARKETING COMMUNICATIONS KUWAIT **0365**

KATE RIESENBERG USA **0366**

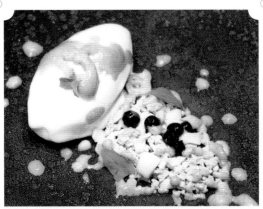

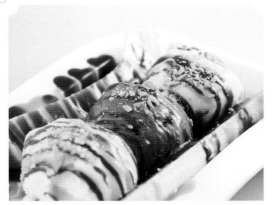

PARAGON MARKETING COMMUNICATIONS KUWAIT **0367**

TY LETTAU USA **0368**

PARAGON MARKETING COMMUNICATIONS KUWAIT **0369**

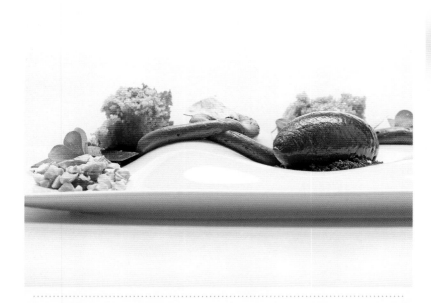

ANTHONY TAHLIER
USA

0370

GALDONES PHOTOGRAPHY
USA

0371

ERIC KLEINBERG
USA

0372

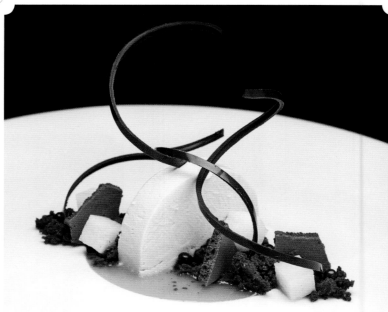

ERIC KLEINBERG
USA

0373

CARA AND SCOTT NAVA
USA

0374

TUAN H. BUI
USA

0375

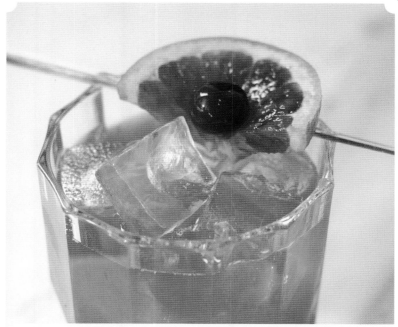

HEATHER SPERLING
USA

0376

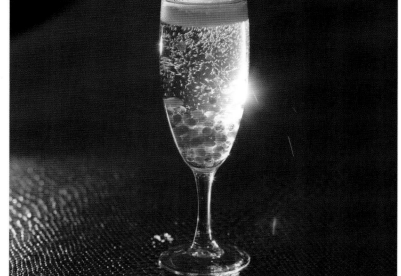

TUAN H. BUI
USA

0377

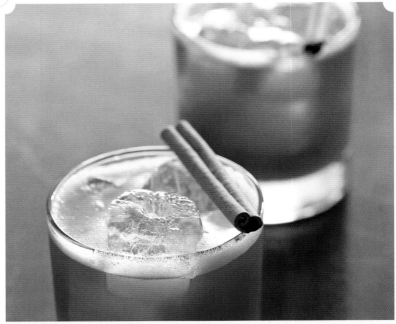

ANTHONY TAHLIER
USA

0378

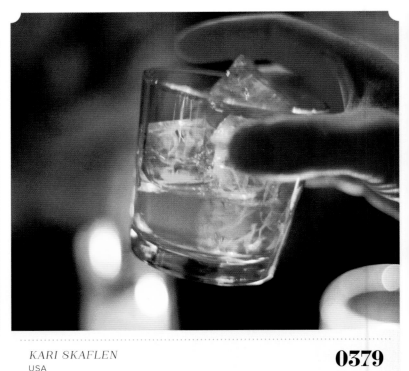

KARI SKAFLEN
USA

0379

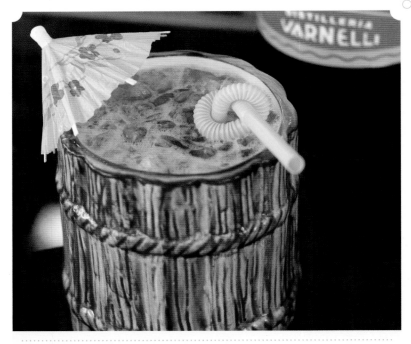

HEATHER SPERLING
USA

0380

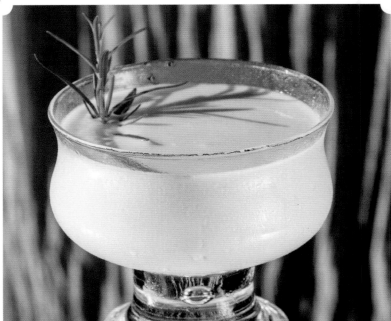

MICHELLE DEITER
USA

0381

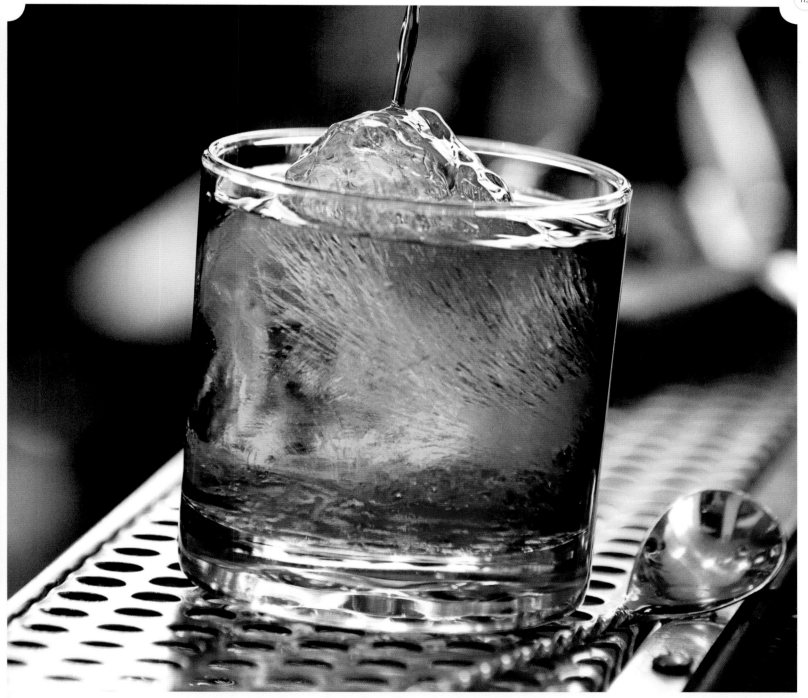

ERIC KLEINBERG
USA

0382

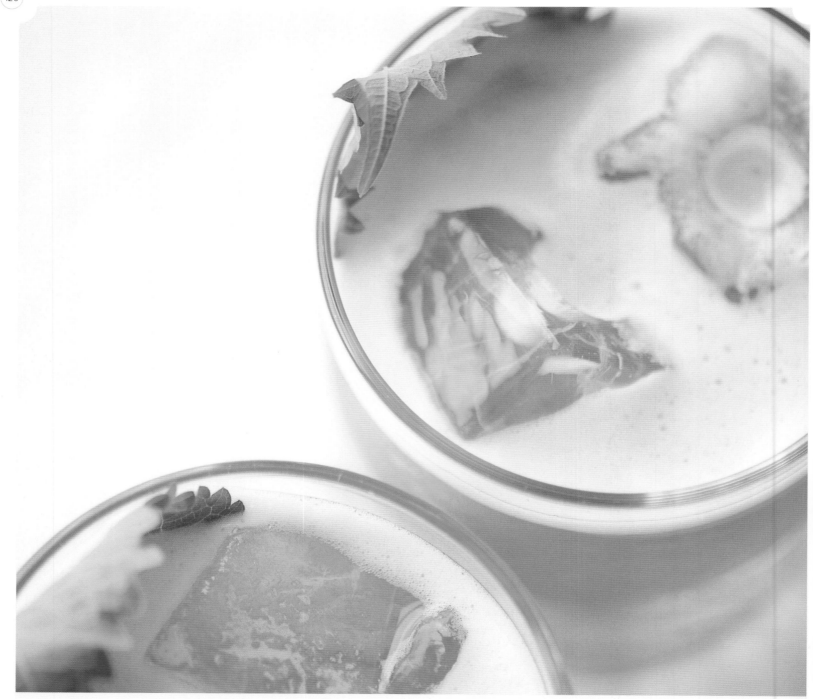

ANTHONY TAHLIER
USA

0383

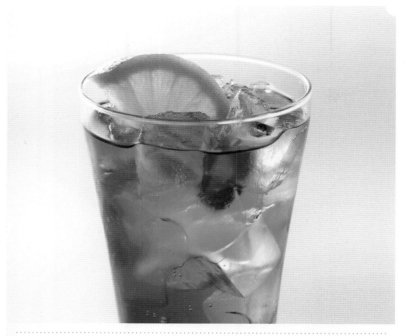

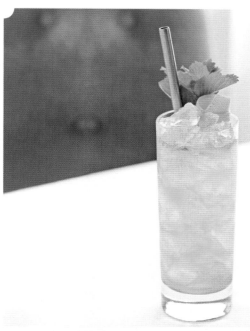

PARAGON MARKETING COMMUNICATIONS
KUWAIT

0384

ANTHONY TAHLIER
USA

0385

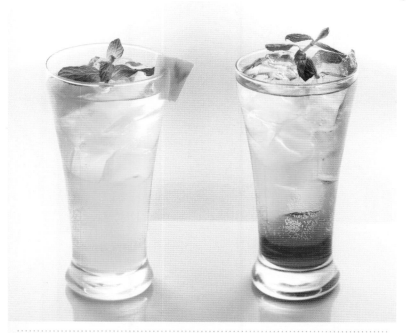

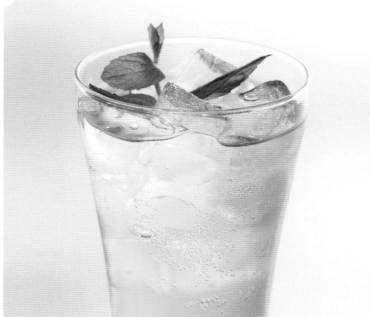

PARAGON MARKETING COMMUNICATIONS
KUWAIT

0386

PARAGON MARKETING COMMUNICATIONS
KUWAIT

0387

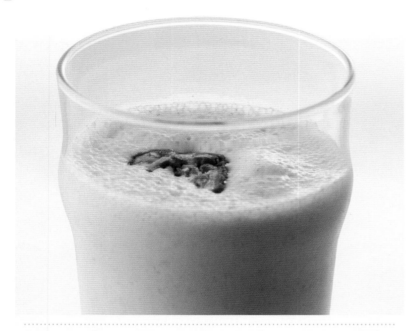

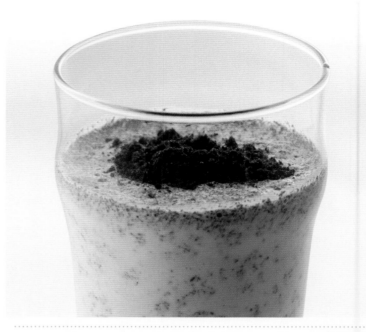

PARAGON MARKETING COMMUNICATIONS
KUWAIT **0388**

PARAGON MARKETING COMMUNICATIONS
KUWAIT **0389**

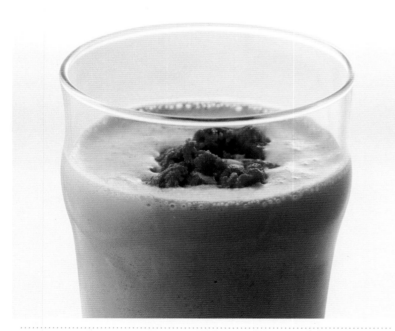

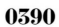

PARAGON MARKETING COMMUNICATIONS
KUWAIT **0390**

PARAGON MARKETING COMMUNICATIONS
KUWAIT **0391**

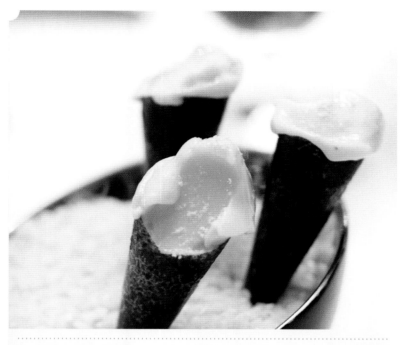

HEATHER SPERLING
USA
0392

SHERI SILVER
USA
0393

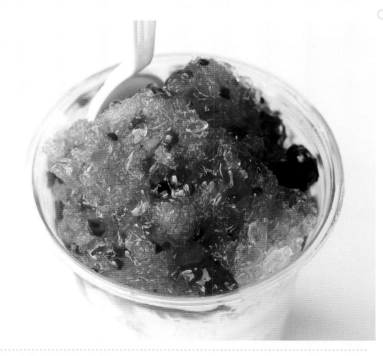

HEATHER SPERLING
USA
0394

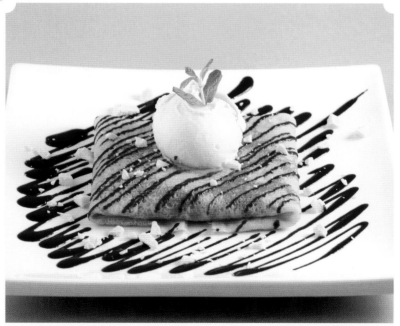

PARAGON MARKETING COMMUNICATIONS
USA
0395

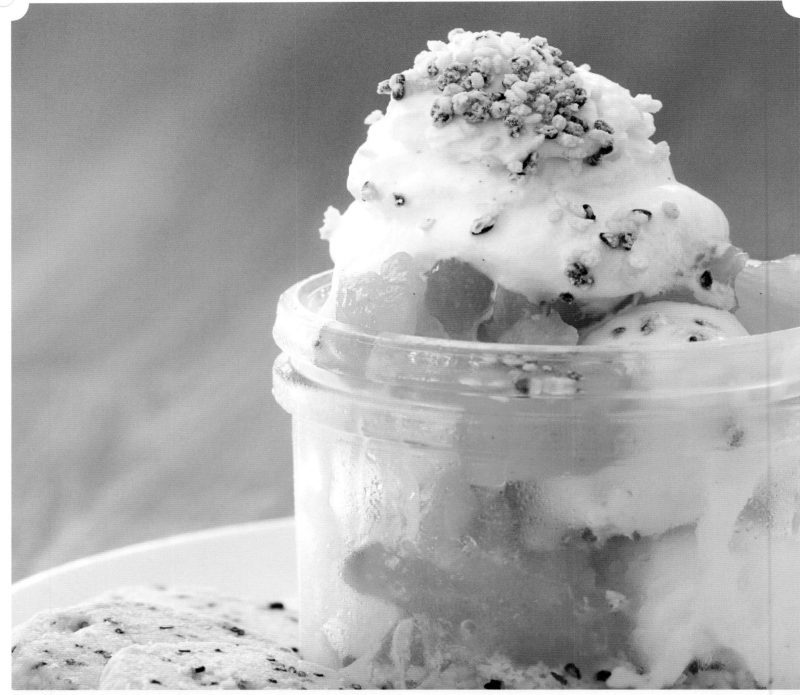

ERIC KLEINBERG
USA

0396

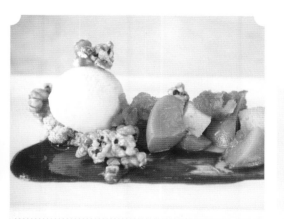

GALDONES PHOTOGRAPHY
USA
0397

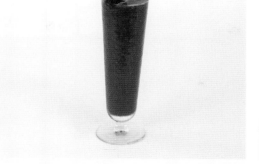

PARAGON MARKETING
COMMUNICATIONS KUWAIT
0398

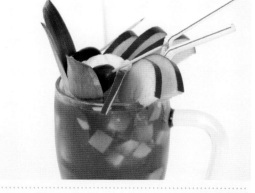

PARAGON MARKETING
COMMUNICATIONS KUWAIT
0399

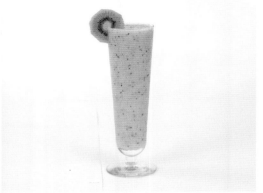

PARAGON MARKETING
COMMUNICATIONS KUWAIT
0400

PARAGON MARKETING
COMMUNICATIONS KUWAIT
0401

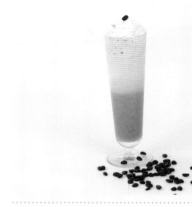

PARAGON MARKETING
COMMUNICATIONS KUWAIT
0402

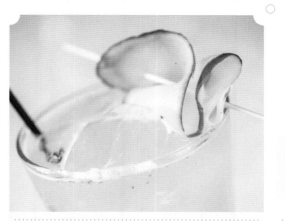

GALDONES PHOTOGRAPHY
USA
0403

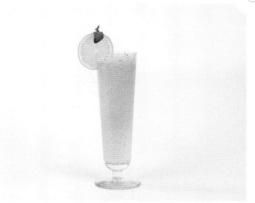

PARAGON MARKETING
COMMUNICATIONS KUWAIT
0404

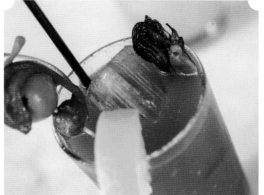

GALDONES PHOTOGRAPHY
USA
0405

HEAT

SPICY / FIERY / SMOKY / ZESTY / STEAMY

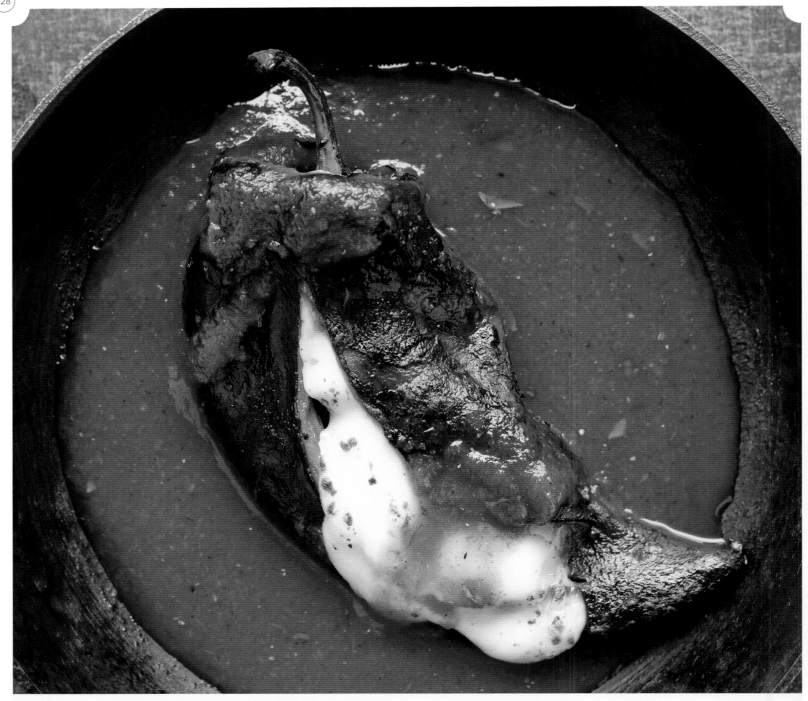

JUSTIN B. PARIS
USA

0406

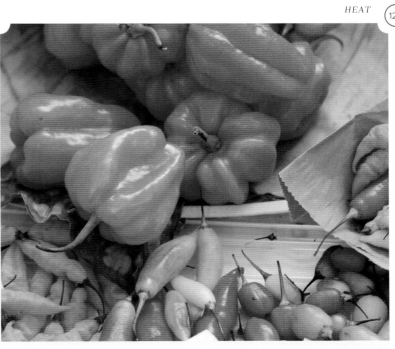

PARAGON MARKETING COMMUNICATIONS **0407**
KUWAIT

HEATHER SPERLING **0408**
USA

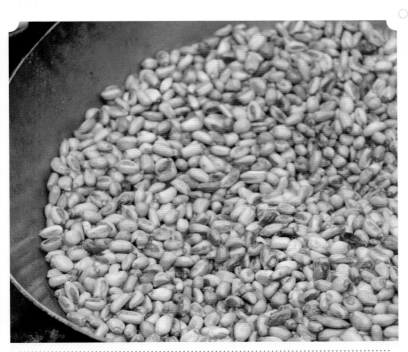

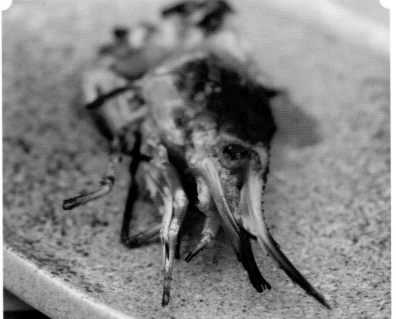

HEATHER SPERLING **0409**
USA

HEATHER SPERLING **0410**
USA

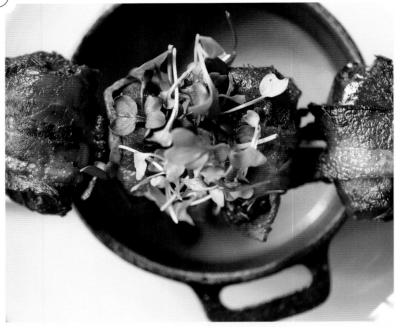

ANTHONY TAHLIER
USA

0411

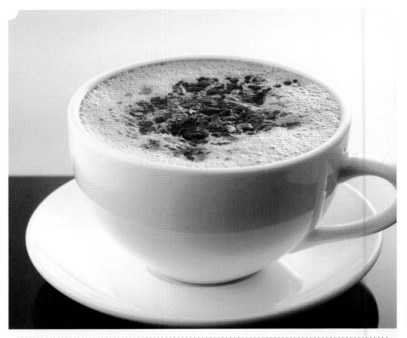

PARAGON MARKETING COMMUNICATIONS
KUWAIT

0412

ANTHONY TAHLIER
USA

0443

SCOTT ERB AND DONNA DUFAULT
USA

0444

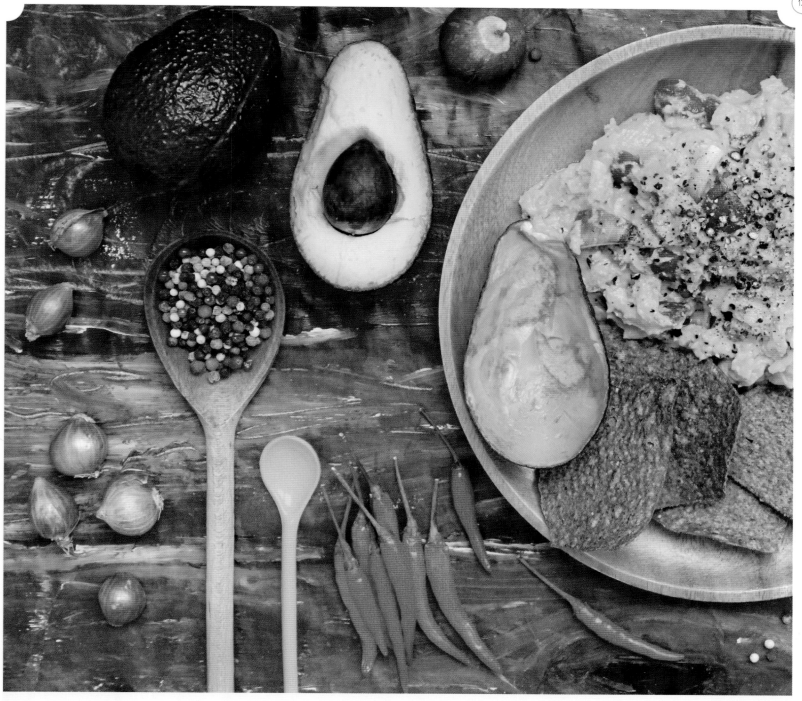

ELISABETTA REDAELLI
ITALY

0415

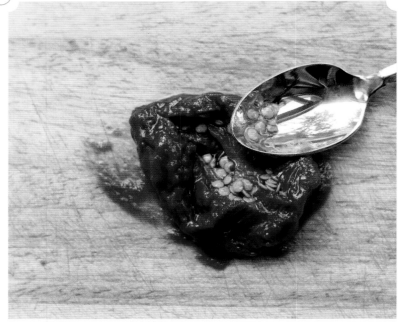

MOLLY MCMAHON
USA

0416

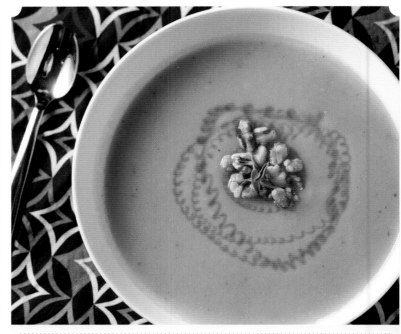

MOLLY MCMAHON
USA

0417

PARAGON MARKETING COMMUNICATIONS
KUWAIT

0418

MICHELLE DEITER
USA

0449

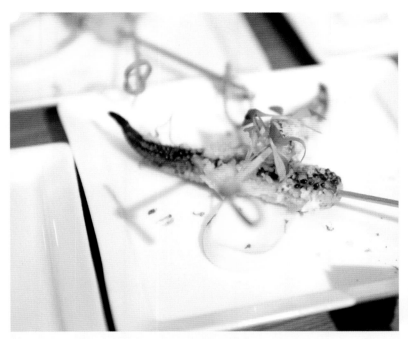

CARA AND SCOTT NAVA
USA

0420

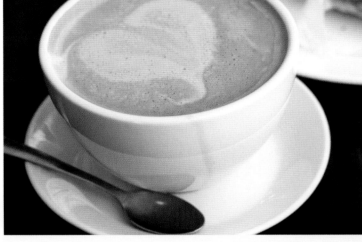

ANDREW HICKEY
USA

0421

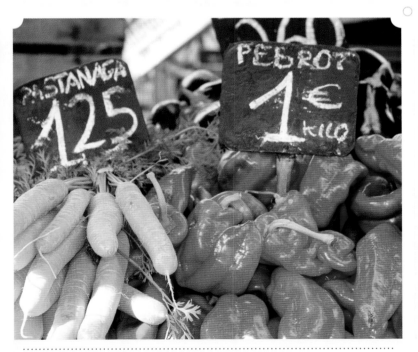

BRIAN POREA
USA

0422

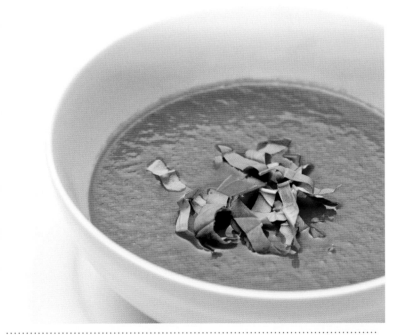

NICOLE ZARATE
USA

0423

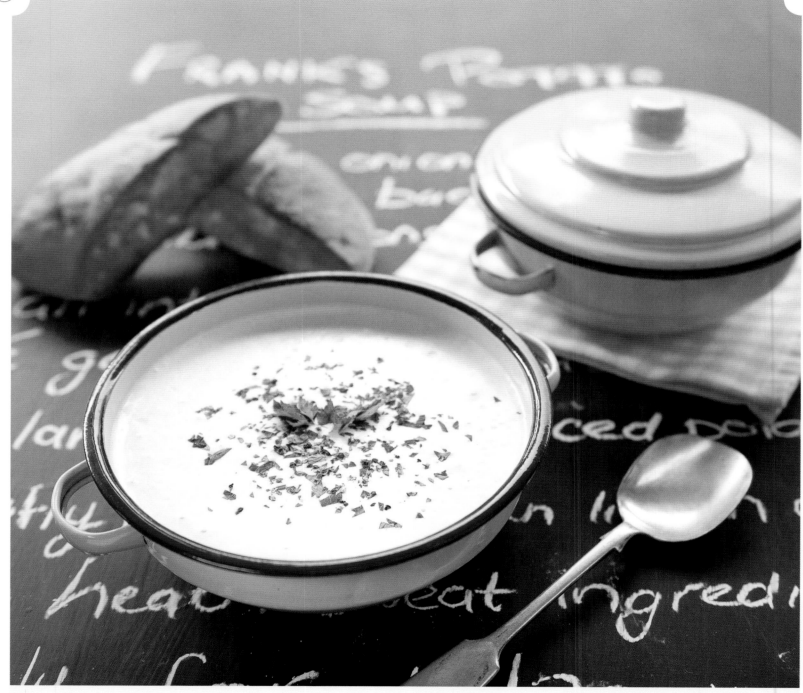

NADINE SHAW
AUSTRALIA

0424

SHERI SILVER
USA
0425

PARAGON MARKETING COMMUNICATIONS
KUWAIT
0426

MOLLY MCMAHON
USA
0427

HEATHER SPERLING
USA
0428

GLENN SCOTT
USA

0429

GLENN SCOTT
USA

0430

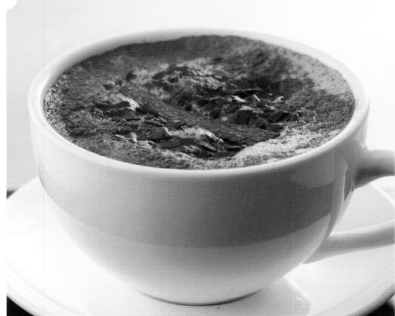

PARAGON MARKETING COMMUNICATIONS
KUWAIT

0431

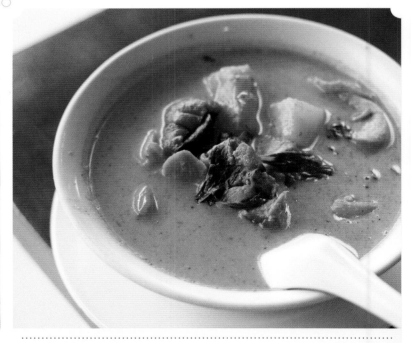

DENNIS LEE
USA

0432

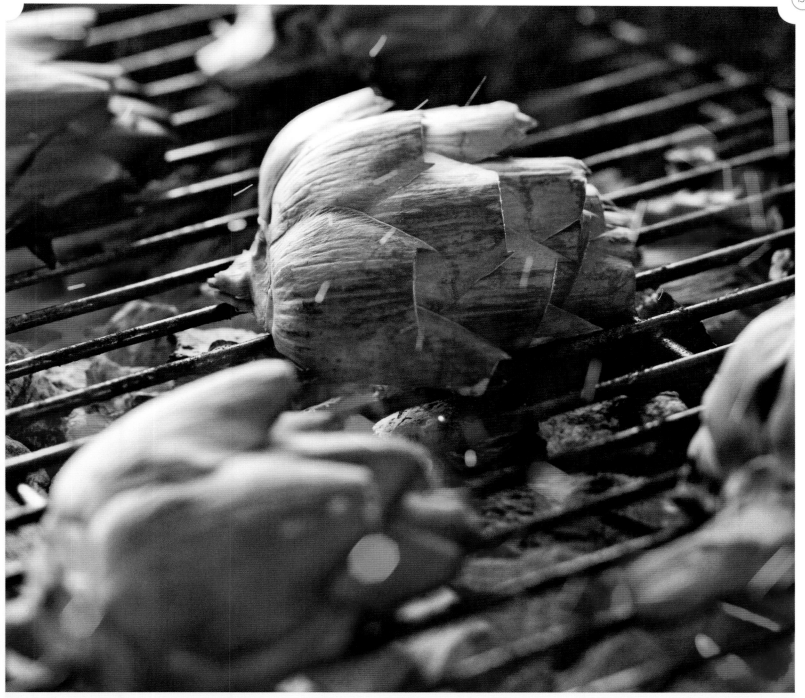

GLENN SCOTT
USA

0433

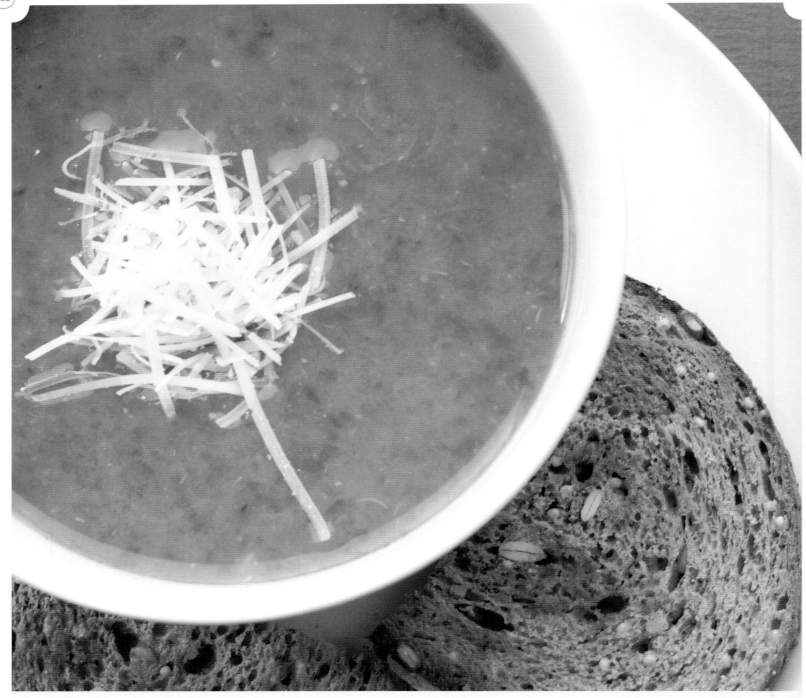

MOLLY MCMAHON
USA

0434

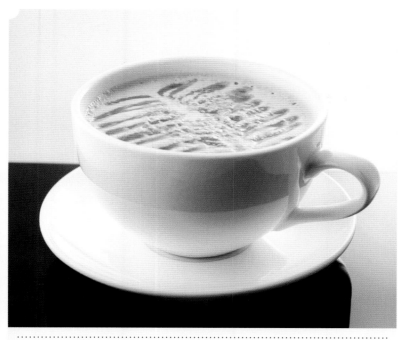

PARAGON MARKETING COMMUNICATIONS
KUWAIT

0435

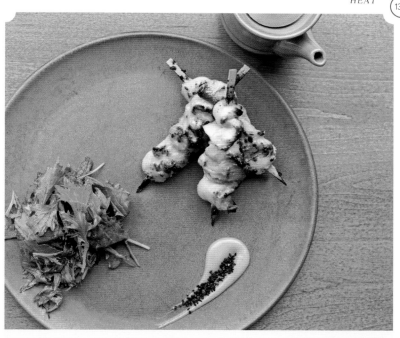

ANTHONY TAHLIER
USA

0436

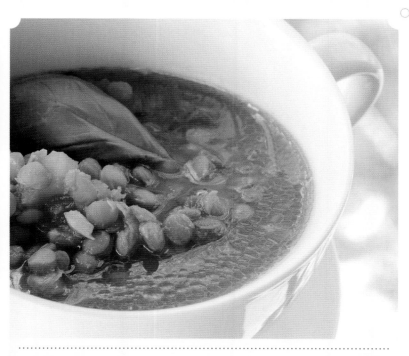

MICHELLE DEITER
USA

0437

PARAGON MARKETING COMMUNICATIONS
KUWAIT

0438

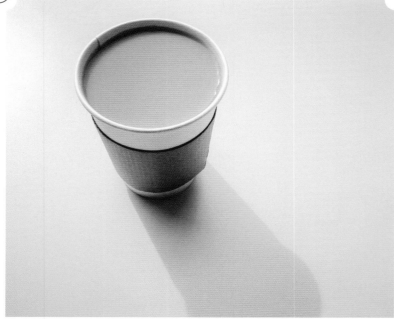

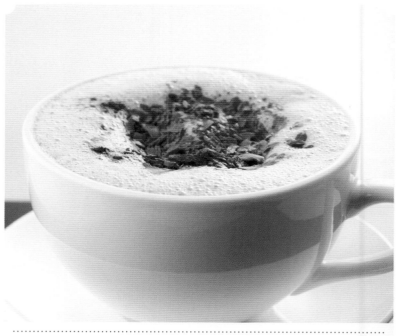

BRANDON FREITAS
USA
0439

PARAGON MARKETING COMMUNICATIONS
KUWAIT
0440

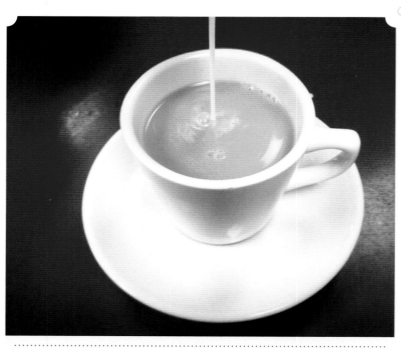

BRANDON FREITAS
USA
0441

BRANDON FREITAS
USA
0442

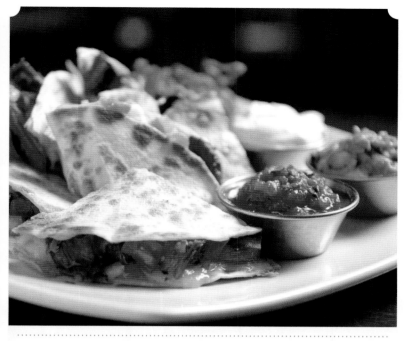

GRIP
USA

0443

GALDONES PHOTOGRAPHY
USA

0444

GALDONES PHOTOGRAPHY
USA

0445

GRIP
USA

0446

WET

BUBBLY / REFRESHING / FIZZY / TART / SMOOTH

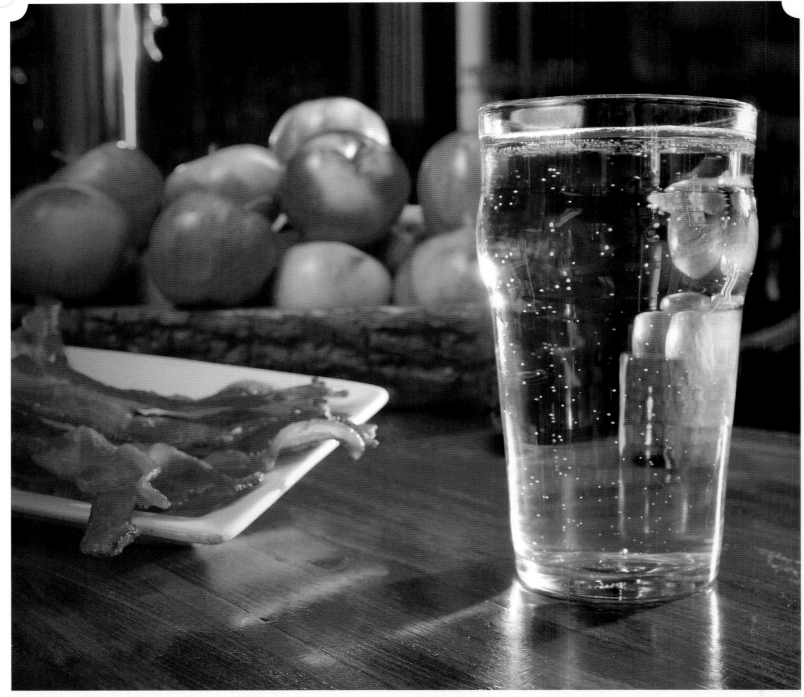

GRIP
USA

0447

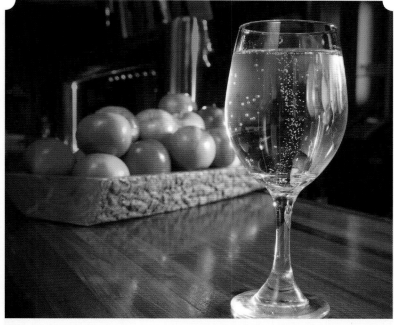

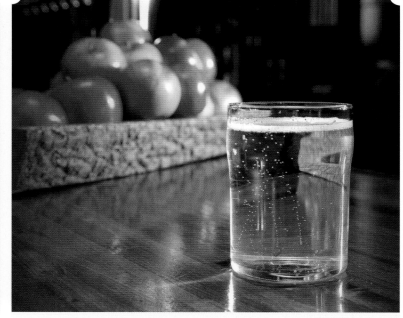

GRIP
USA

0448

GRIP
USA

0449

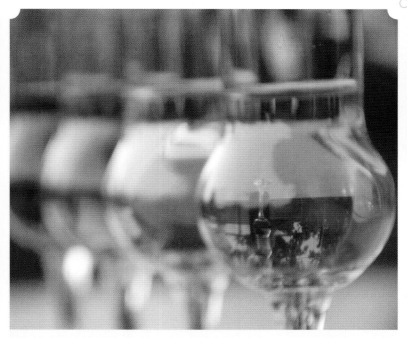

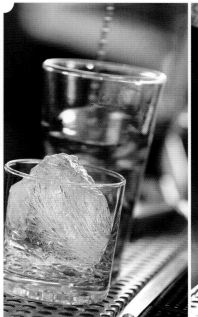

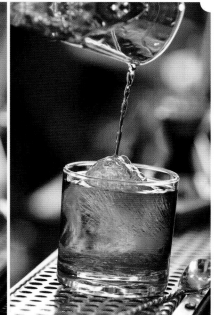

GEORGIOS DETSIS
GREECE

0450

ERIC KLEINBERG
USA

0451

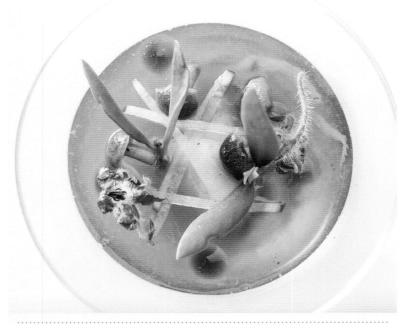

GALDONES PHOTOGRAPHY
USA

0452

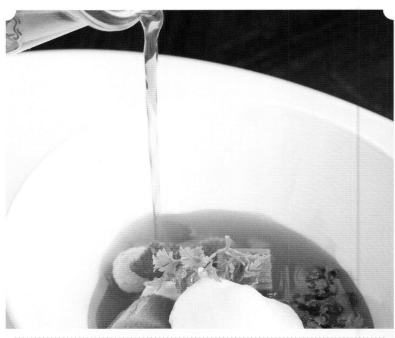

GALDONES PHOTOGRAPHY
USA

0453

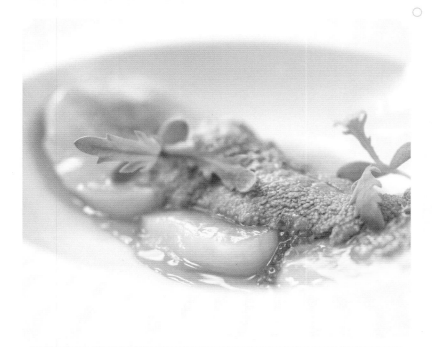

GALDONES PHOTOGRAPHY
USA

0454

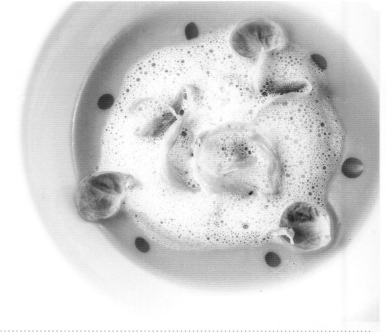

GALDONES PHOTOGRAPHY
USA

0455

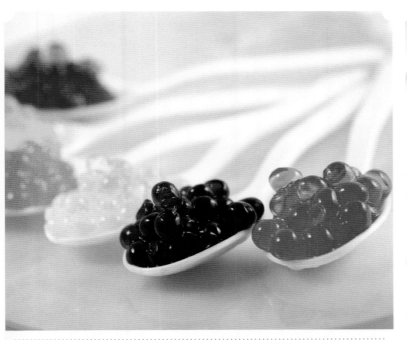

0456

0457

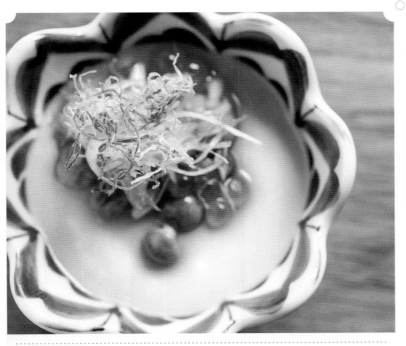

0458

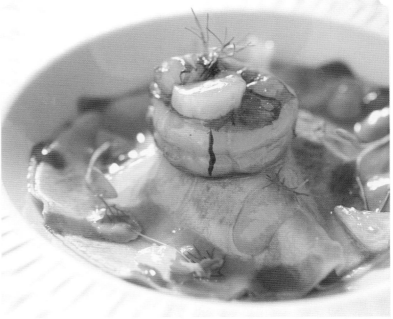

0459

RUTH HUIMERIND
ESTONIA

0460

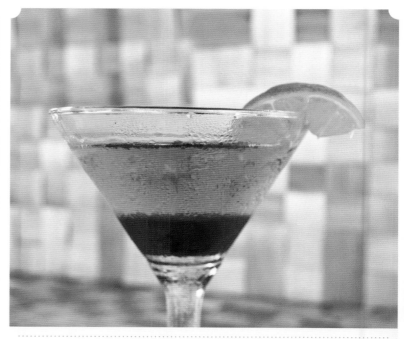

DWAYNE KNIGHT
BARBADOS

0461

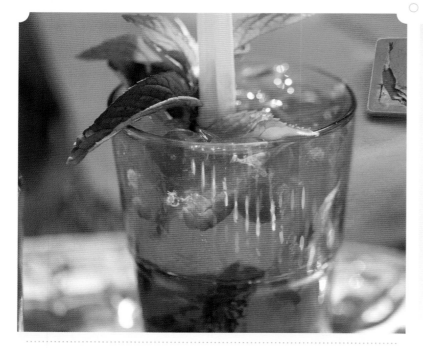

RUTH HUIMERIND
ESTONIA

0462

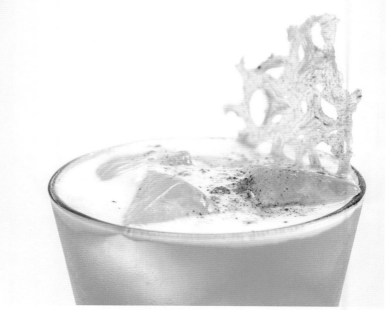

GALDONES PHOTOGRAPHY
USA

0463

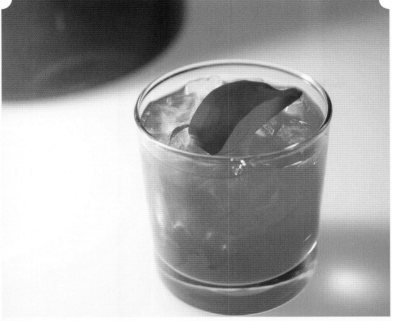

TUAN H. BUI
USA

0464

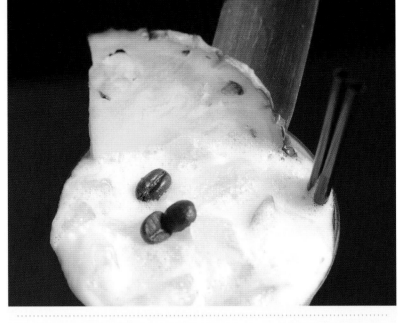

HEATHER SPERLING
USA

0465

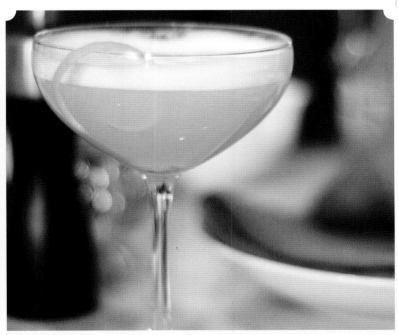

ANDREW HICKEY
USA

0466

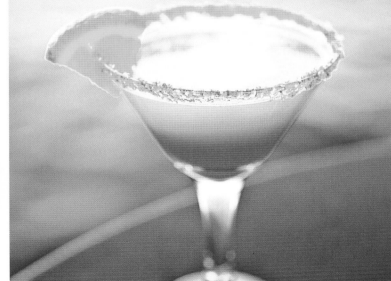

SCOTT ERB AND DONNA DUFAULT
USA

0467

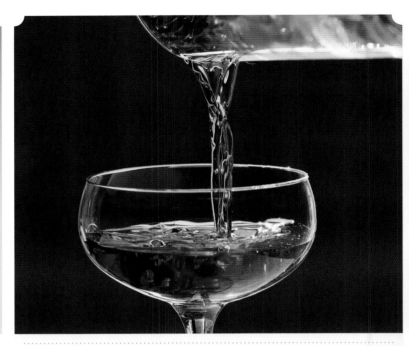

ERIC KLEINBERG
USA

0468

ERIC KLEINBERG
USA

0469

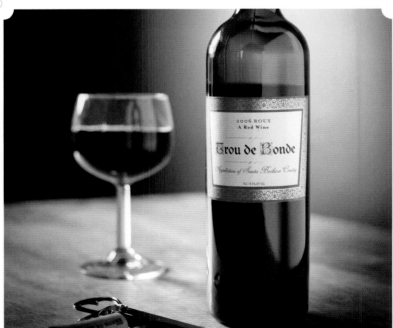

REGAN BARONI
USA

0470

SCOTT ERB AND DONNA DUFAULT
USA

0471

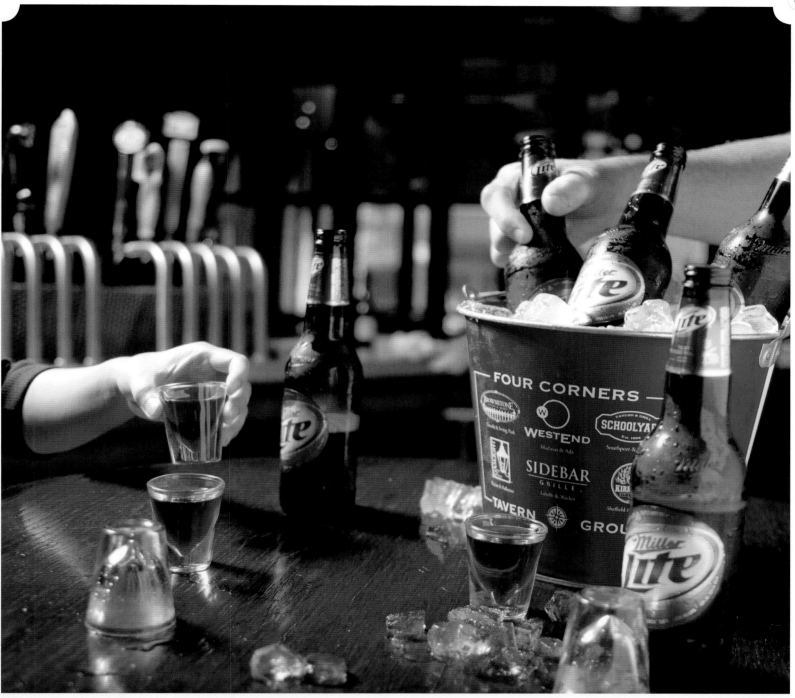

GRIP
USA

0472

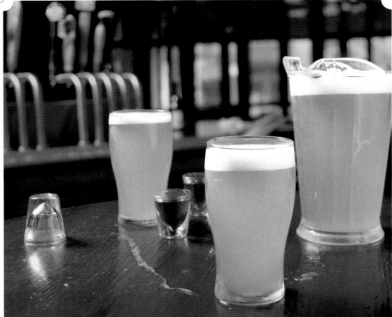

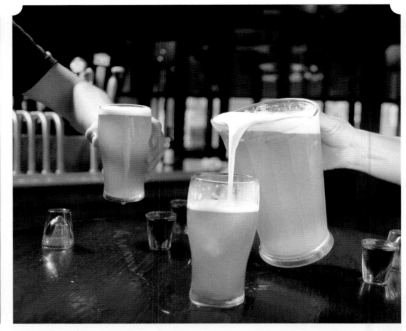

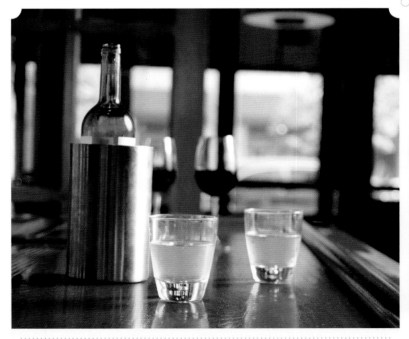

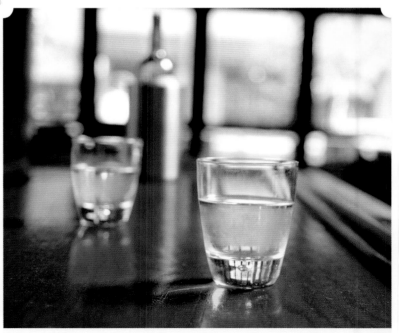

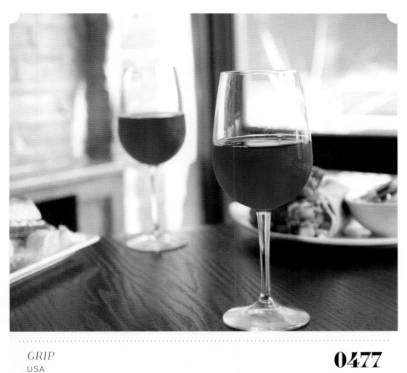

GRIP
USA

0477

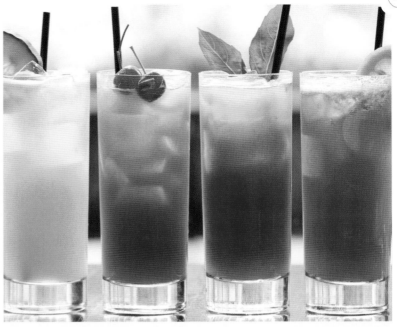

ERIC KLEINBERG
USA

0478

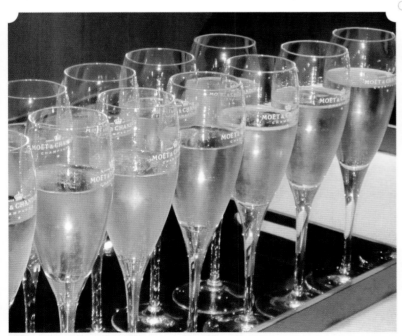

KATE RIESENBERG
USA

0479

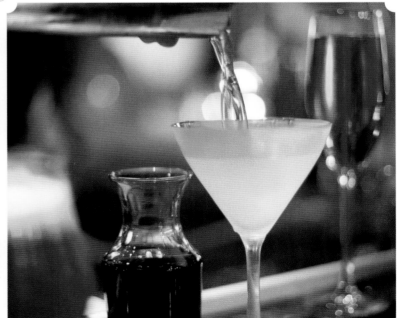

KARI SKAFLEN
USA

0480

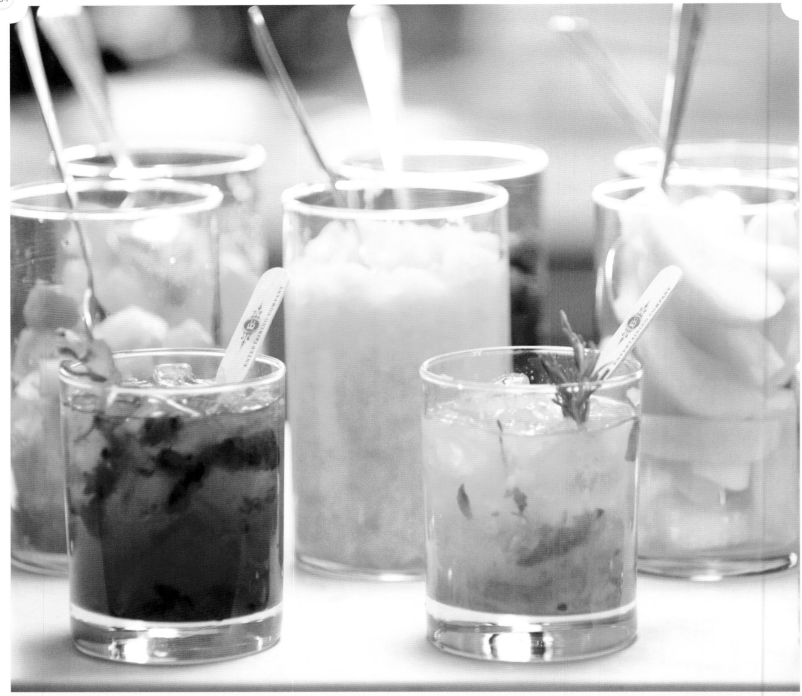

RACHEL DE MARTE
USA

0481

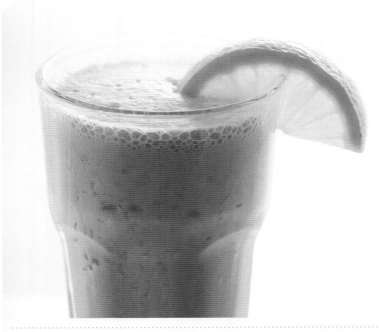

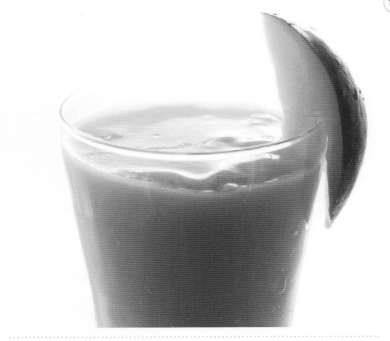

PARAGON MARKETING COMMUNICATIONS
KUWAIT

0482

PARAGON MARKETING COMMUNICATIONS
KUWAIT

0483

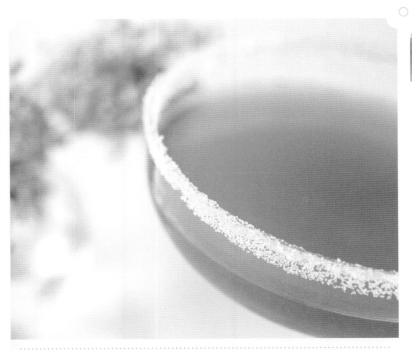

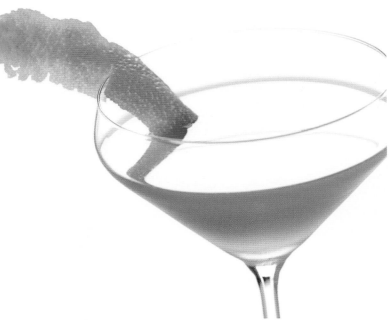

GALDONES PHOTOGRAPHY
USA

0484

ERIC KLEINBERG
USA

0485

GARNISH

FINISHING TOUCH / TOP OFF / ACCENT

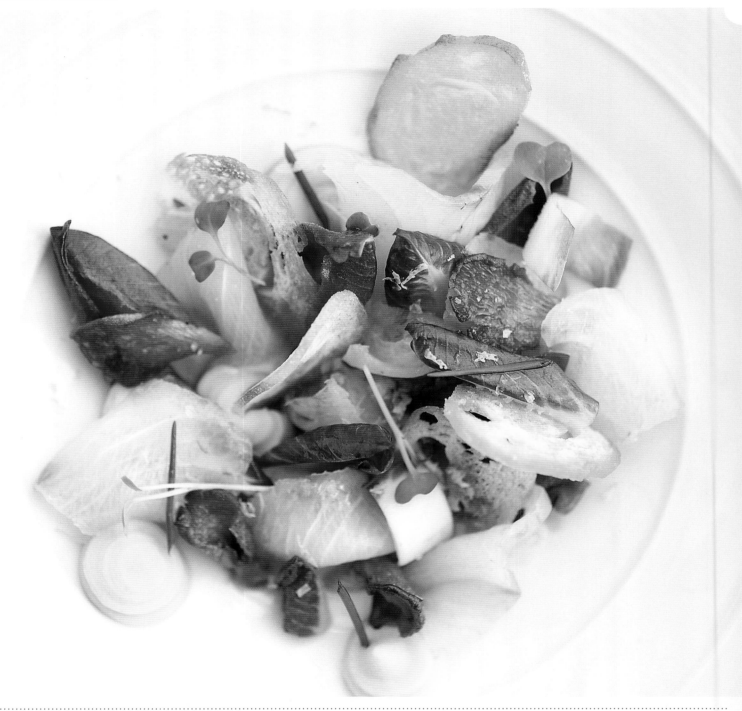

ANTHONY TAHLIER
USA

0486

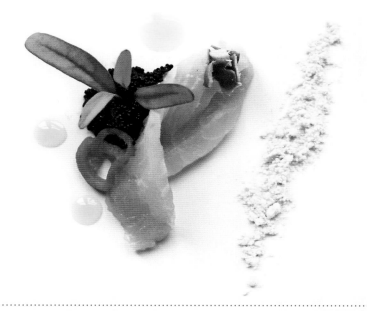

GALDONES PHOTOGRAPHY
USA

0487

ANDRES DANGOND
USA

0488

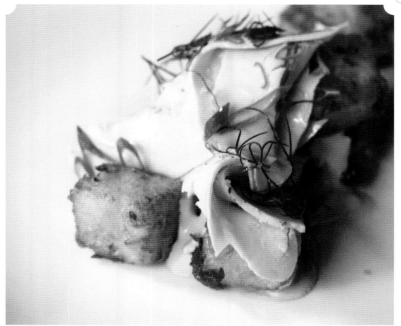

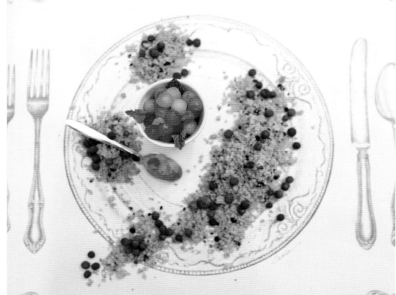

HEATHER SPERLING
USA

0489

GALDONES PHOTOGRAPHY
USA

0490

GALDONES PHOTOGRAPHY
USA

0491

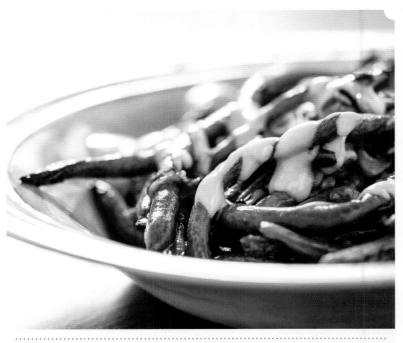

GALDONES PHOTOGRAPHY
USA

0492

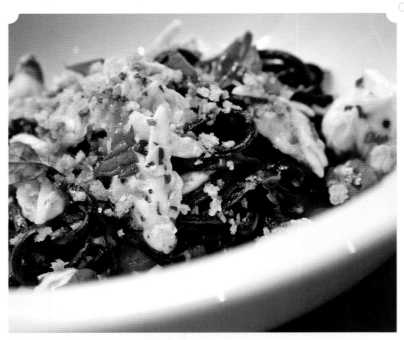

GALDONES PHOTOGRAPHY
USA

0493

GALDONES PHOTOGRAPHY
USA

0494

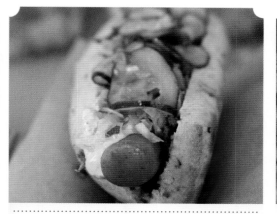

HEATHER SPERLING
USA
0495

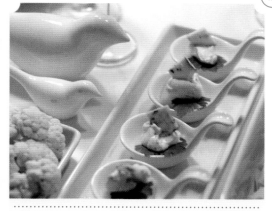

BERNADINE ROLNICKI
USA
0496

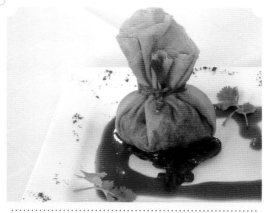

LUKASZ FUKS
POLAND
0497

KARI SKAFLEN
USA
0498

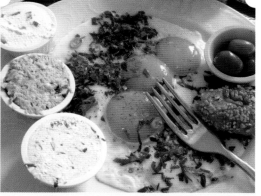

KATE RIESENBERG
USA
0499

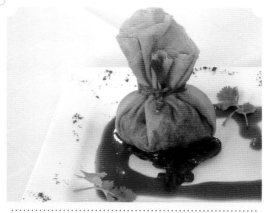

PARAGON MARKETING
COMMUNICATIONS KUWAIT
0500

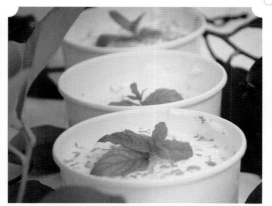

GEORGIOS DETSIS
GREECE
0501

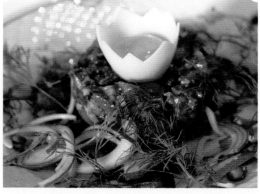

HEATHER SPERLING
USA
0502

GEORGIOS DETSIS
GREECE
0503

JACQUI WEDEWER
USA

0504

KARI SKAFLEN
USA

0505

ELLIE MEYER
USA

0506

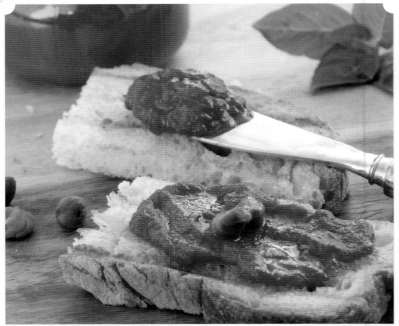

GEORGIOS DETSIS
GREECE

0507

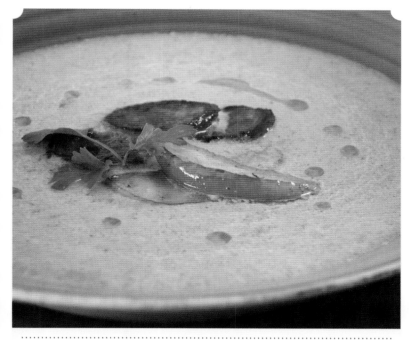

GEORGIOS DETSIS
GREECE

0508

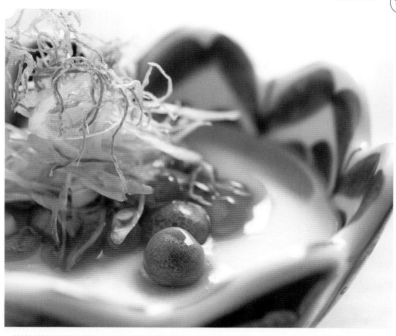

GALDONES PHOTOGRAPHY
USA

0509

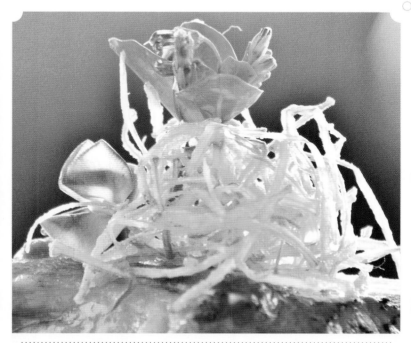

DWAYNE KNIGHT
BARBADOS

0510

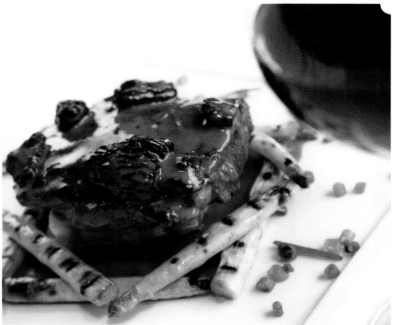

CARA AND SCOTT NAVA
USA

0511

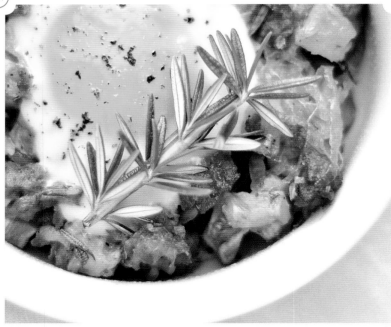

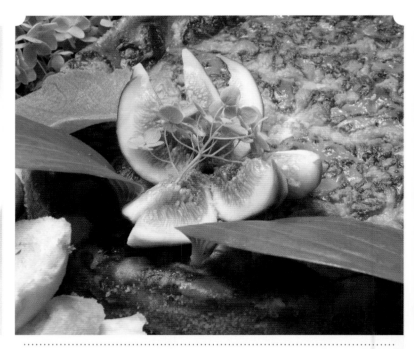

NICOLE ZARATE
USA
0512

MICHELLE DEITER
USA
0513

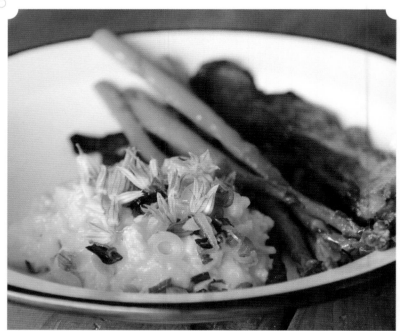

NADINE SHAW
AUSTRALIA
0514

HEATHER SPERLING
USA
0515

LAURA SANT
USA

0516

MOLLY MCMAHON
USA

0517

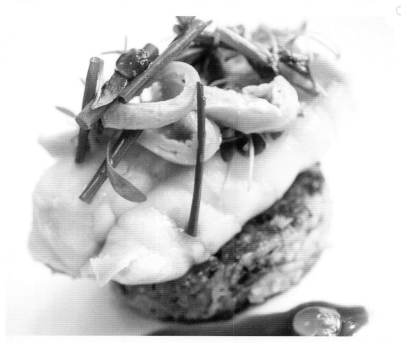

GALDONES PHOTOGRAPHY
USA

0518

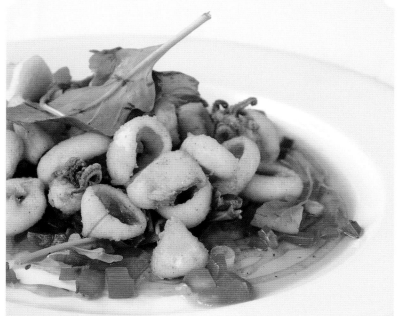

KATE RIESENBERG
USA

0519

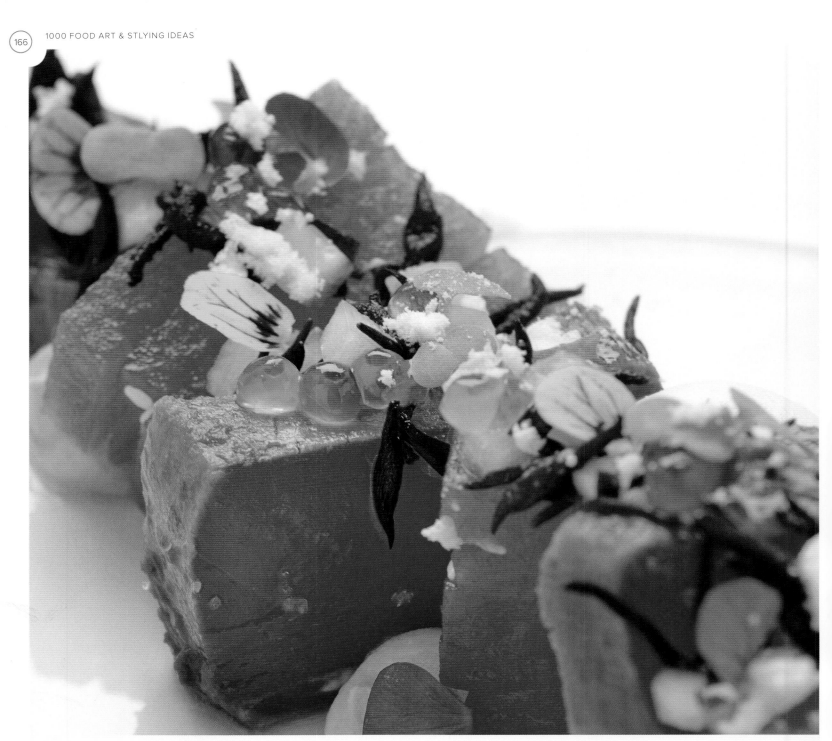

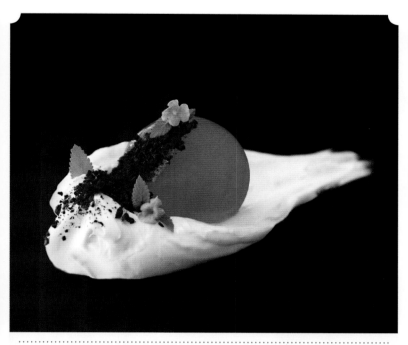

ANDRES DANGOND
USA

0521

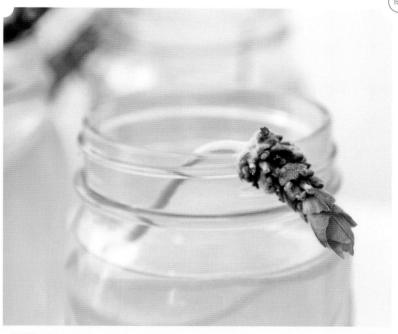

CARA AND SCOTT NAVA
USA

0522

TY LETTAU
USA

0523

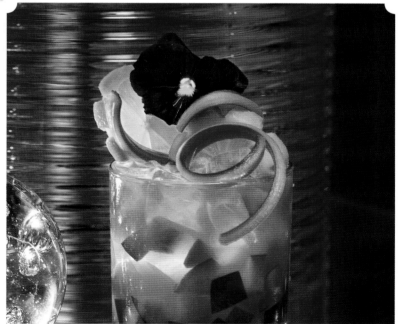

TUAN H. BUI
USA

0524

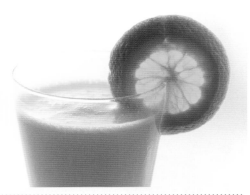

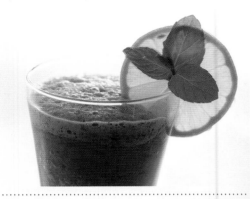

*PARAGON MARKETING
COMMUNICATIONS* KUWAIT **0525**

*PARAGON MARKETING
COMMUNICATIONS* KUWAIT **0526**

*PARAGON MARKETING
COMMUNICATIONS* KUWAIT **0527**

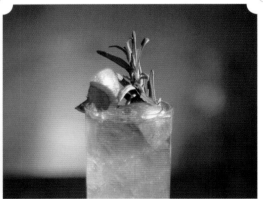

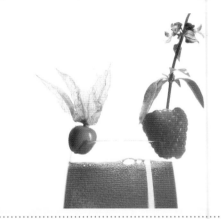

TUAN H. BUI
USA **0528**

TUAN H. BUI
USA **0529**

TUAN H. BUI
USA **0530**

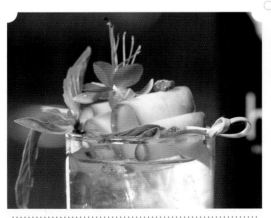

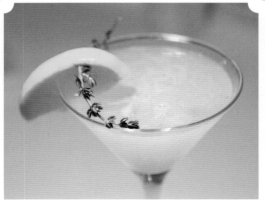

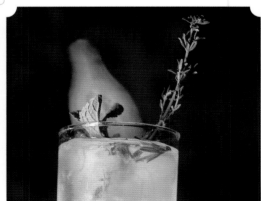

TUAN H. BUI
USA **0531**

TUAN H. BUI
USA **0532**

TUAN H. BUI
USA **0533**

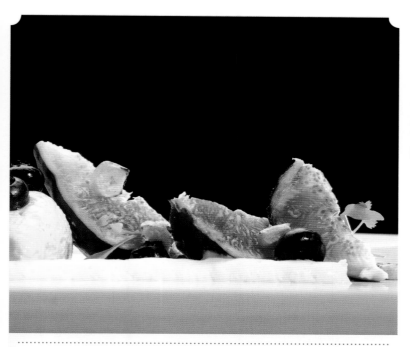

TUAN H. BUI
USA
0534

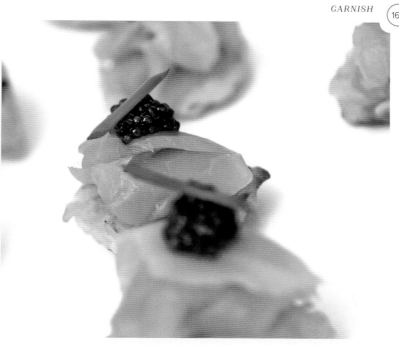

CARA AND SCOTT NAVA
USA
0535

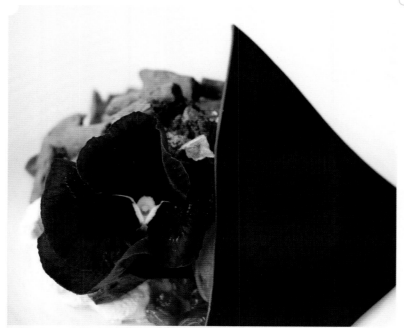

HEATHER SPERLING
USA
0536

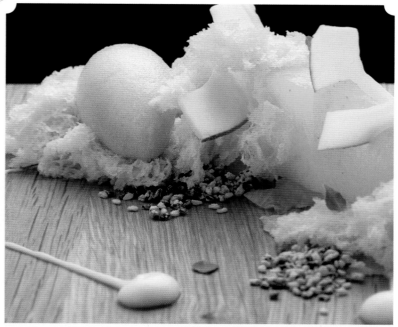

ERIC KLEINBERG
USA
0537

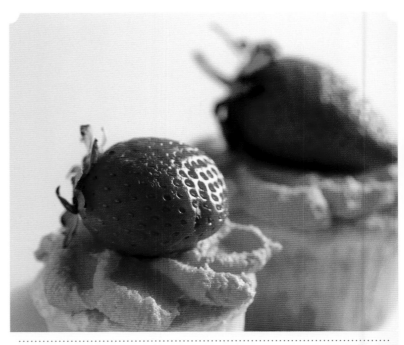

BRIAN POREA
USA
0538

PARAGON MARKETING COMMUNICATIONS
KUWAIT
0539

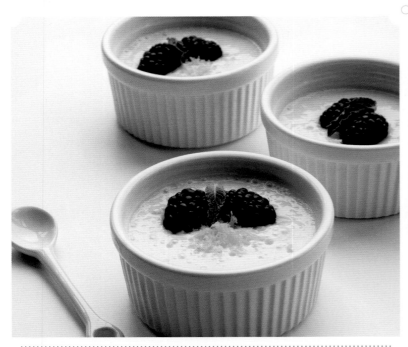

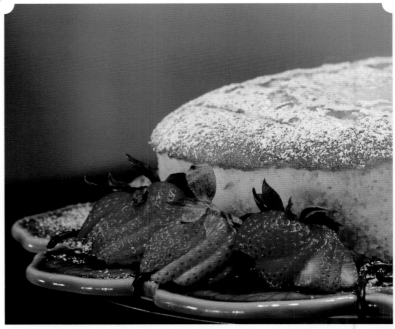

MOLLY MCMAHON
USA
0540

MICHELLE DEITER
USA
0541

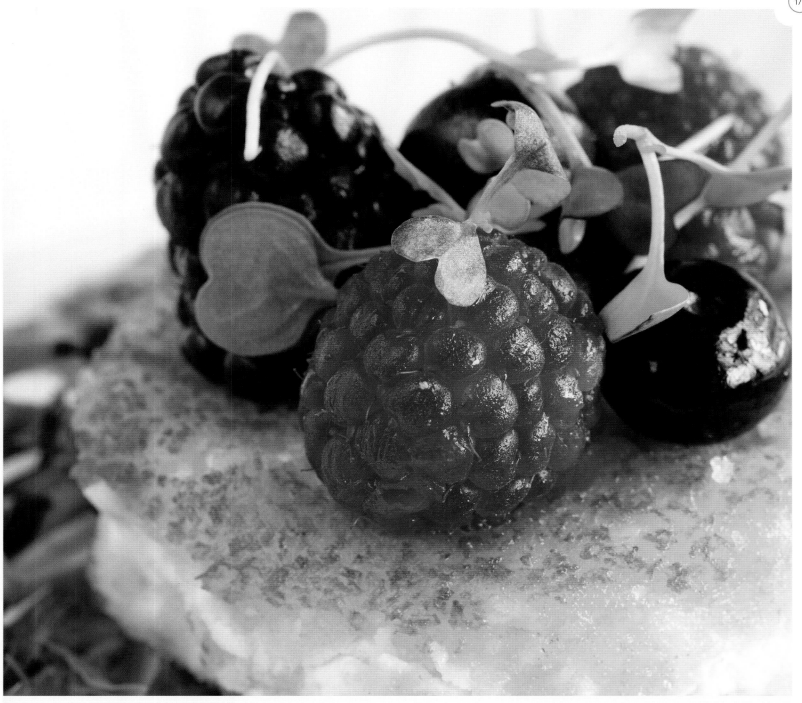

SCOTT ERB AND DONNA DUFAULT
USA

0542

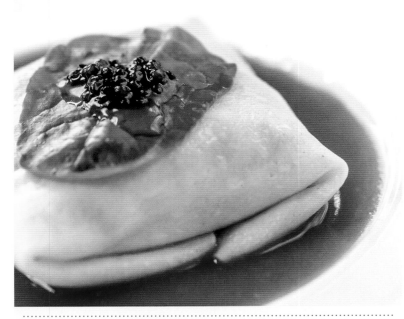

GALDONES PHOTOGRAPHY
USA

0543

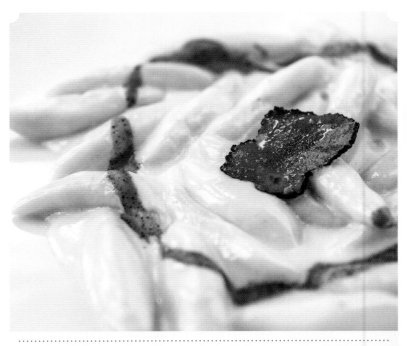

GALDONES PHOTOGRAPHY
USA

0544

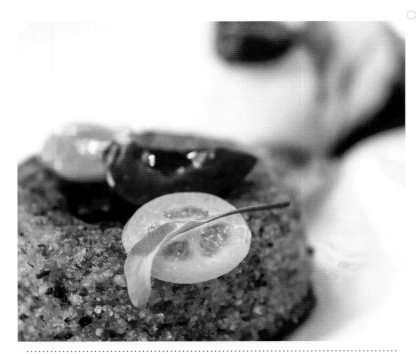

GALDONES PHOTOGRAPHY
USA

0545

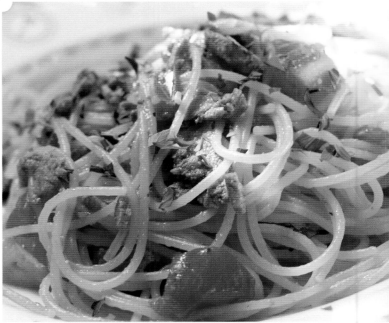

HEATHER SPERLING
USA

0546

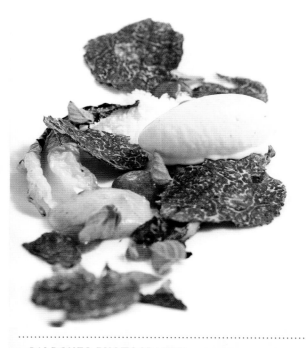

GALDONES PHOTOGRAPHY
USA
0547

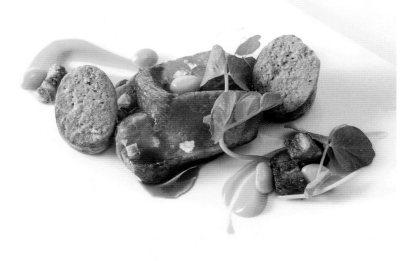

GALDONES PHOTOGRAPHY
USA
0548

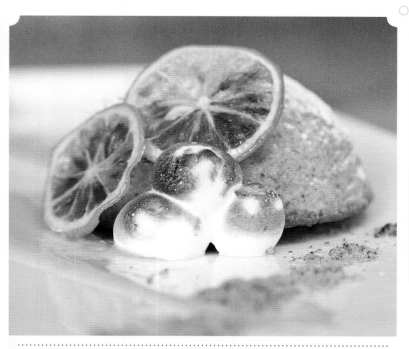

GALDONES PHOTOGRAPHY
USA
0549

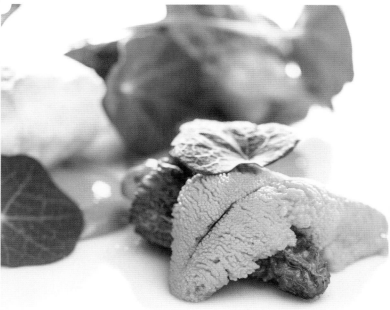

GALDONES PHOTOGRAPHY
USA
0550

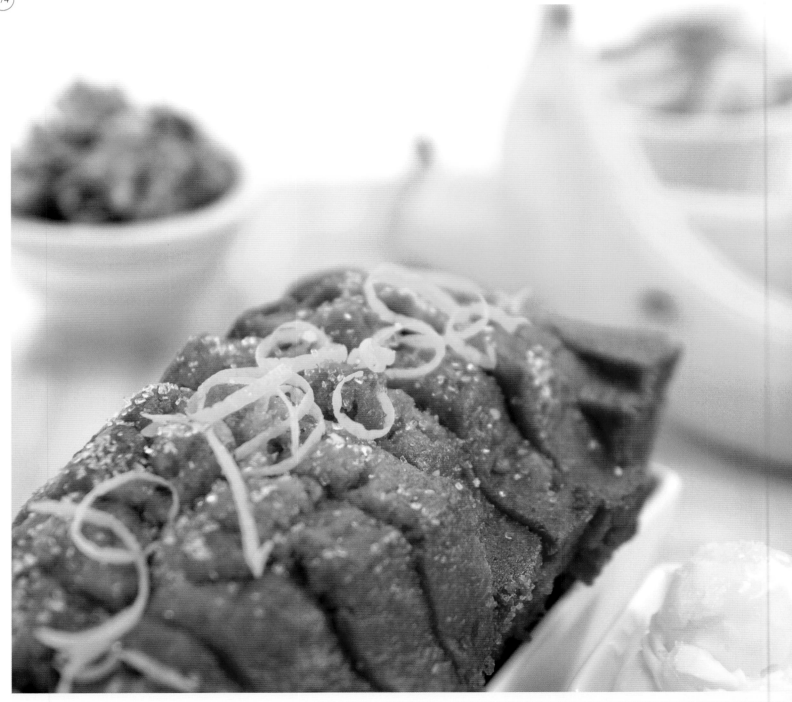

GRIP
USA

0551

MOLLY MCMAHON
USA

0552

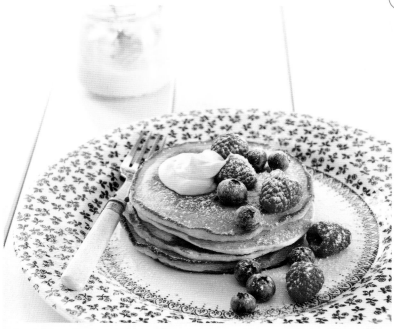

NADINE SHAW
AUSTRALIA

0553

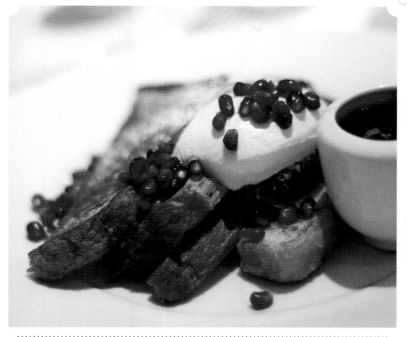

ANDREW HICKEY
USA

0554

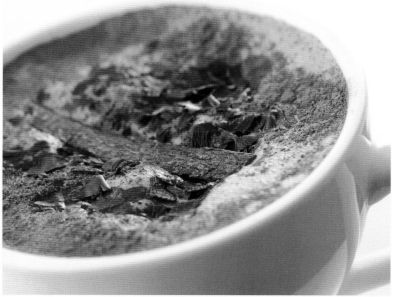

PARAGON MARKETING COMMUNICATIONS
KUWAIT

0555

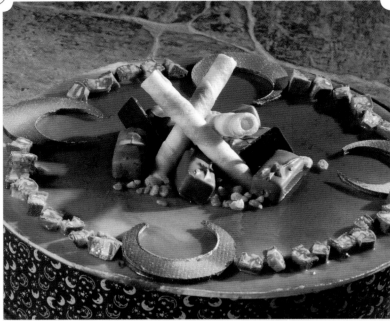

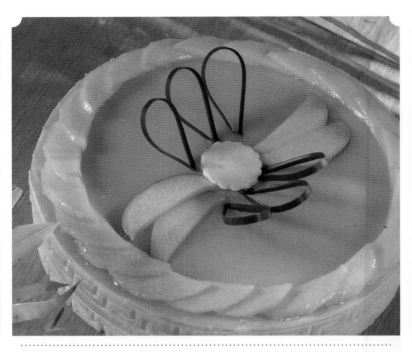

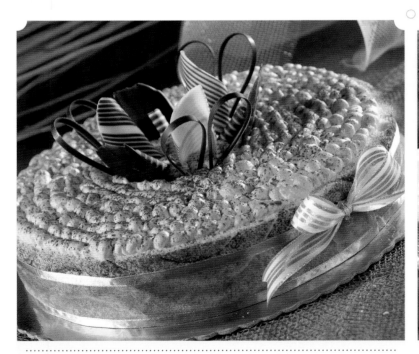

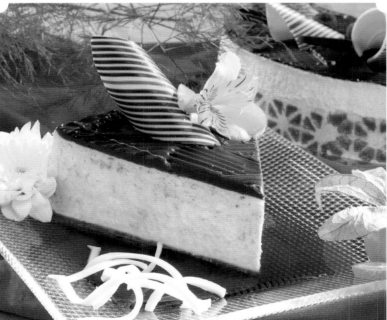

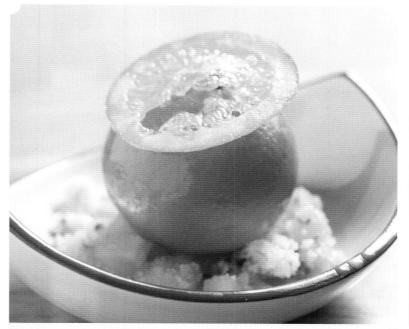

GALDONES PHOTOGRAPHY
USA

0560

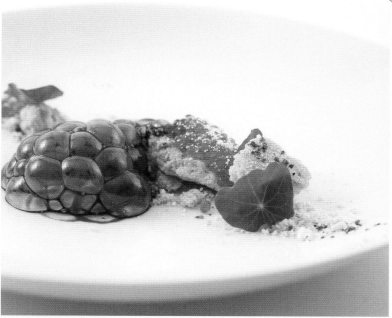

GALDONES PHOTOGRAPHY
USA

0561

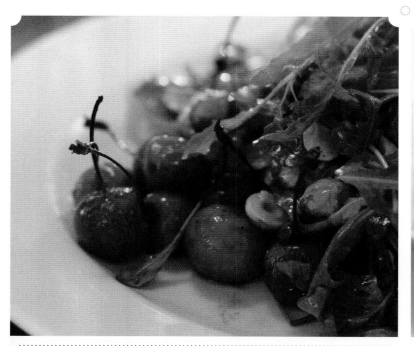

HEATHER SPERLING
USA

0562

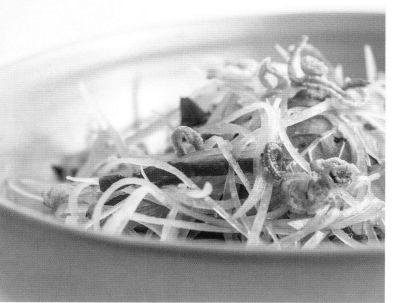

GALDONES PHOTOGRAPHY
USA

0563

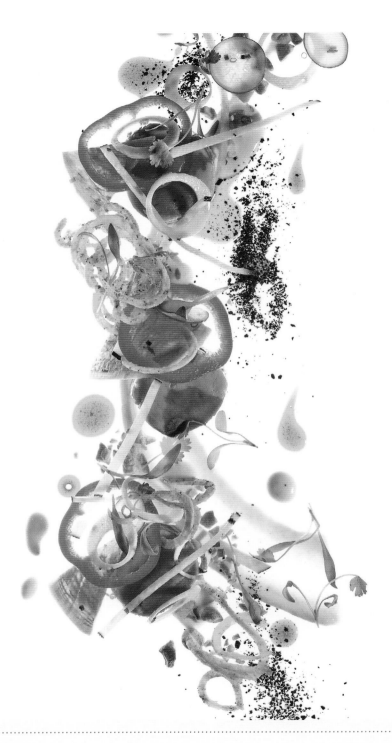

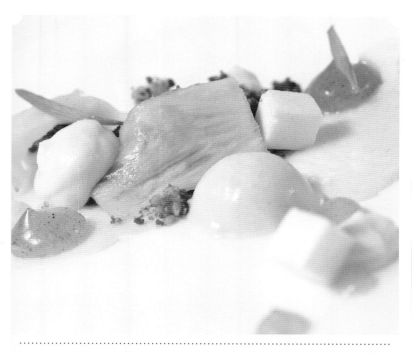

0565

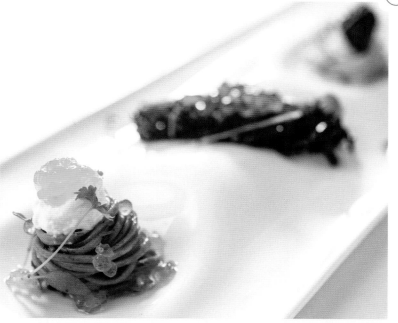

0566

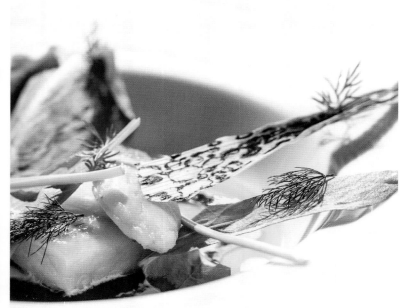

0567

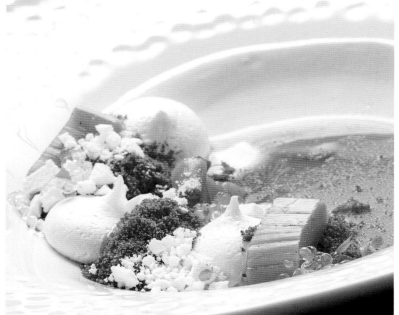

0568

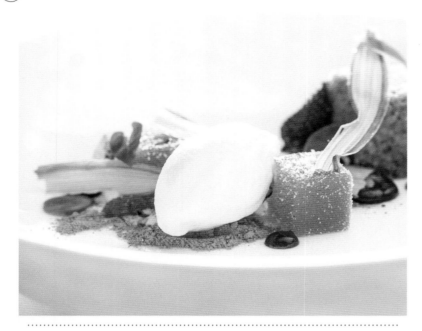

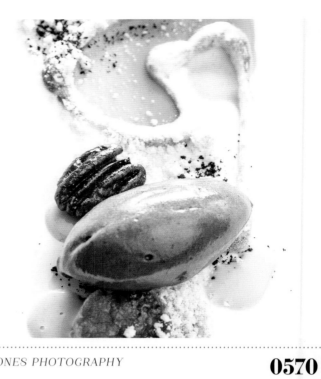

GALDONES PHOTOGRAPHY
USA

0569

GALDONES PHOTOGRAPHY
USA

0570

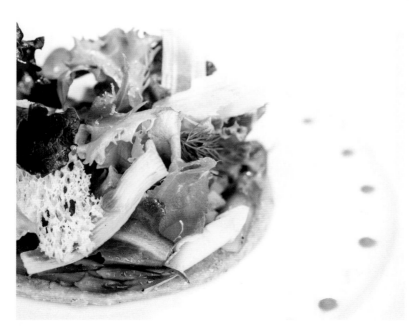

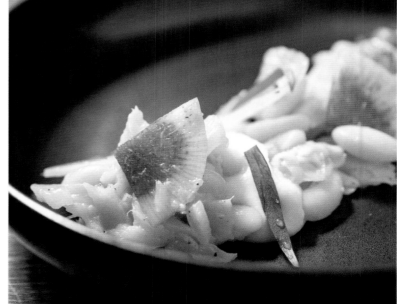

GALDONES PHOTOGRAPHY
USA

0571

GALDONES PHOTOGRAPHY
USA

0572

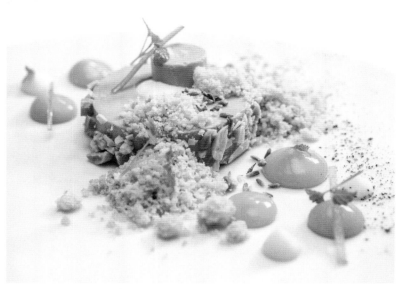

GALDONES PHOTOGRAPHY
USA

0573

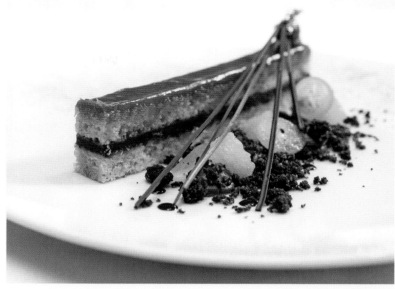

GALDONES PHOTOGRAPHY
USA

0574

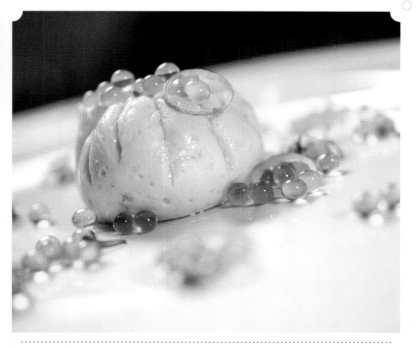

GALDONES PHOTOGRAPHY
USA

0575

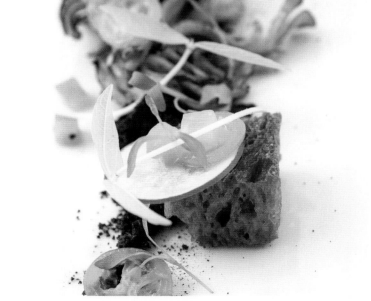

GALDONES PHOTOGRAPHY
USA

0576

AERIAL

OVERHEAD / FROM ABOVE / BIRDS-EYE VIEW

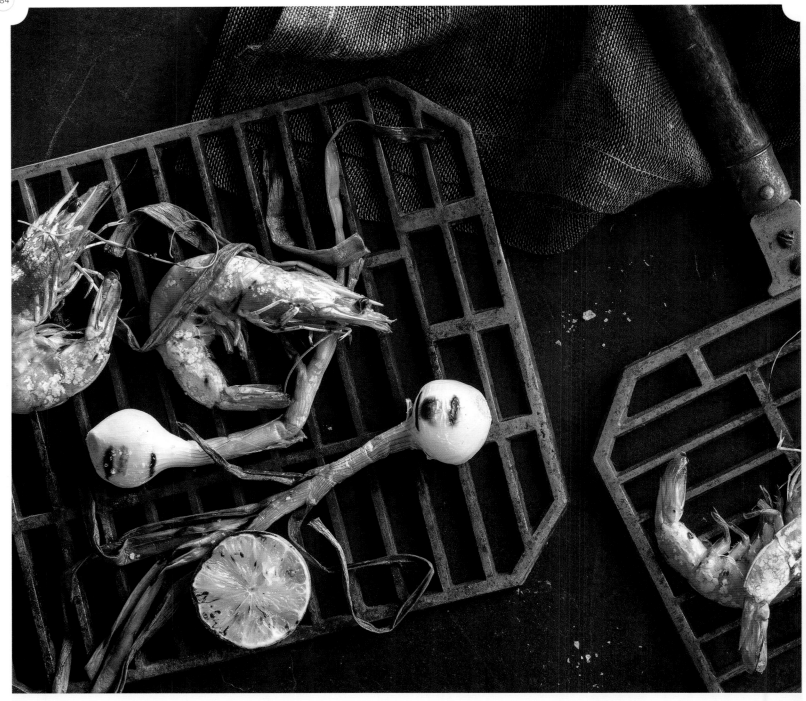

JUSTIN B. PARIS
USA

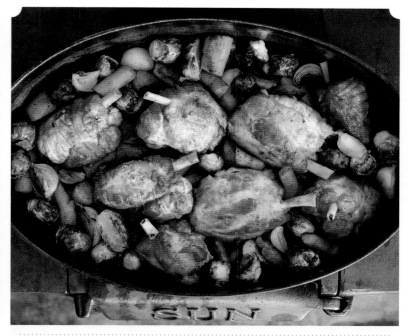

JUSTIN B. PARIS
USA
0578

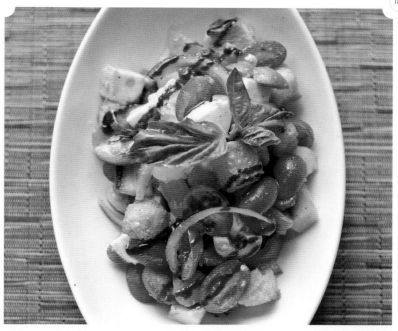

TUAN H. BUI
USA
0579

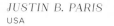

NADINE SHAW
AUSTRALIA
0580

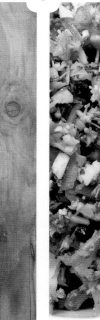

MOLLY MCMAHON
USA
0581

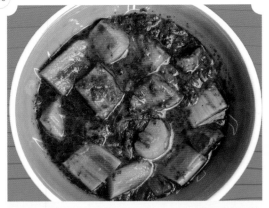

AZITA HOUSHIAR
USA
0582

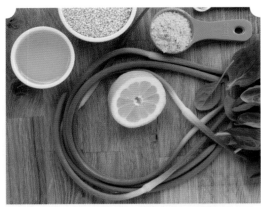

MOLLY MCMAHON
USA
0583

TUAN H. BUI
USA
0584

TY LETTAU
USA
0585

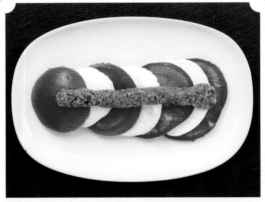

MOLLY MCMAHON
USA
0586

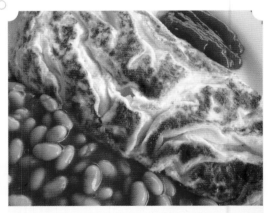

KATE RIESENBERG
USA
0587

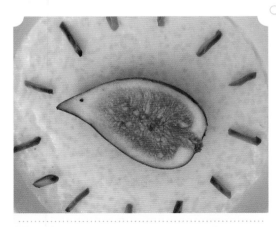

AZITA HOUSHIAR
USA
0588

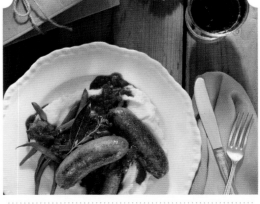

NADINE SHAW
AUSTRALIA
0589

TY LETTAU
USA
0590

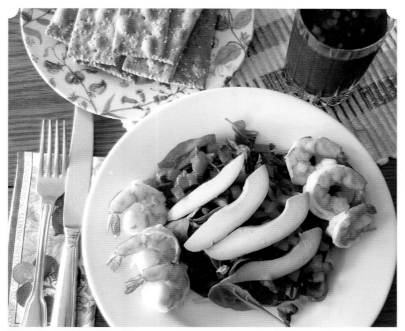

LISA ALLEN LAMBERT
USA

0591

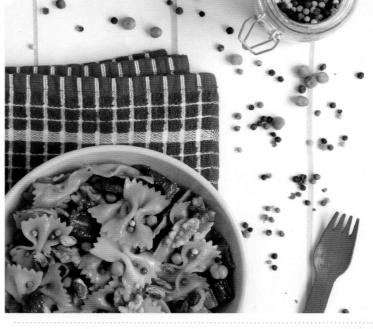

ELISABETTA REDAELLI
ITALY

0592

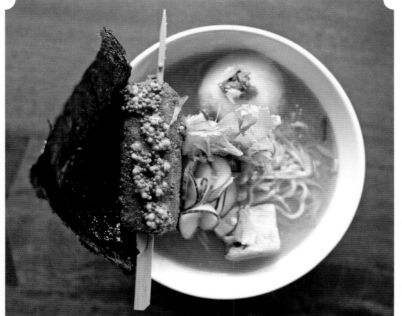

ANTHONY TAHLIER
USA

0593

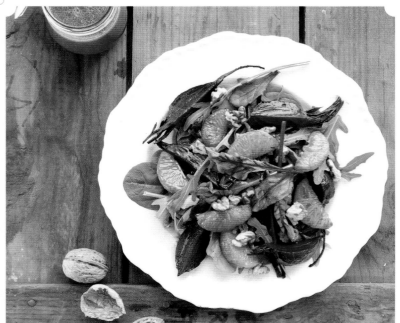

NADINE SHAW
AUSTRALIA

0594

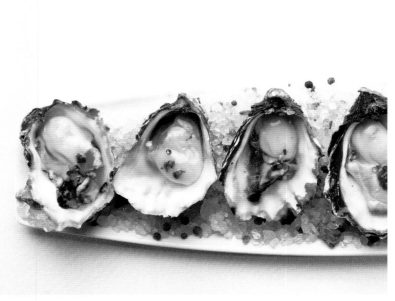

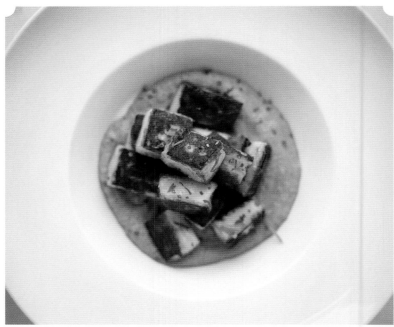

TUAN H. BUI
USA **0595**

ERIC KLEINBERG
USA **0596**

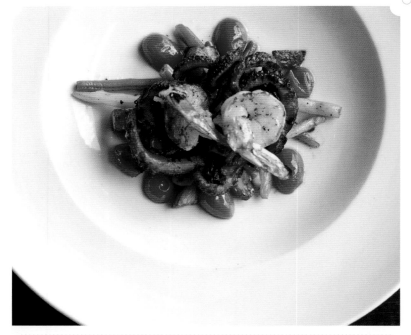

TUAN H. BUI
USA **0597**

GALDONES PHOTOGRAPHY
USA **0598**

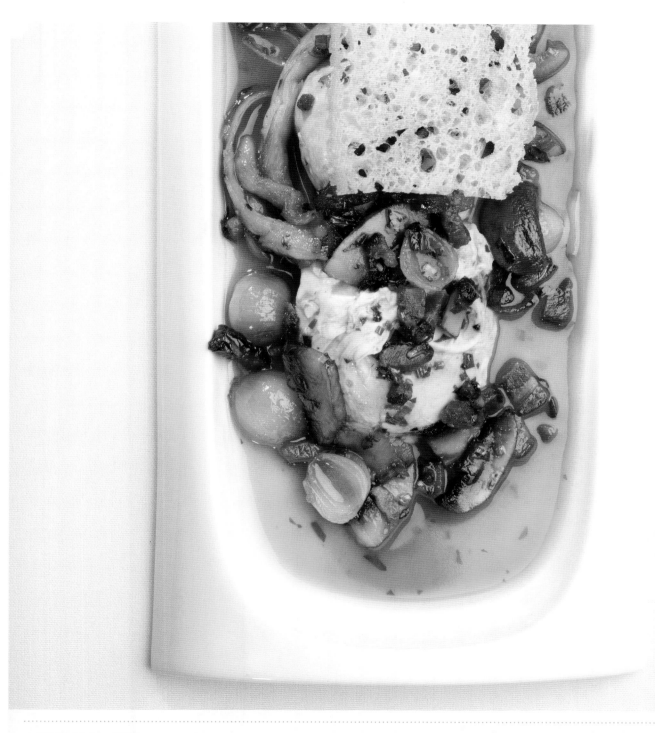

TUAN H. BUI
USA

0599

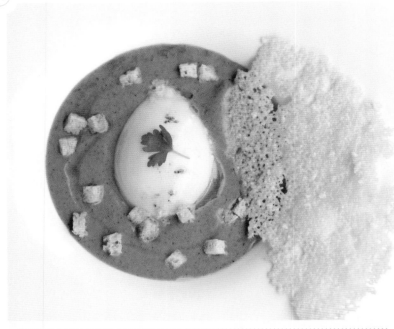

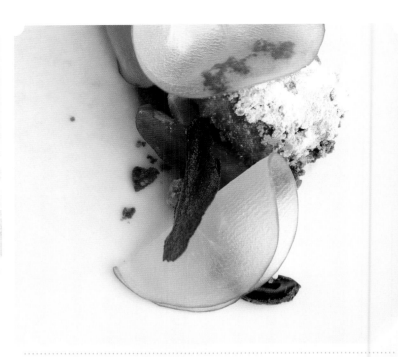

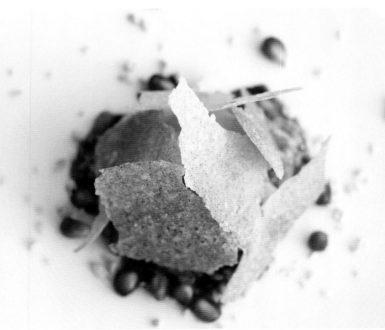

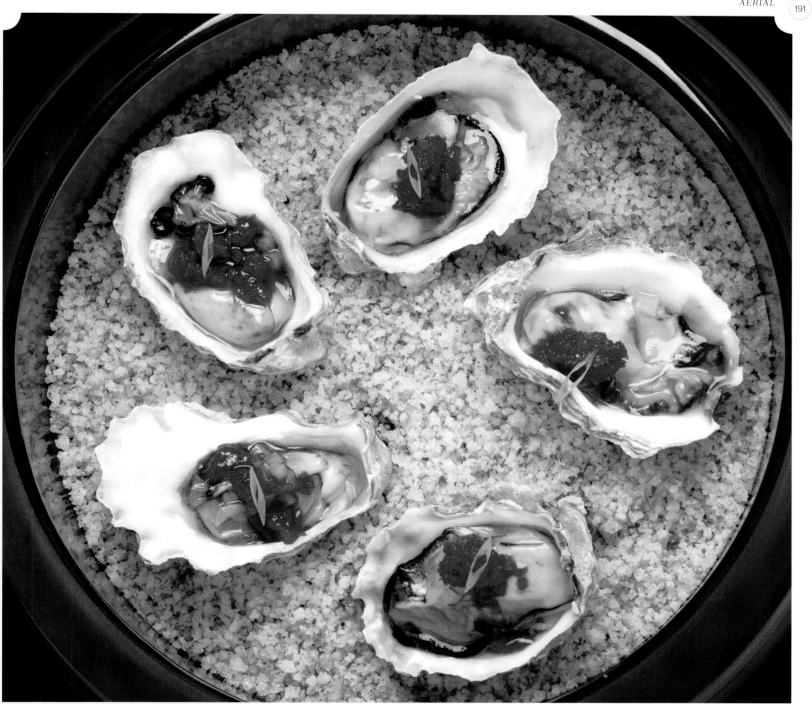

ERIC KLEINBERG
USA

0604

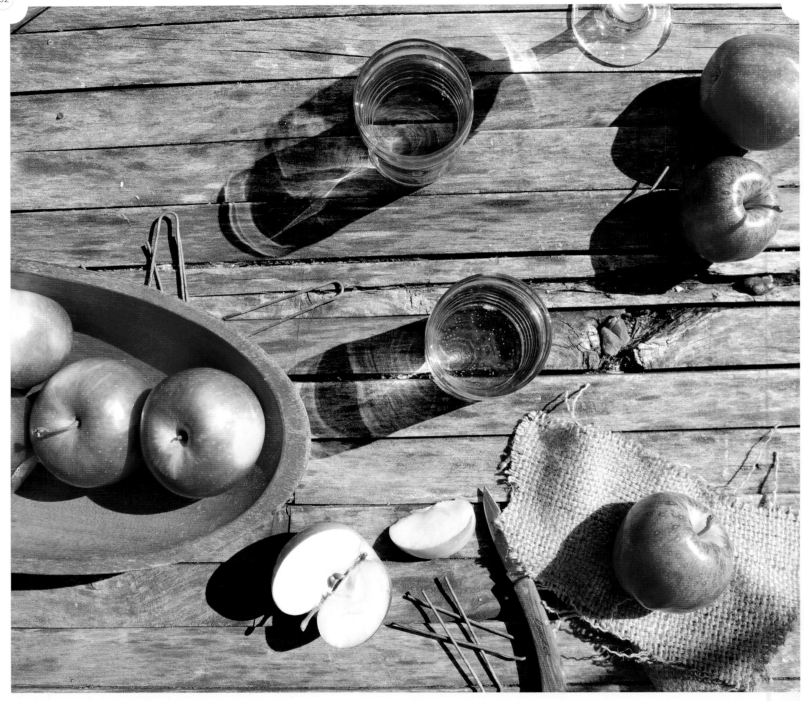

GRIP
USA

0605

DENNIS LEE
USA

0606

JUSTIN B. PARIS
USA

0607

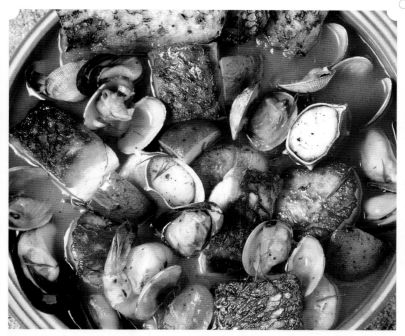

ERIC KLEINBERG
USA

0608

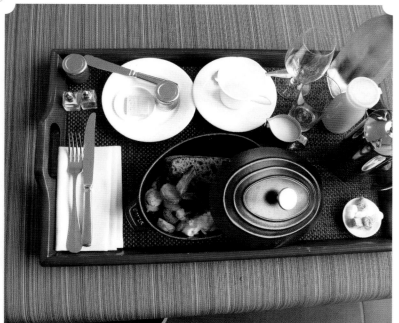

ARI BENDERSKY
USA

0609

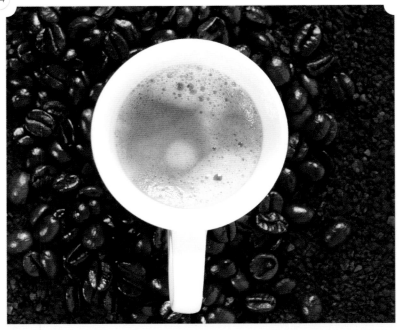

CARLOS RIBEIRO
PORTUGAL

0610

MOLLY MCMAHON
USA

0611

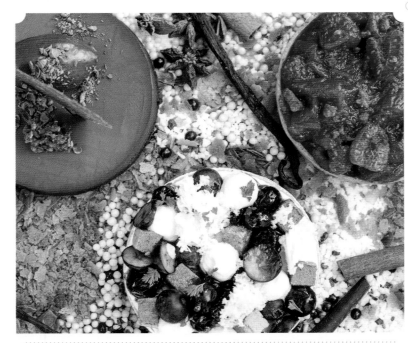

GALDONES PHOTOGRAPHY
USA

0612

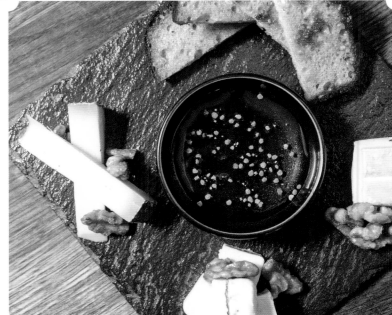

GALDONES PHOTOGRAPHY
USA

0613

arob

BORIS LJUBICIC
CROATIA
0614

BORIS LJUBICIC
CROATIA
0615

BORIS LJUBICIC
CROATIA
0616

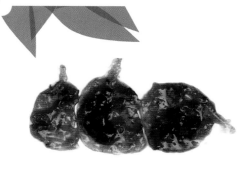

nge

BORIS LJUBICIC
CROATIA
0617

BORIS LJUBICIC
CROATIA
0618

BORIS LJUBICIC
CROATIA
0619

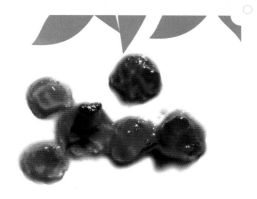

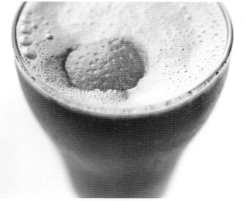

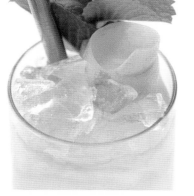

BRANDON FREITAS
USA
0620

ANTHONY TAHLIER
USA
0621

ANTHONY TAHLIER
USA
0622

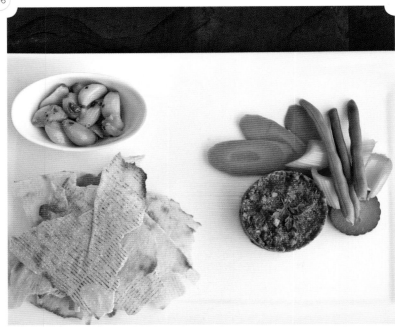

SCOTT ERB AND DONNA DUFAULT
USA
0623

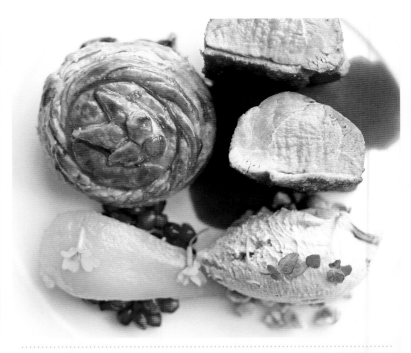

ANTHONY TAHLIER
USA
0624

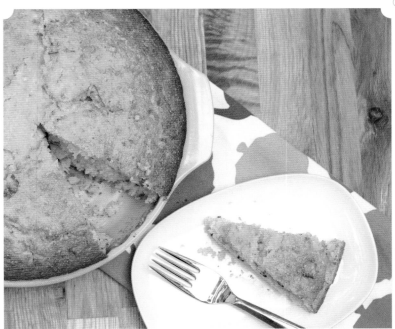

MOLLY MCMAHON
USA
0625

HEATHER SPERLING
USA
0626

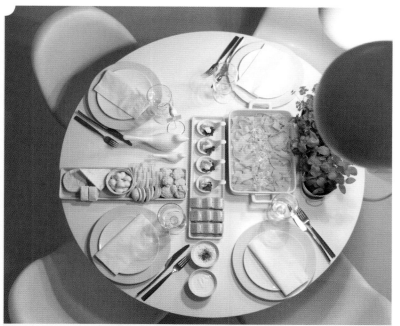

LUKASZ FUKS
POLAND

0627

NADINE SHAW
AUSTRALIA

0628

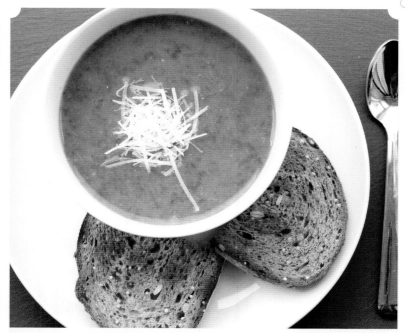

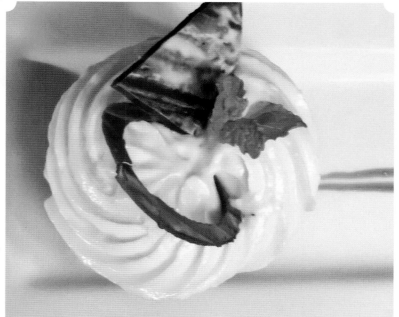

MOLLY MCMAHON
USA

0629

RENATO SEALY
BARBADOS, W.I.

0630

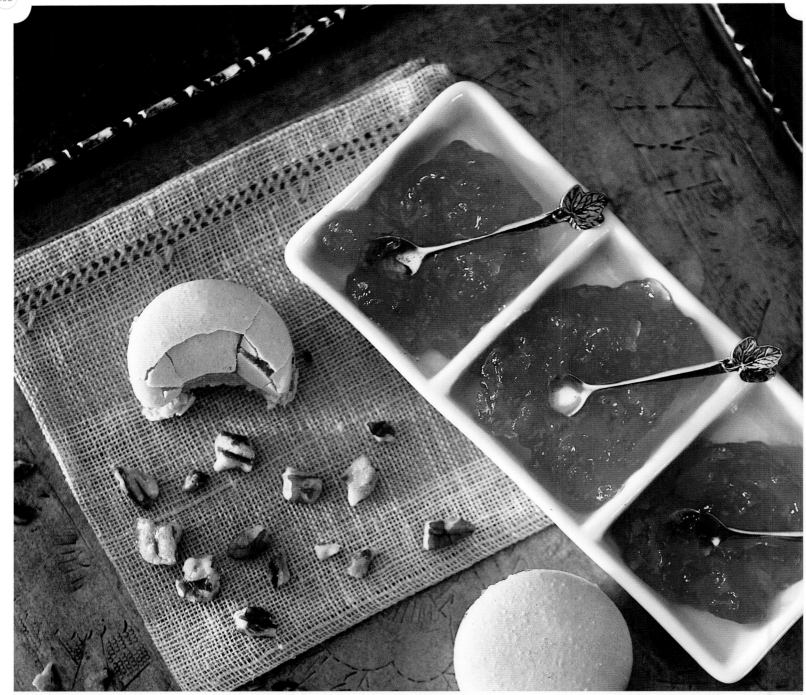

HEATHER VAN GAALE
USA

0631

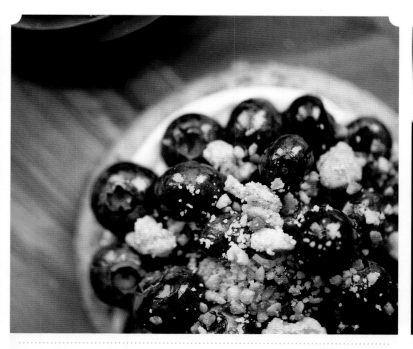

ANTHONY TAHLIER
USA
0632

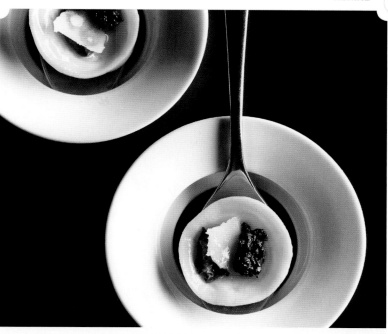

ANTHONY TAHLIER
USA
0633

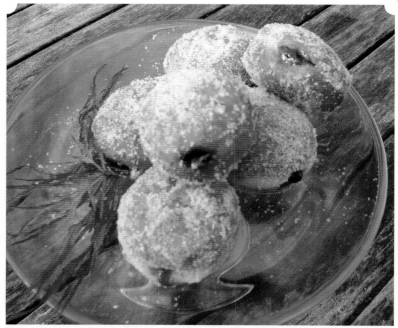

ALYSA SLAY
USA
0634

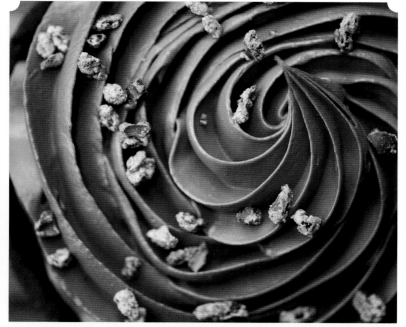

ANTHONY TAHLIER
USA
0635

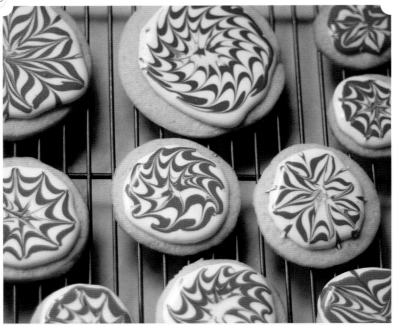

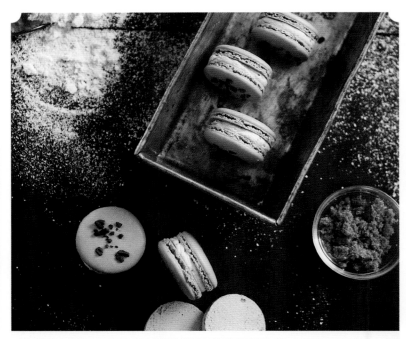

SHERI SILVER
USA
0636

HEATHER VAN GAALE
USA
0637

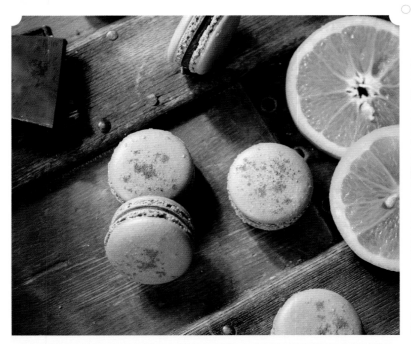

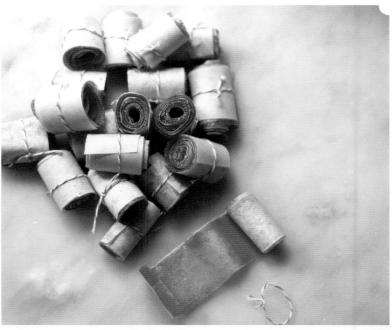

HEATHER VAN GAALE
USA
0638

SHERI SILVER
USA
0639

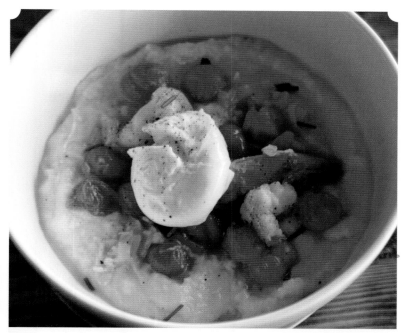

DENNIS LEE
USA

0640

MOLLY MCMAHON
USA

0641

MARTA SASINOWSKA
USA

0642

NICOLE ZARATE
USA

0643

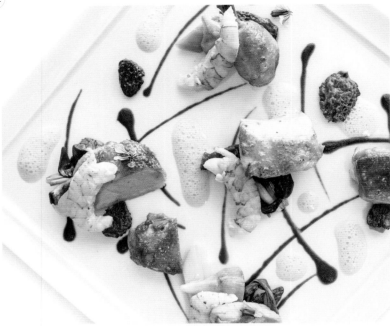

GALDONES PHOTOGRAPHY
USA **0644**

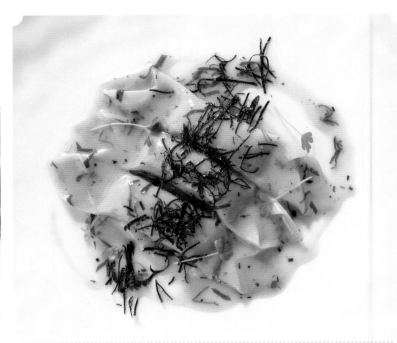

GALDONES PHOTOGRAPHY
USA **0645**

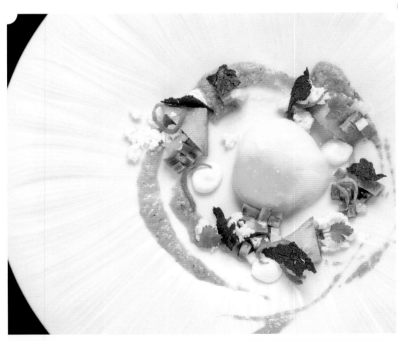

ERIC KLEINBERG
USA **0646**

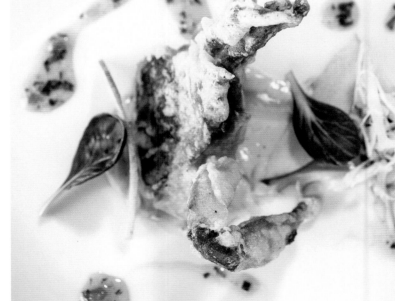

GALDONES PHOTOGRAPHY
USA **0647**

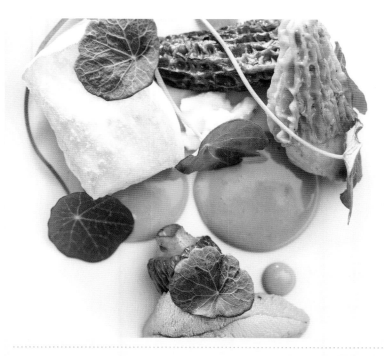

GALDONES PHOTOGRAPHY
USA

0648

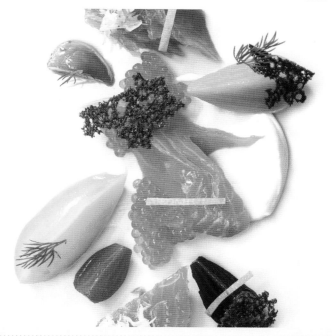

GALDONES PHOTOGRAPHY
USA

0649

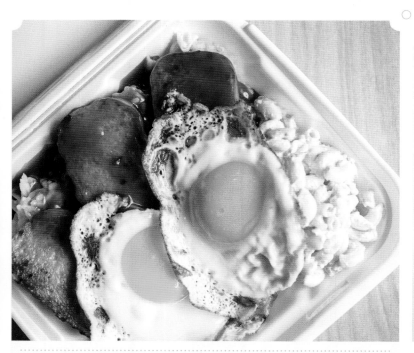

GALDONES PHOTOGRAPHY
USA

0650

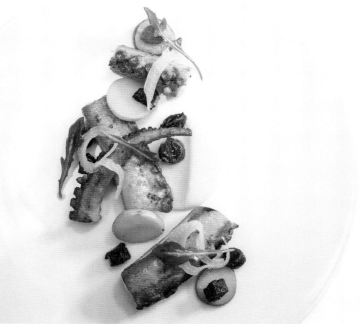

GALDONES PHOTOGRAPHY
USA

0651

NARRATIVE

SCENE / MOOD / TALE / CONTEXT / STAGE

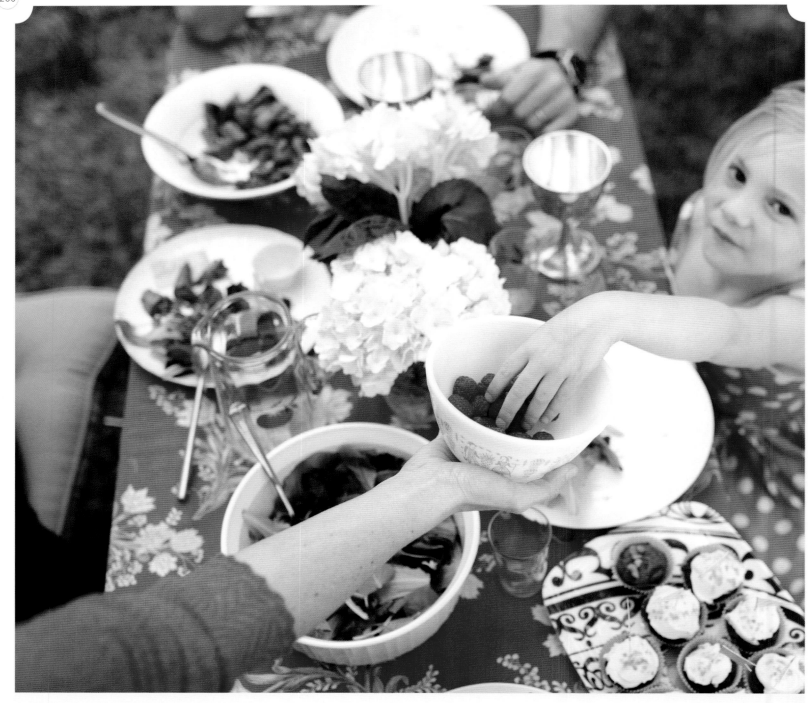

MARTA SASINOWSKA
USA

0652

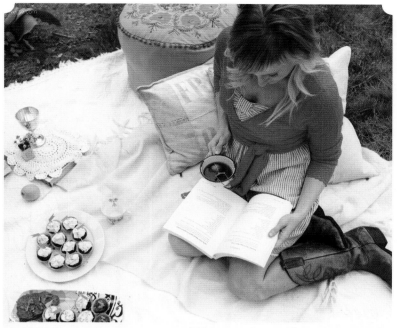

MARTA SASINOWSKA
USA

0653

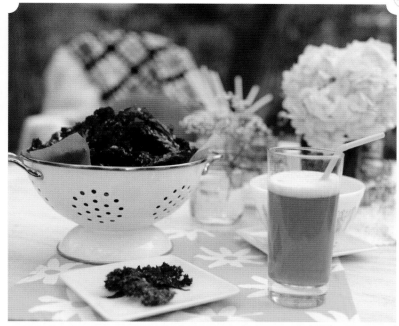

MARTA SASINOWSKA
USA

0654

MOLLY MCMAHON
USA

0655

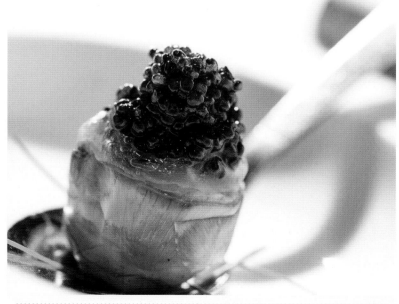

GALDONES PHOTOGRAPHY
USA

0656

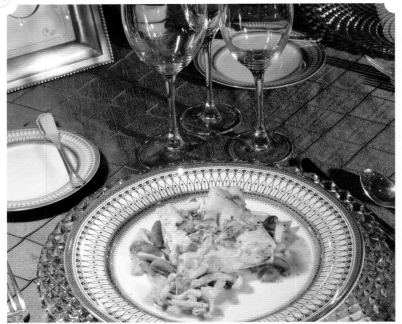

TUAN H. BUI
USA
0657

NANDY VILLONGCO
USA
0658

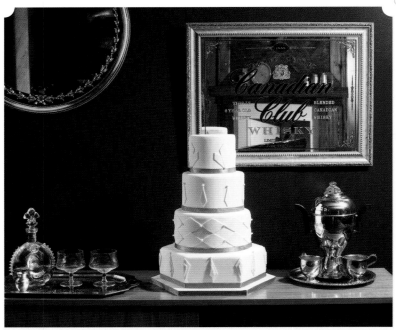

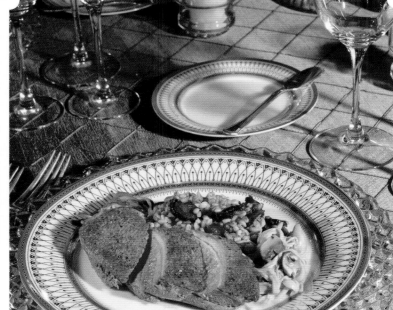

TUAN H. BUI
USA
0659

TUAN H. BUI
USA
0660

GEORGIOS DETSIS
GREECE
0661

GEORGIOS DETSIS
GREECE
0662

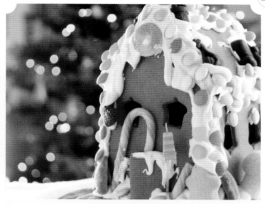

GEORGIOS DETSIS
GREECE
0663

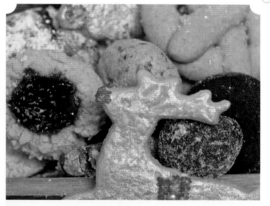

BERNADINE ROLNICKI
USA
0664

KATE RIESENBERG
USA
0665

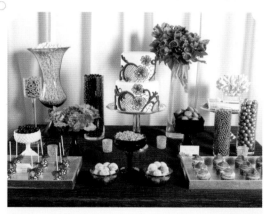

TUAN H. BUI
USA
0666

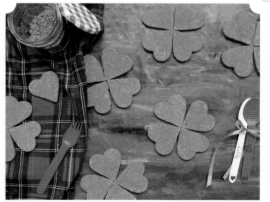

ELISABETTA REDAELLI
ITALY
0667

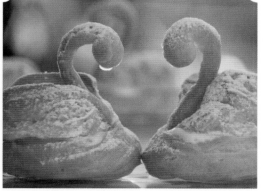

GEORGIOS DETSIS
GREECE
0668

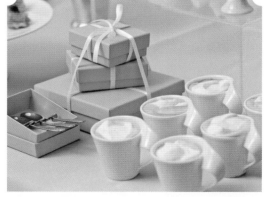

CARA AND SCOTT NAVA
USA
0669

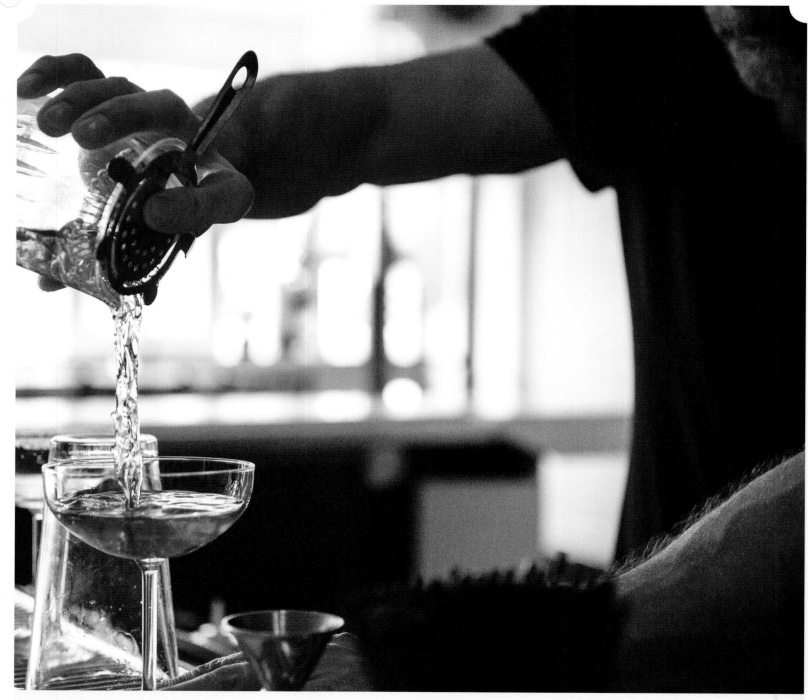

GALDONES PHOTOGRAPHY
USA

0670

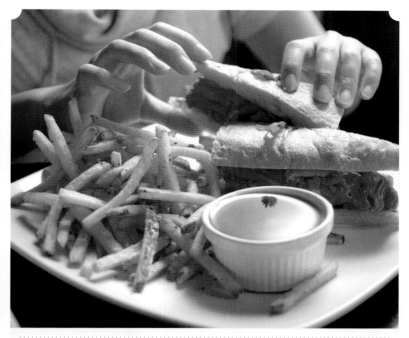

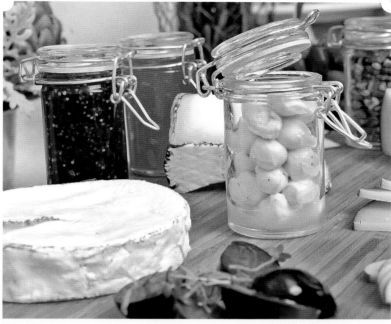

GRIP
USA
0671

CARA AND SCOTT NAVA
USA
0672

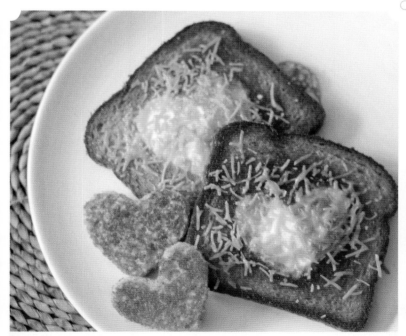

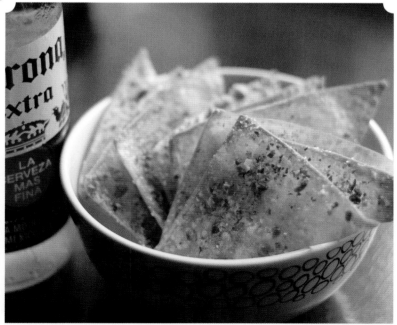

SHERI SILVER
USA
0673

SHERI SILVER
USA
0674

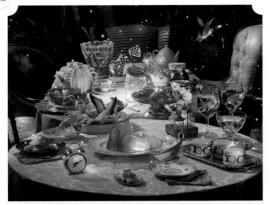

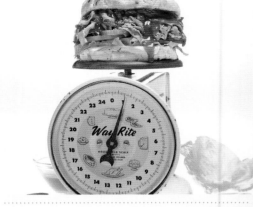

NADINE SHAW
AUSTRALIA
0675

ARI BENDERSKY
USA
0676

ARI BENDERSKY
USA
0677

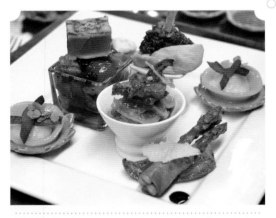

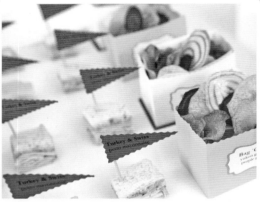

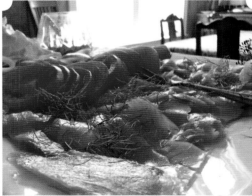

RACHEL DE MARTE
USA
0678

AZITA HOUSHIAR
USA
0679

ELLIE MEYER
USA
0680

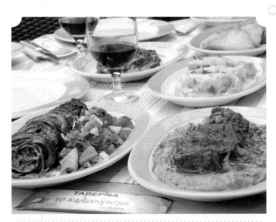

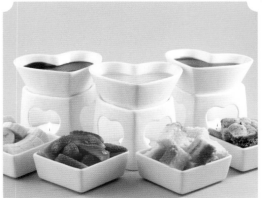

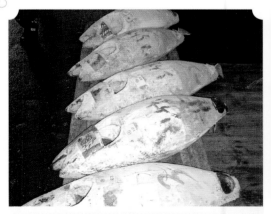

GEORGIOS DETSIS
GREECE
0681

PARAGON MARKETING
COMMUNICATIONS KUWAIT
0682

BRIAN POREA
USA
0683

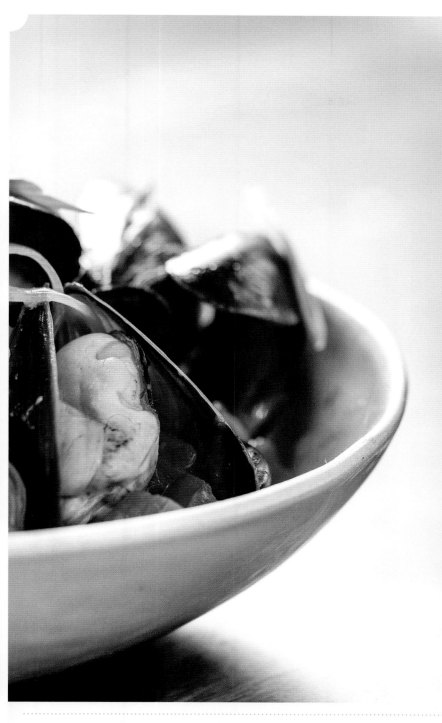

the
SAUTÉ

Net Wt. 16 oz {454g}

THE
flavor
by
STEPHANIE IZARD

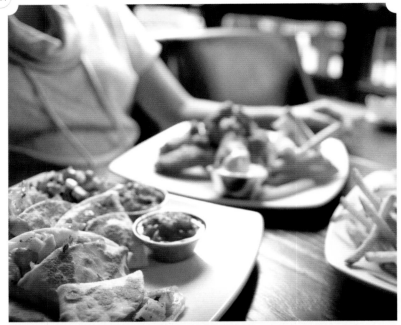

GRIP
USA

0685

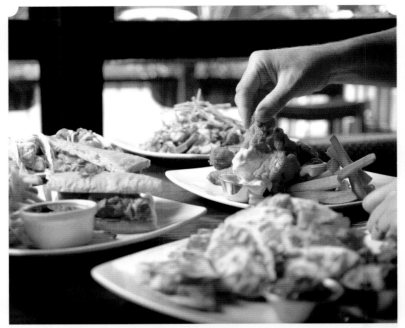

GRIP
USA

0686

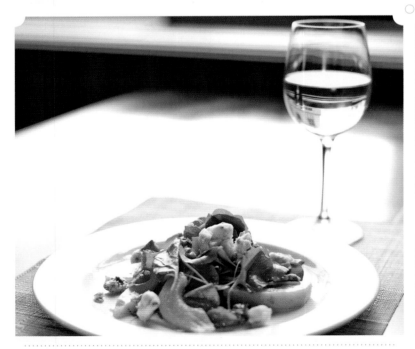

TUAN H. BUI
USA

0687

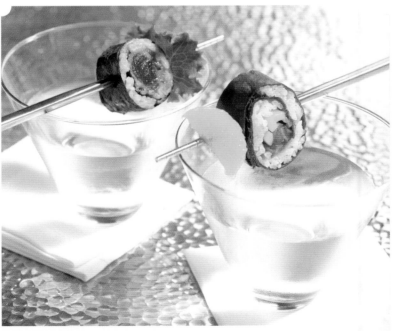

RACHEL DE MARTE
USA

0688

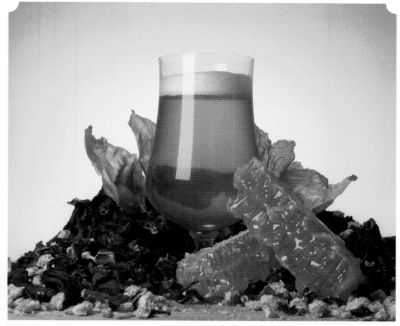

DAVID ROBERT ELLIOTT
USA
0689

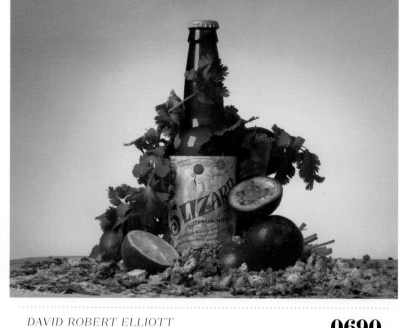

DAVID ROBERT ELLIOTT
USA
0690

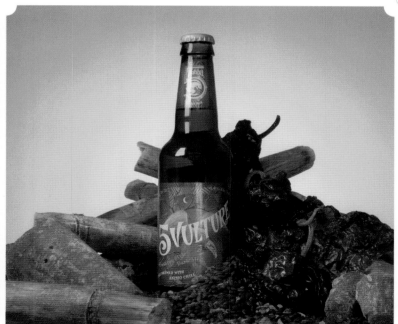

DAVID ROBERT ELLIOTT
USA
0691

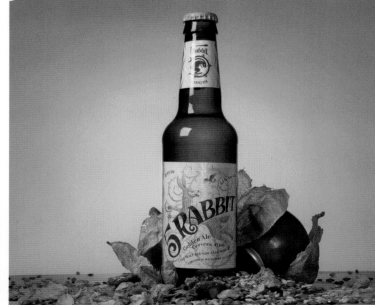

DAVID ROBERT ELLIOTT
USA
0692

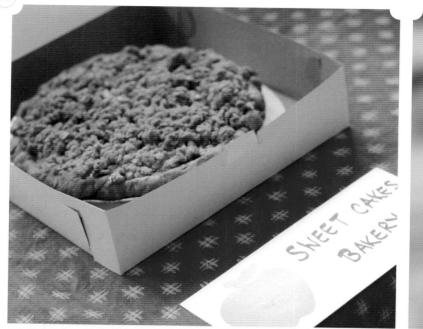

DENNIS LEE
USA

0693

DENNIS LEE
USA

0694

DENNIS LEE
USA

0695

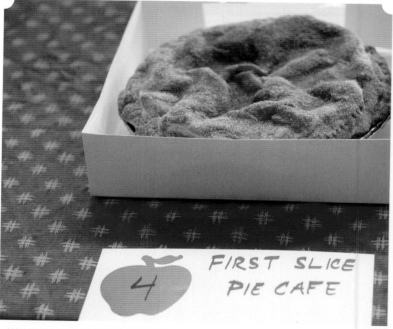

DENNIS LEE
USA

0696

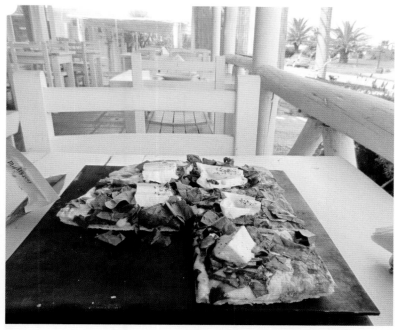

KATE RIESENBERG
USA

0697

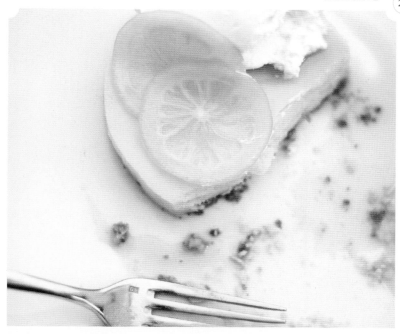

ANTHONY TAHLIER
USA

0698

ERIC KLEINBERG
USA

0699

KATE RIESENBERG
USA

0700

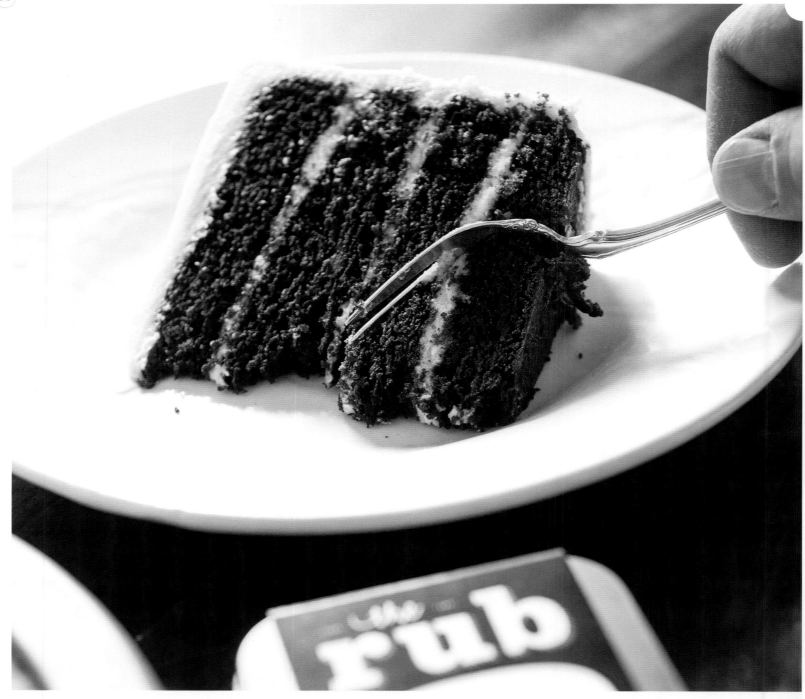

GALDONES PHOTOGRAPHY
USA

0701

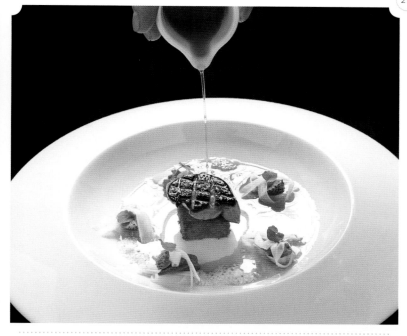

GALDONES PHOTOGRAPHY
USA

0702

ERIC KLEINBERG
USA

0703

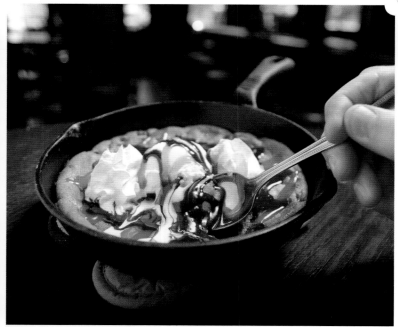

GRIP
USA

0704

BRANDON FREITAS
USA

0705

MOLLY MCMAHON
USA

0706

MOLLY MCMAHON
USA

0707

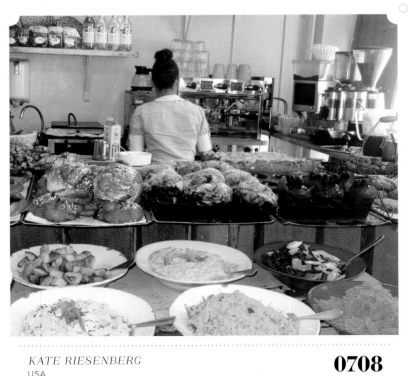

KATE RIESENBERG
USA

0708

ANDREW HICKEY
USA

0709

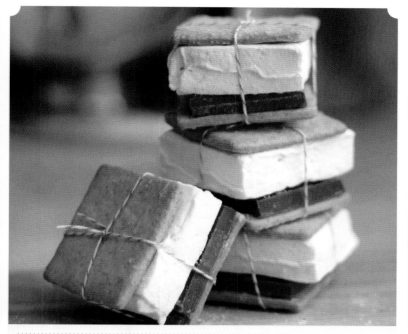

SHERI SILVER
USA

0710

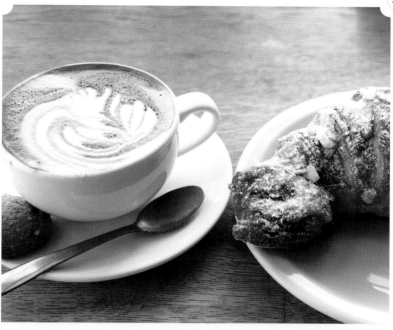

ANDREW HICKEY
USA

0711

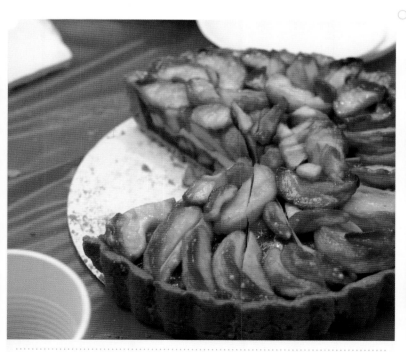

DENNIS LEE
USA

0712

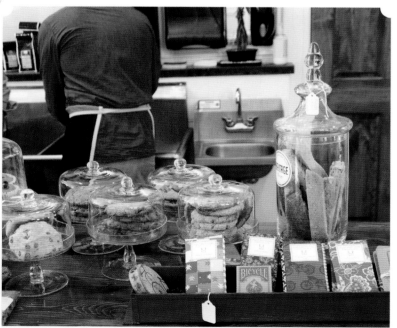

ANDREW HICKEY
USA

0713

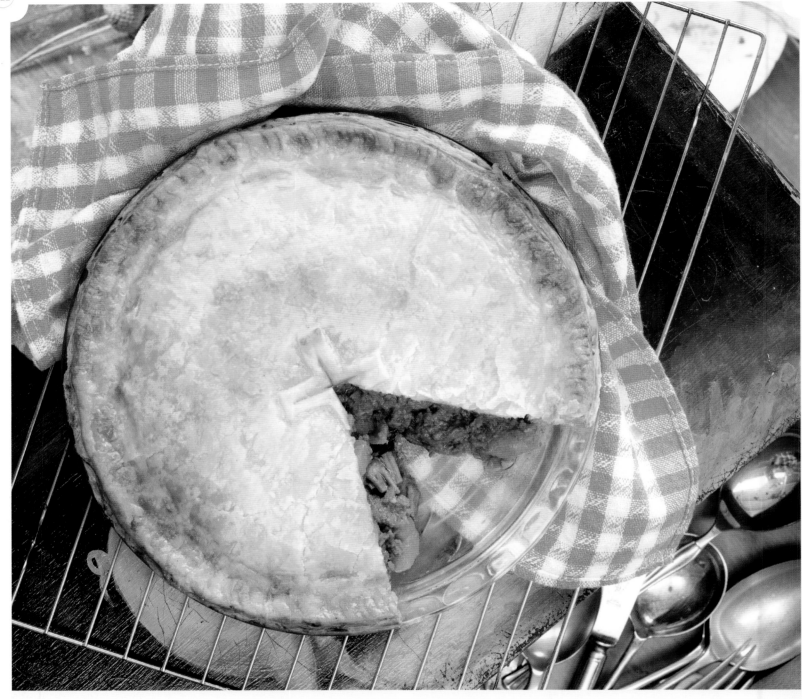

NADINE SHAW
AUSTRALIA

0714

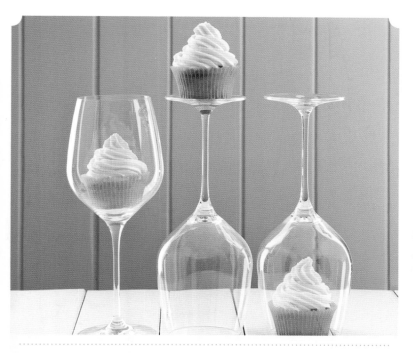

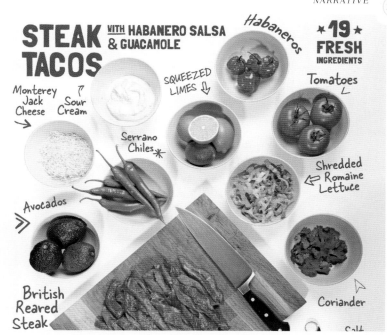

NADINE SHAW
AUSTRALIA

0715

ROOT STUDIO
ENGLAND

0716

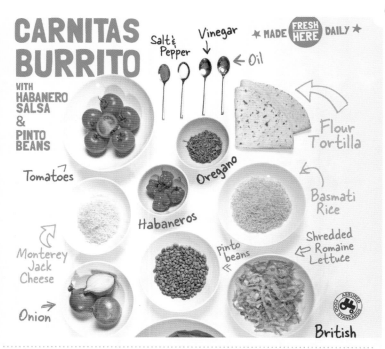

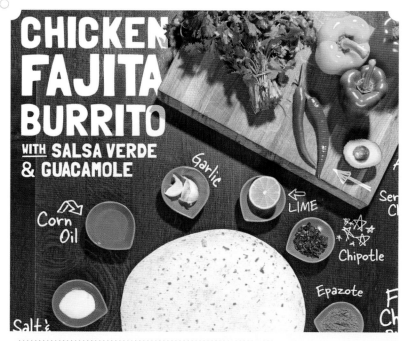

ROOT STUDIO
ENGLAND

0717

ROOT STUDIO
ENGLAND

0718

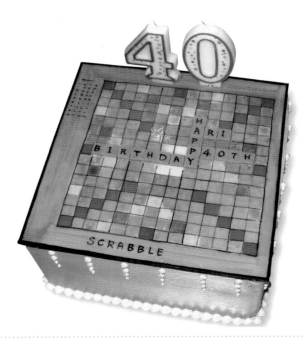

PARAGON MARKETING COMMUNICATIONS
KUWAIT
0719

ARI BENDERSKY
USA
0720

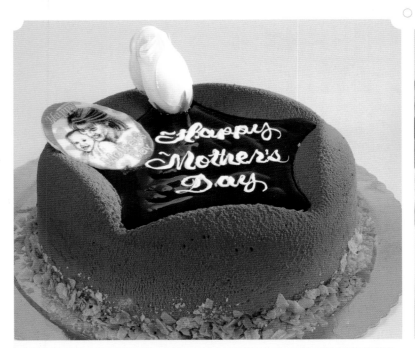

PARAGON MARKETING COMMUNICATIONS
KUWAIT
0721

PARAGON MARKETING COMMUNICATIONS
KUWAIT
0722

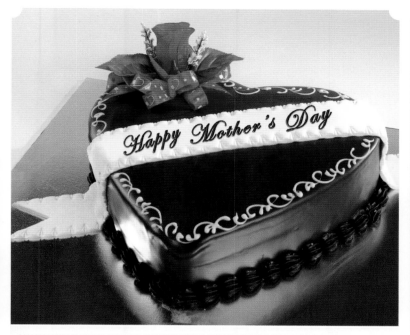

PARAGON MARKETING COMMUNICATIONS
KUWAIT

0723

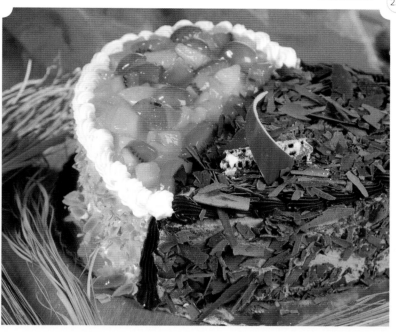

PARAGON MARKETING COMMUNICATIONS
KUWAIT

0724

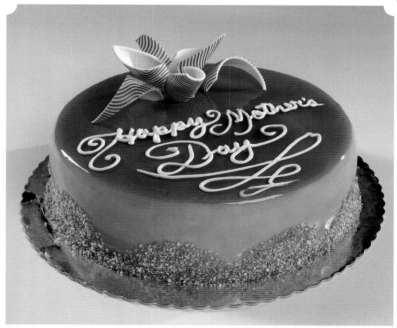

PARAGON MARKETING COMMUNICATIONS
KUWAIT

0725

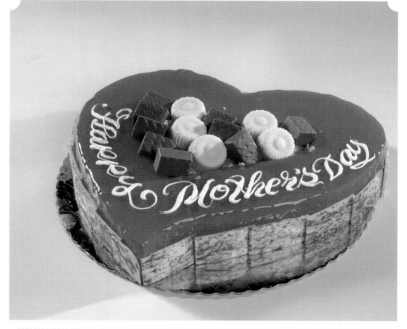

PARAGON MARKETING COMMUNICATIONS
KUWAIT

0726

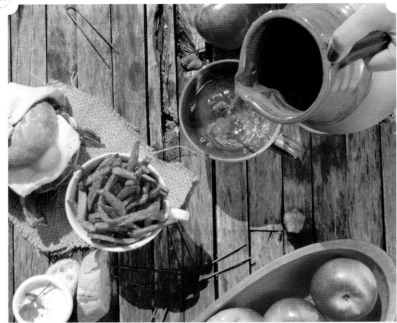

GRIP
USA
0727

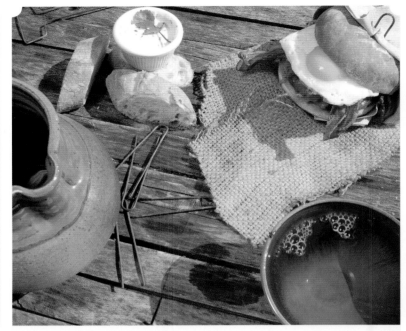

GRIP
USA
0728

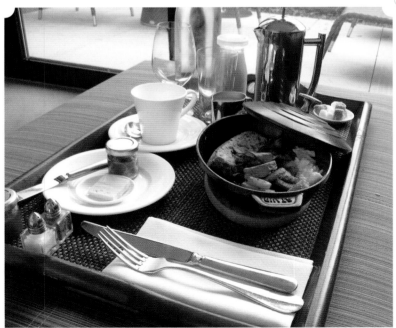

ARI BENDERSKY
USA
0729

KATE RIESENBERG
USA
0730

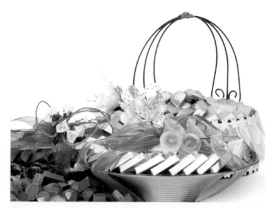

PARAGON MARKETING
COMMUNICATIONS KUWAIT **0731**

HEATHER SPERLING
USA **0732**

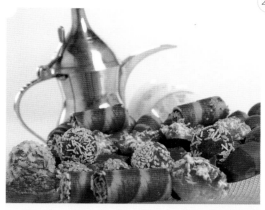

PARAGON MARKETING
COMMUNICATIONS KUWAIT **0733**

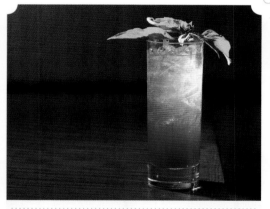

TUAN H. BUI
USA **0734**

ANTHONY TAHLIER
USA **0735**

PARAGON MARKETING
COMMUNICATIONS KUWAIT **0736**

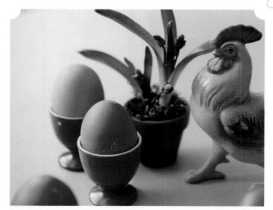

RUTH HUIMERIND
ESTONIA **0737**

RUTH HUIMERIND
ESTONIA **0738**

PARAGON MARKETING
COMMUNICATIONS KUWAIT **0739**

LUKASZ FUKS
POLAND
0740

LUKASZ FUKS
POLAND
0741

LUKASZ FUKS
POLAND
0742

ALLAN PENN
USA
0743

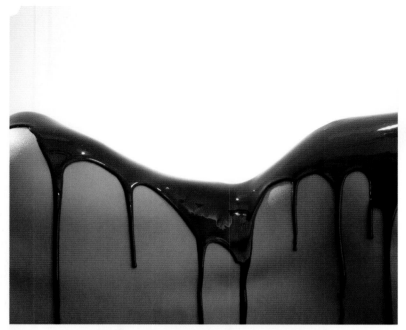

ALLAN PENN
USA

0744

ALLAN PENN
USA

0745

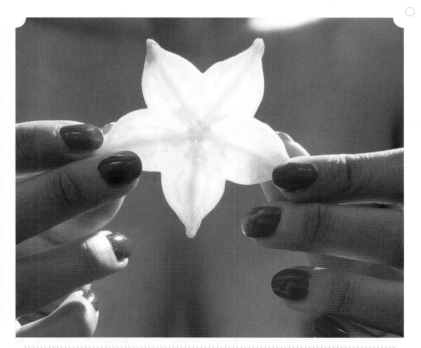

ALLAN PENN
USA

0746

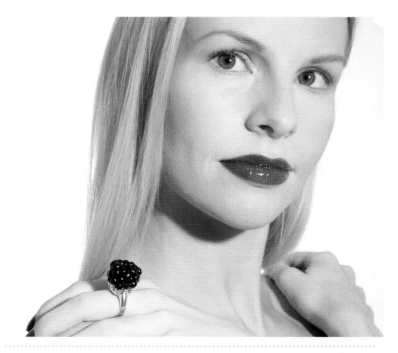

ALLAN PENN
USA

0747

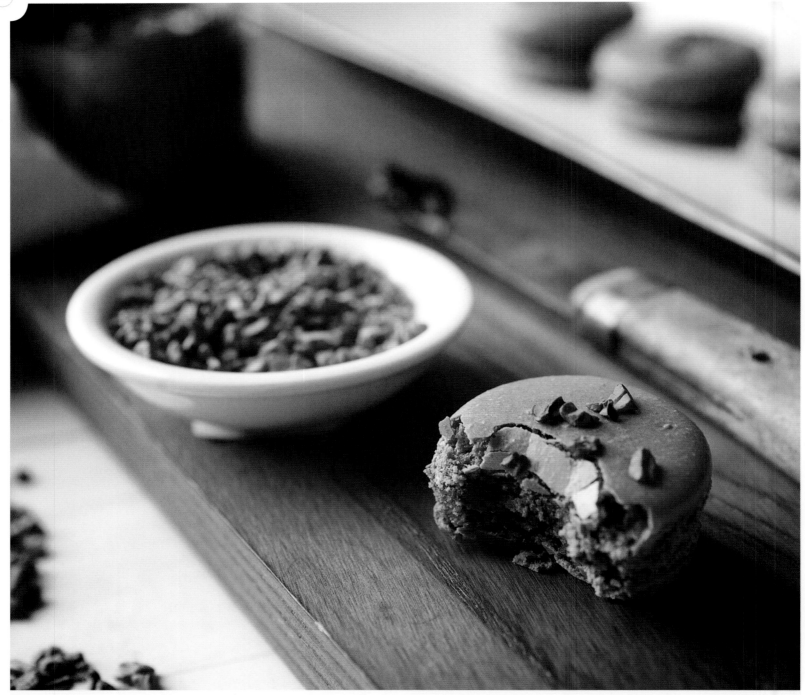

HEATHER VAN GAALE

USA

0748

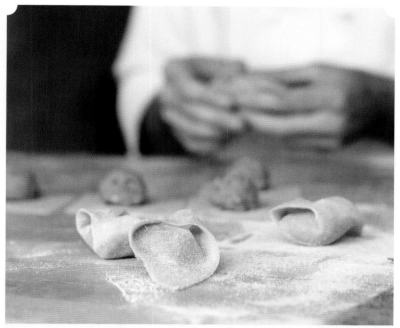

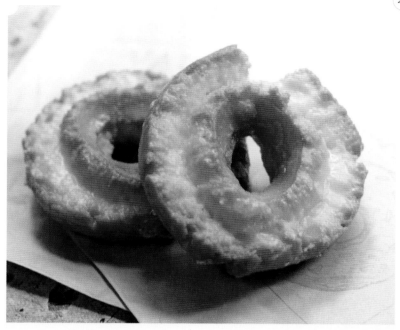

HEATHER SPERLING
USA
0749

HEATHER SPERLING
USA
0750

KATE RIESENBERG
USA
0751

GRIP
USA
0752

MULTIPLES

NUMEROUS / COPIUS / AMPLIFIED / DIVERSE

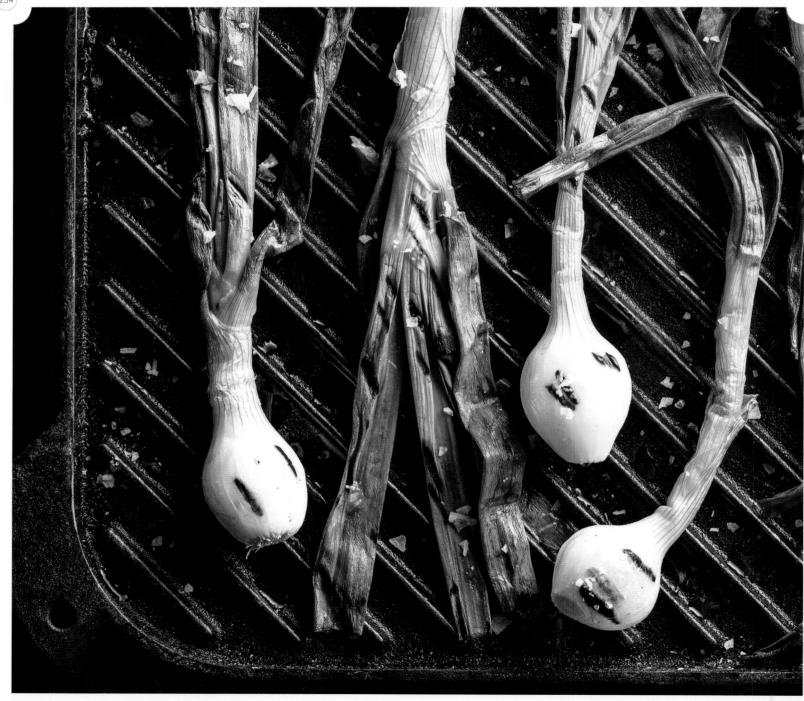

JUSTIN B. PARIS
USA

0753

GALDONES PHOTOGRAPHY
USA
0754

GALDONES PHOTOGRAPHY
USA
0755

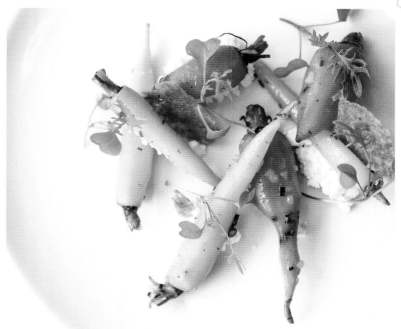

GALDONES PHOTOGRAPHY
USA
0756

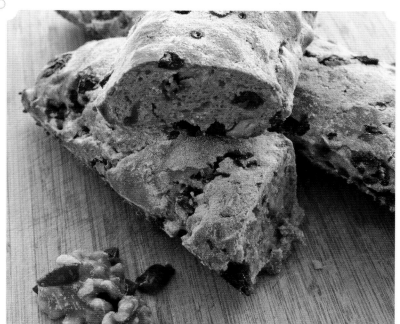

SCOTT ERB AND DONNA DUFAULT
USA
0757

TUAN H. BUI
USA

0758

TUAN H. BUI
USA

0759

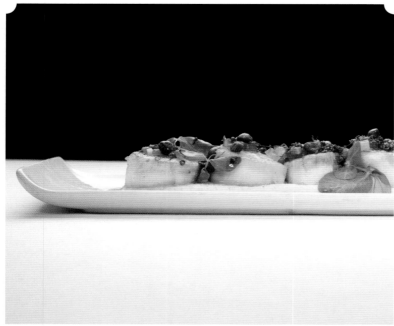

TUAN H. BUI
USA

0760

NANDY VILLONGCO
USA

0761

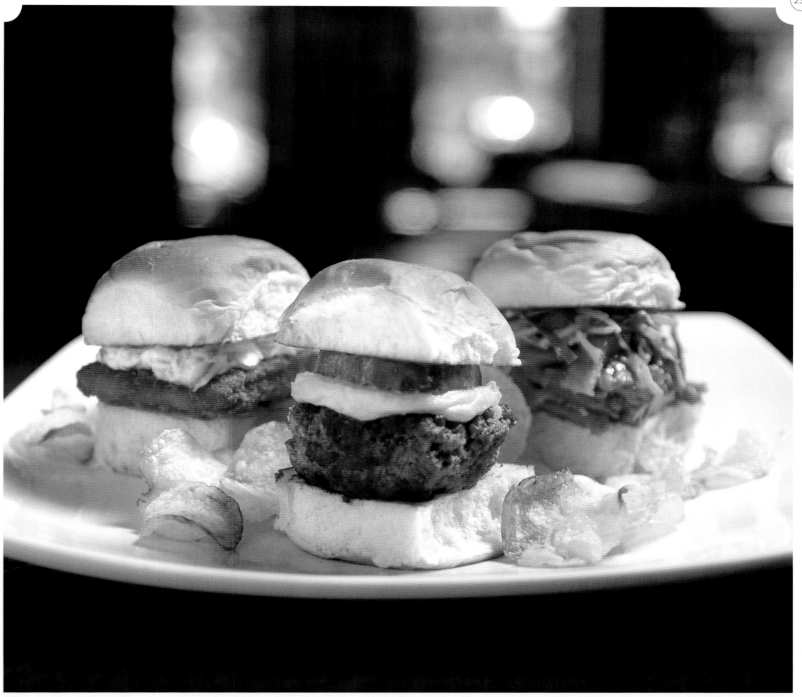

GRIP
USA

0762

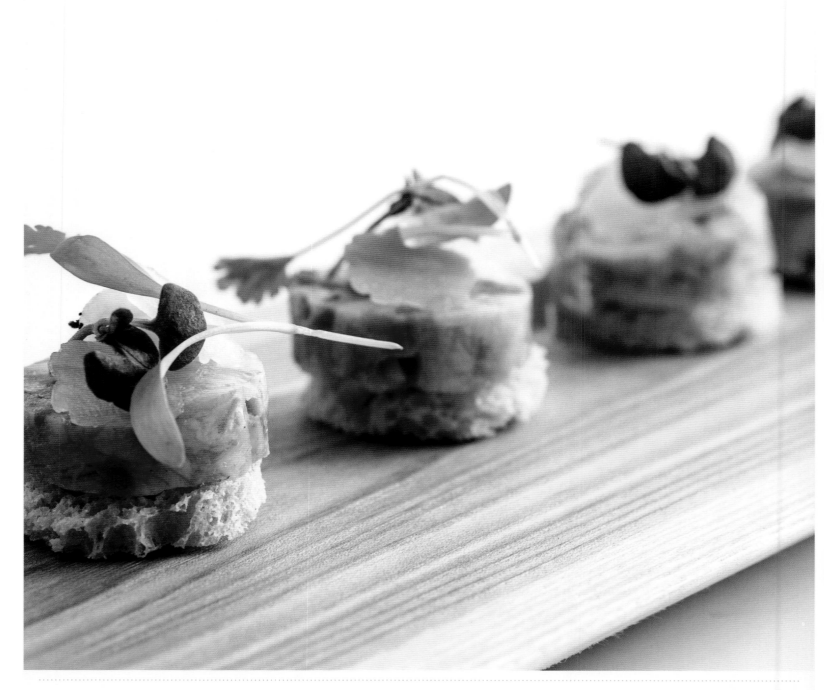

GALDONES PHOTOGRAPHY
USA

0763

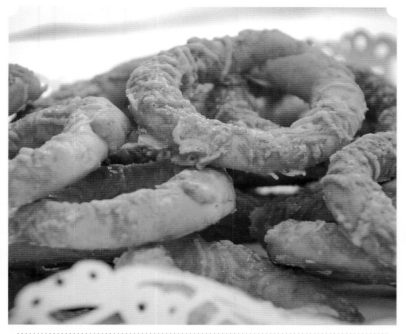

GEORGIOS DETSIS
GREECE

0764

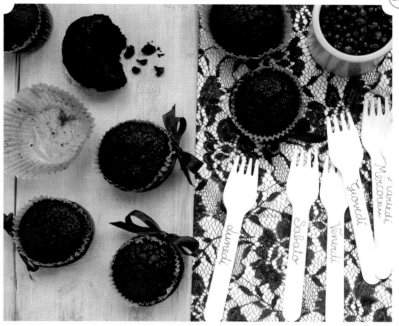

ELISABETTA REDAELLI
ITALY

0765

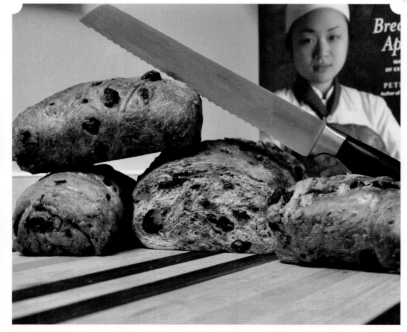

BERNADINE ROLNICKI
USA

0766

TUAN H. BUI
USA

0767

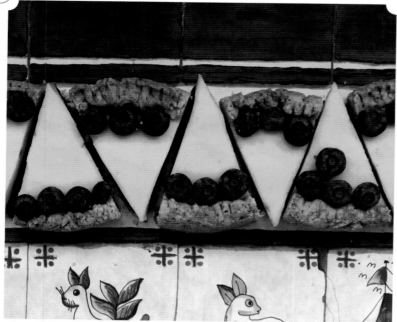

ELISABETTA REDAELLI
ITALY

0768

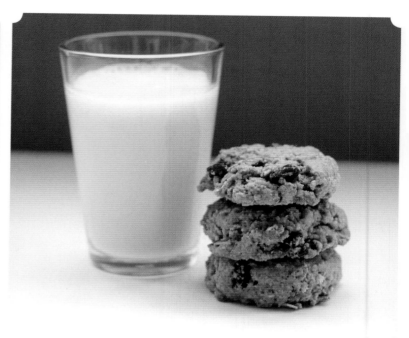

MOLLY MCMAHON
USA

0769

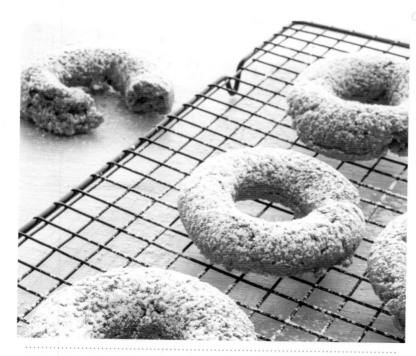

SCOTT ERB AND DONNA DUFAULT
USA

0770

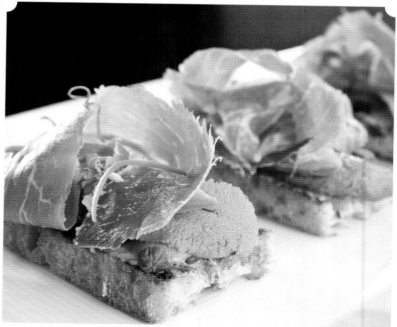

GALDONES PHOTOGRAPHY
USA

0771

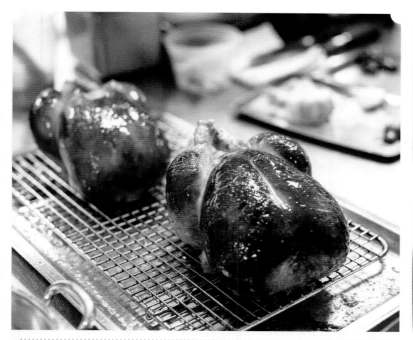

GALDONES PHOTOGRAPHY
USA
0772

MOLLY MCMAHON
USA
0773

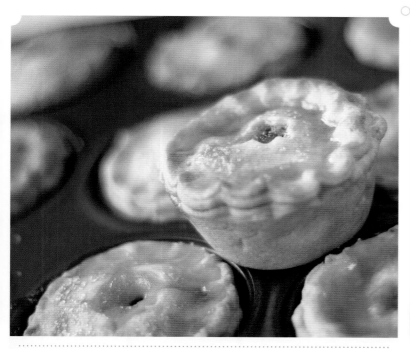

GEORGIOS DETSIS
GREECE
0774

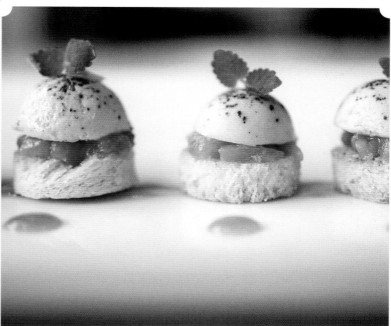

GALDONES PHOTOGRAPHY
USA
0775

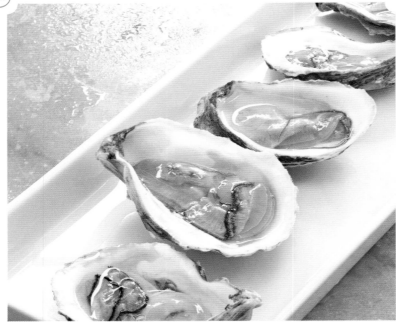

GLENN SCOTT
USA

0776

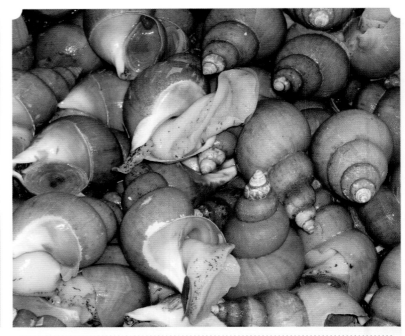

BRIAN POREA
USA

0777

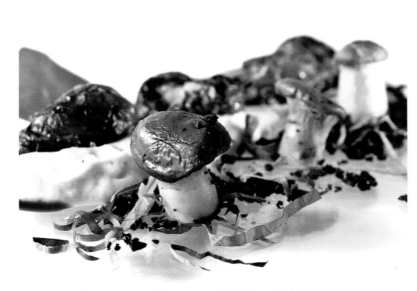

GALDONES PHOTOGRAPHY
USA

0778

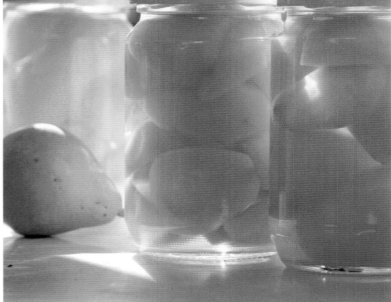

GEORGIOS DETSIS
GREECE

0779

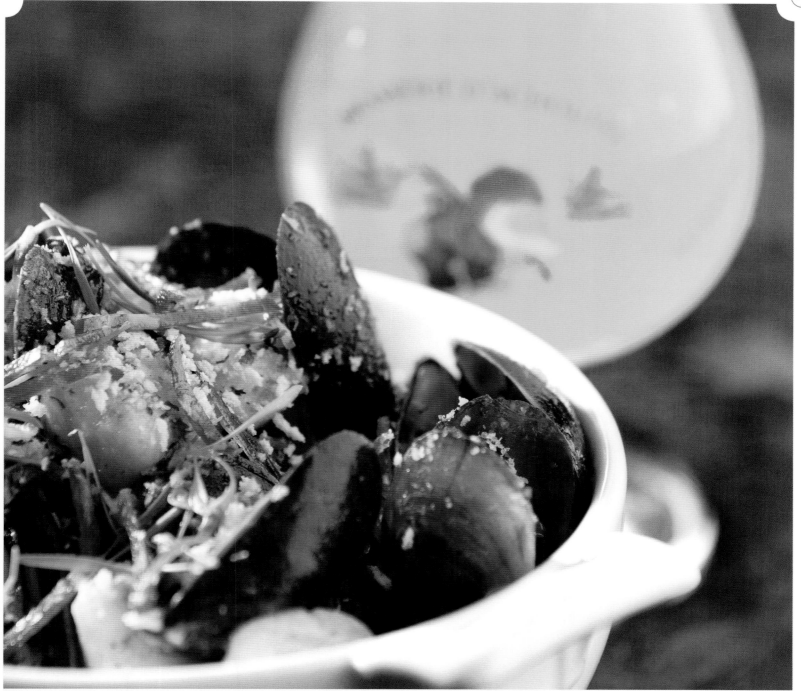

GALDONES PHOTOGRAPHY
USA

0780

DENNIS LEE
USA
0781

DENNIS LEE
USA
0782

AZITA HOUSHIAR
USA
0783

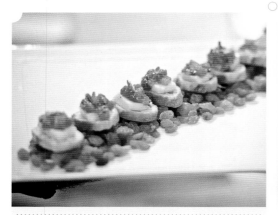

CARA AND SCOTT NAVA
USA
0784

ELLIE MEYER
USA
0785

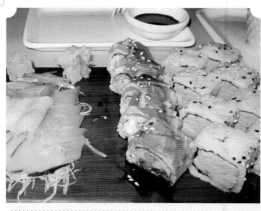

KATE RIESENBERG
USA
0786

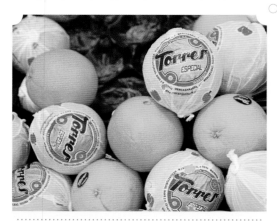

BRIAN POREA
USA
0787

AZITA HOUSHIAR
USA
0788

PARAGON MARKETING
COMMUNICATIONS KUWAIT
0789

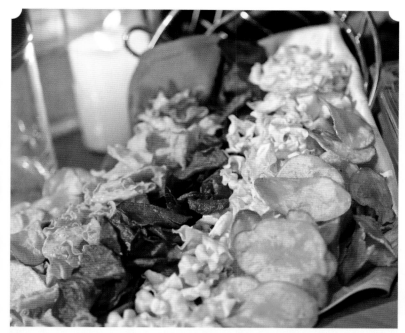

CARA AND SCOTT NAVA
USA

0790

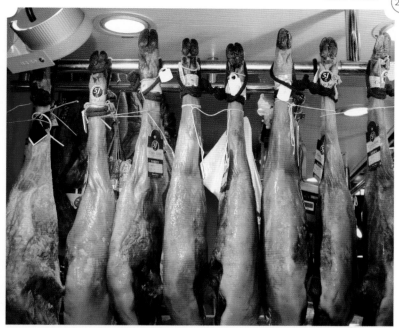

BRIAN POREA
USA

0791

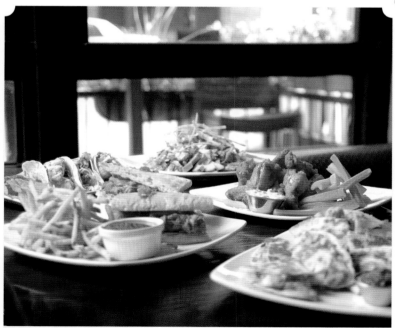

GRIP
USA

0792

DENNIS LEE
USA

0793

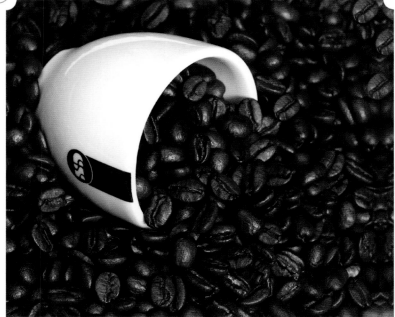

PARAGON MARKETING COMMUNICATIONS
KUWAIT

0794

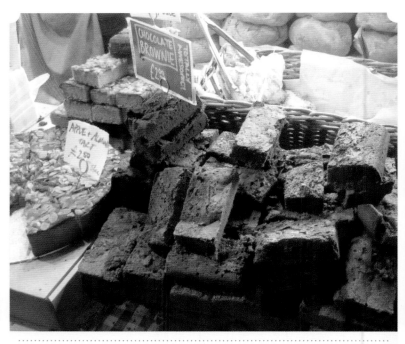

KATE RIESENBERG
USA

0795

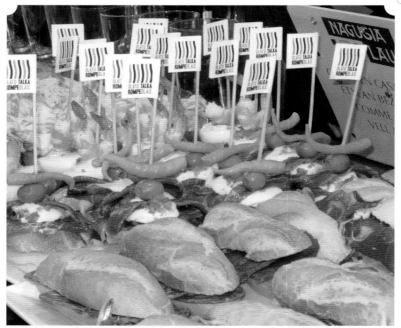

KATE RIESENBERG
USA

0796

KATE RIESENBERG
USA

0797

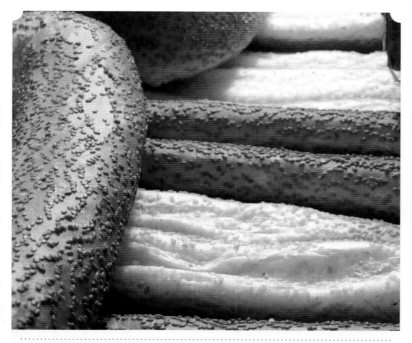

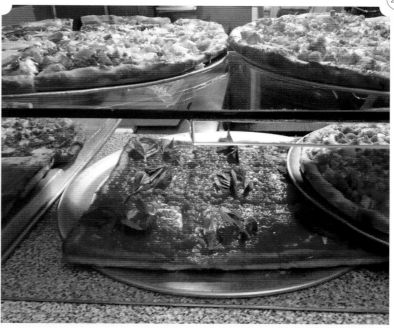

KATE RIESENBERG
USA

0798

KATE RIESENBERG
USA

0799

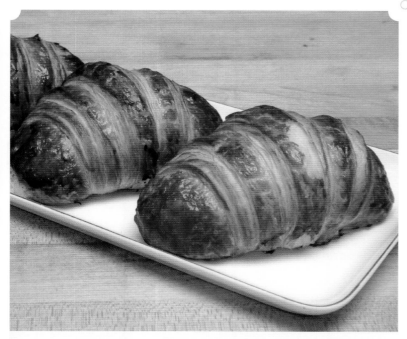

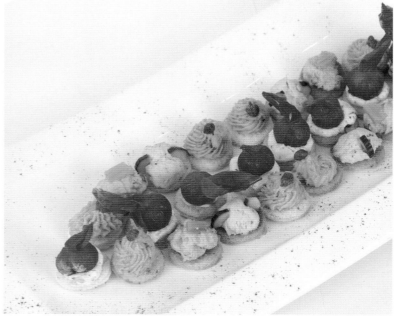

ANDREW HICKEY
USA

0800

PARAGON MARKETING COMMUNICATIONS
KUWAIT

0801

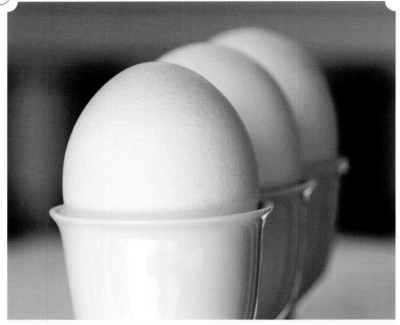

MICHELLE DEITER
USA

0802

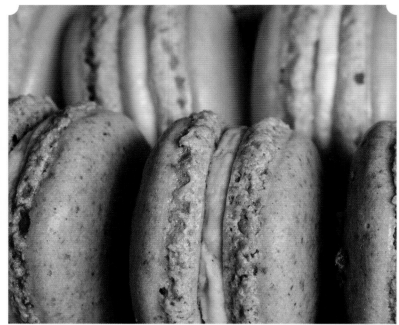

MICHELLE DEITER
USA

0803

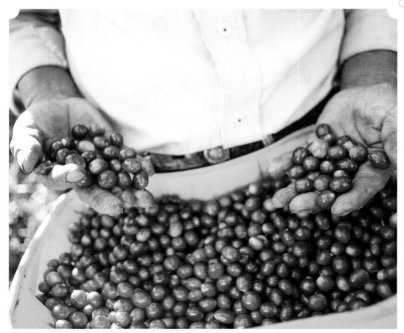

GALDONES PHOTOGRAPHY
USA

0804

ANDREW HICKEY
USA

0805

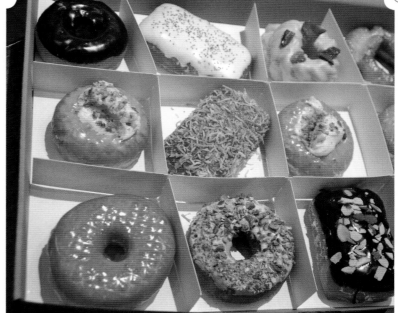

NADINE SHAW
AUSTRALIA

0806

ANDREW HICKEY
USA

0807

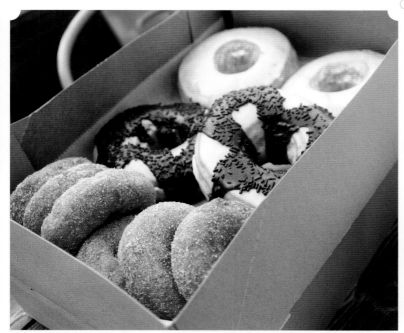

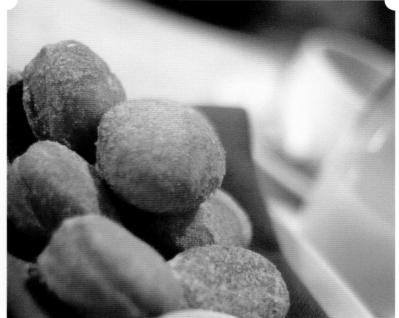

ANDREW HICKEY
USA

0808

ANDREW HICKEY
USA

0809

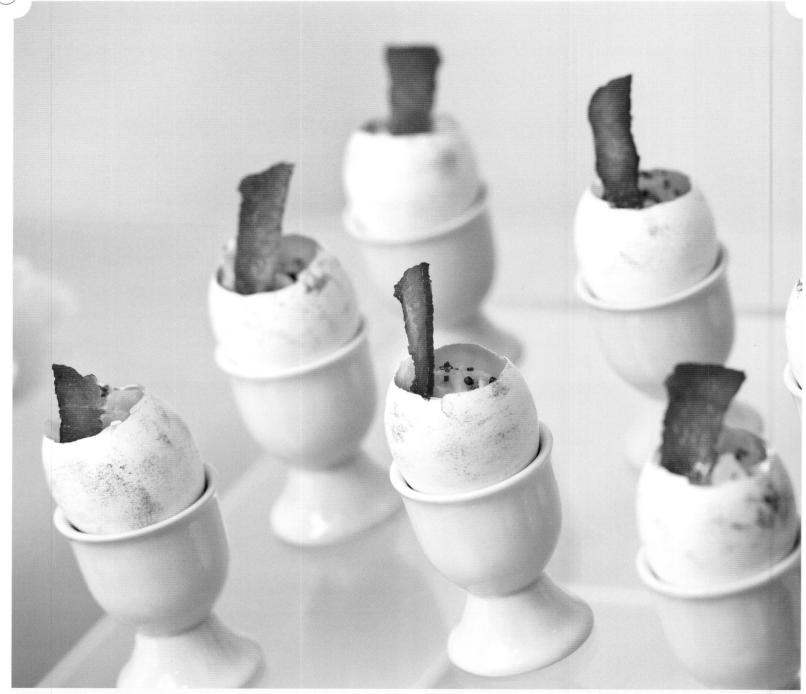

CARA AND SCOTT NAVA
USA

0810

ANDREW HICKEY
USA

0811

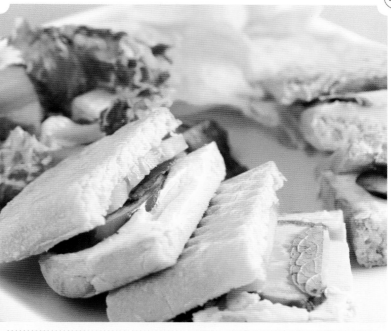

PARAGON MARKETING COMMUNICATIONS
KUWAIT

0812

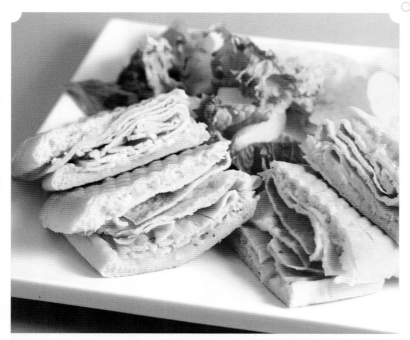

PARAGON MARKETING COMMUNICATIONS
KUWAIT

0813

RACHEL DE MARTE
USA

0814

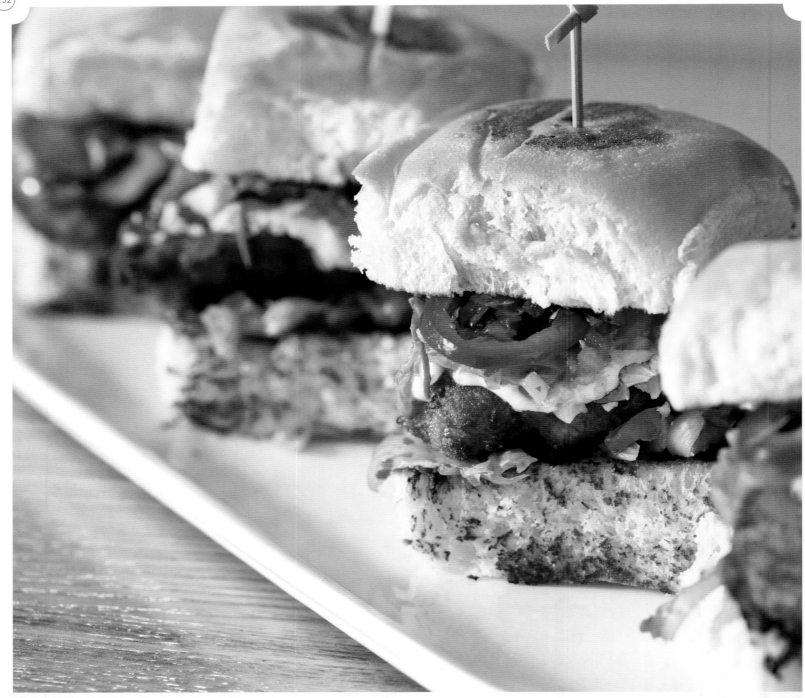

MOLLY MCMAHON

USA

0815

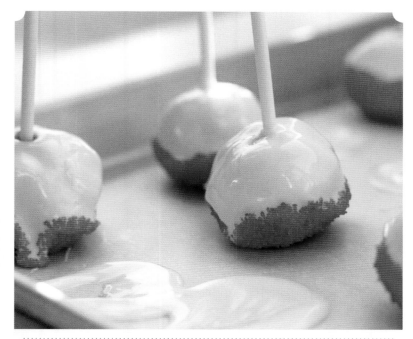

ERIC KLEINBERG
USA

0816

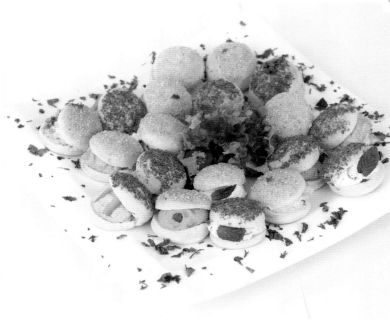

ERIC KLEINBERG
USA

0817

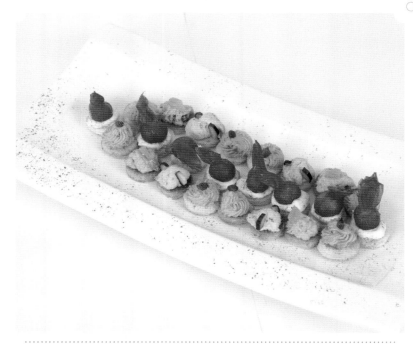

PARAGON MARKETING COMMUNICATIONS
KUWAIT

0818

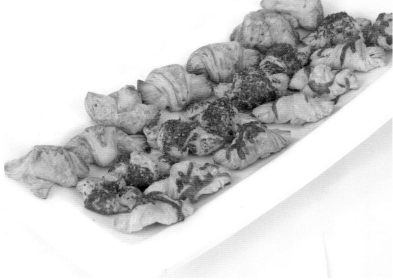

PARAGON MARKETING COMMUNICATIONS
KUWAIT

0819

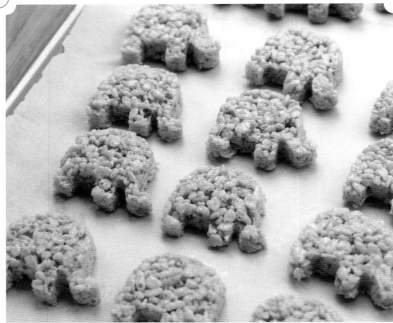

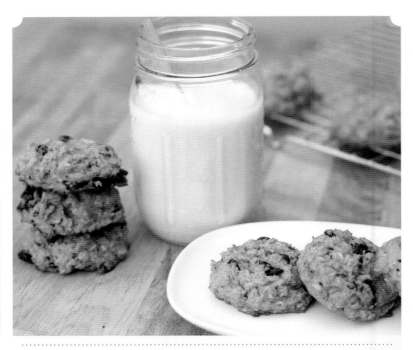

MOLLY MCMAHON
USA

0820

MOLLY MCMAHON
USA

0821

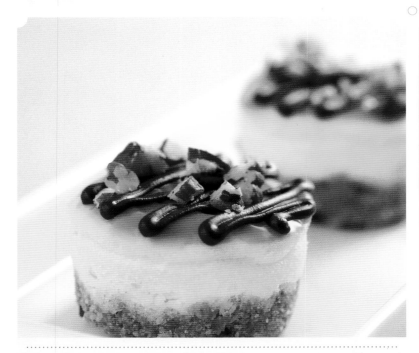

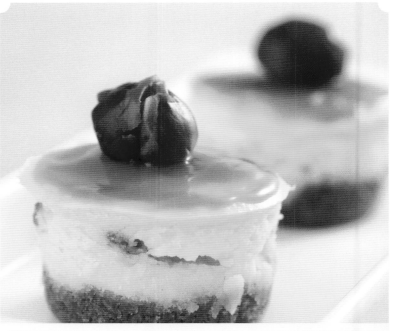

PARAGON MARKETING COMMUNICATIONS
KUWAIT

0822

PARAGON MARKETING COMMUNICATIONS
KUWAIT

0823

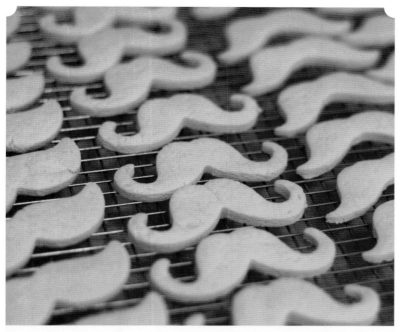

ANDREW HICKEY
USA
0824

PARAGON MARKETING COMMUNICATIONS
KUWAIT
0825

PARAGON MARKETING COMMUNICATIONS
KUWAIT
0826

PARAGON MARKETING COMMUNICATIONS
KUWAIT
0827

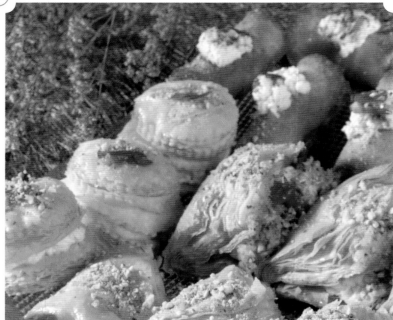

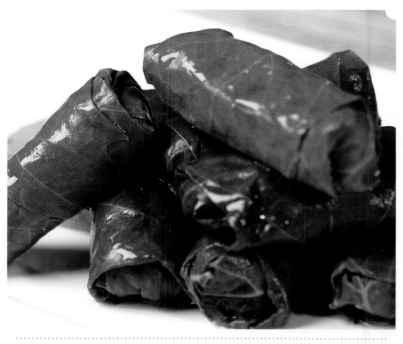

PARAGON MARKETING COMMUNICATIONS
KUWAIT **0828**

PARAGON MARKETING COMMUNICATIONS
KUWAIT **0829**

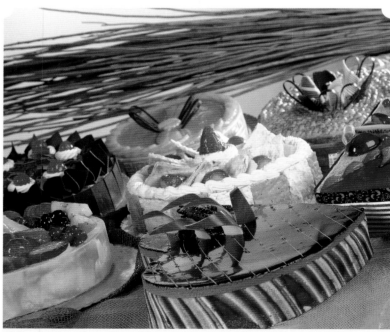

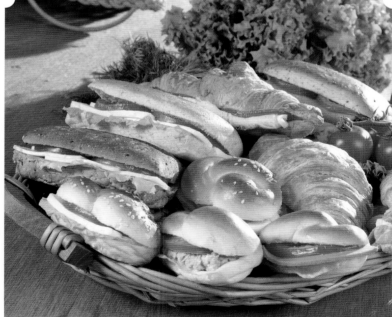

PARAGON MARKETING COMMUNICATIONS
KUWAIT **0830**

PARAGON MARKETING COMMUNICATIONS
KUWAIT **0831**

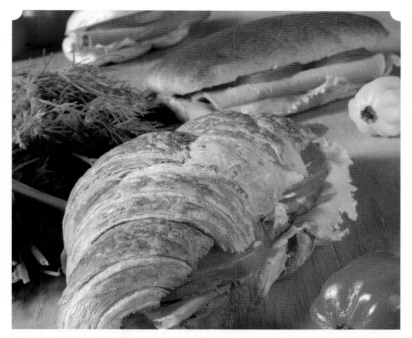

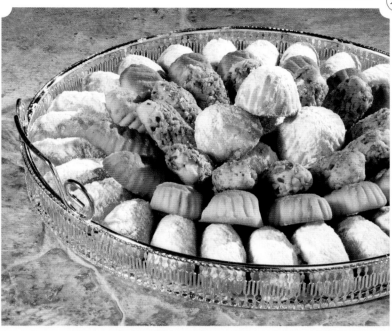

PARAGON MARKETING COMMUNICATIONS
KUWAIT **0832**

PARAGON MARKETING COMMUNICATIONS
KUWAIT **0833**

PARAGON MARKETING COMMUNICATIONS
KUWAIT **0834**

PARAGON MARKETING COMMUNICATIONS
KUWAIT **0835**

PARAGON MARKETING COMMUNICATIONS
KUWAIT
0836

ELISABETTA REDAELLI
ITALY
0837

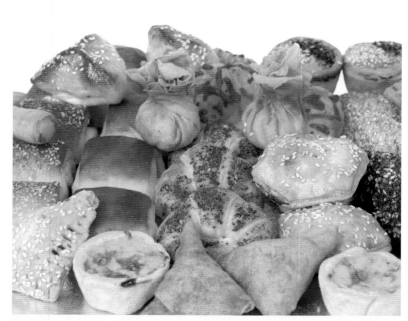

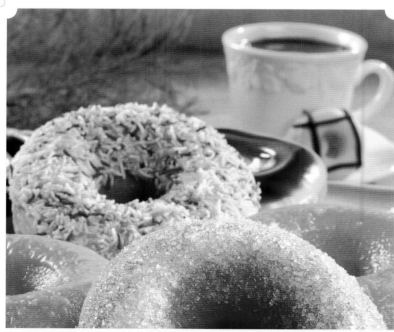

PARAGON MARKETING COMMUNICATIONS
KUWAIT
0838

PARAGON MARKETING COMMUNICATIONS
KUWAIT
0839

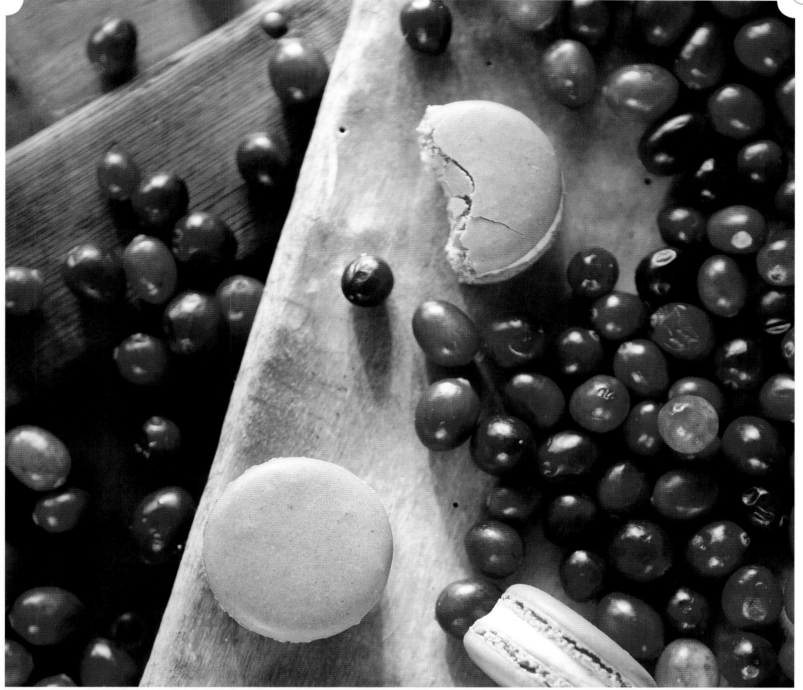

HEATHER VAN GAALE
USA

0840

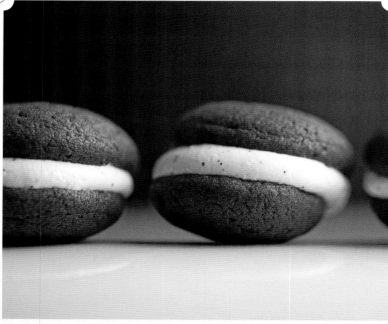

ANTHONY TAHLIER
USA

0841

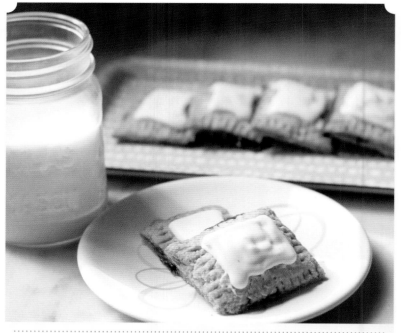

SHERI SILVER
USA

0842

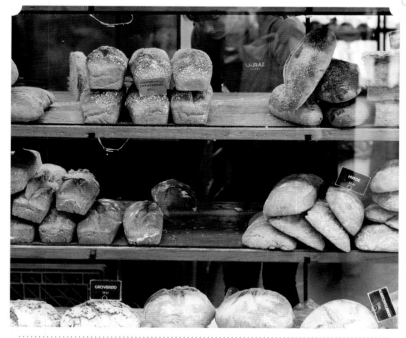

HEATHER SPERLING
USA

0843

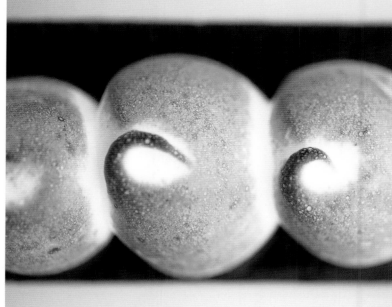

ANTHONY TAHLIER
USA

0844

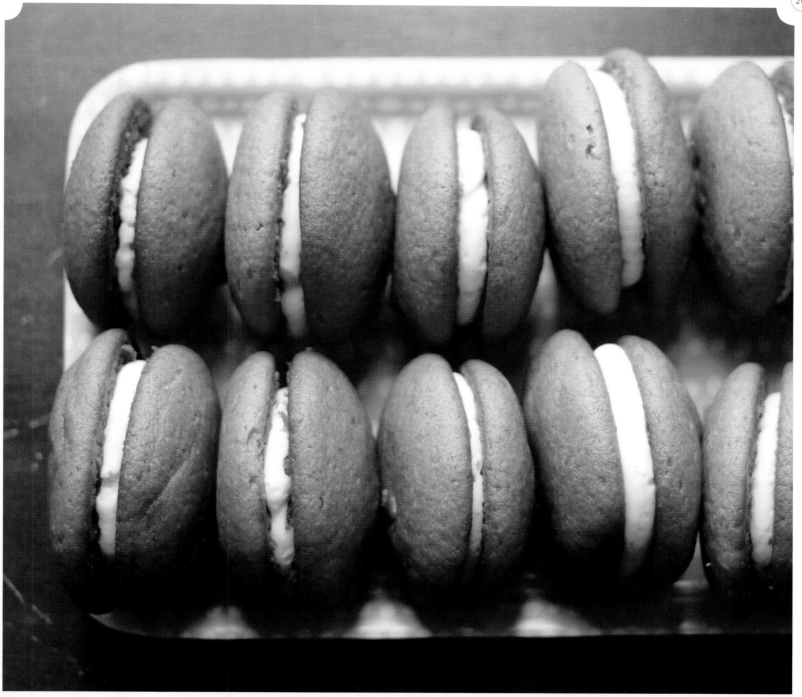

SHERI SILVER
USA

0845

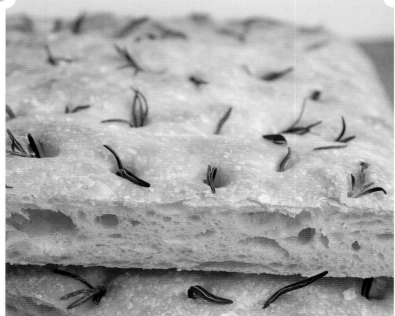

HEATHER SPERLING
USA
0846

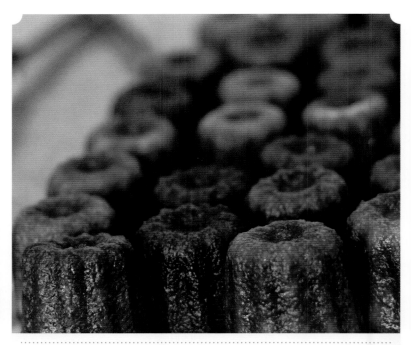

HEATHER SPERLING
USA
0847

HEATHER SPERLING
USA
0848

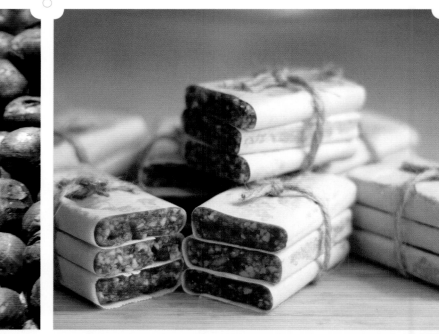

SHERI SILVER
USA
0849

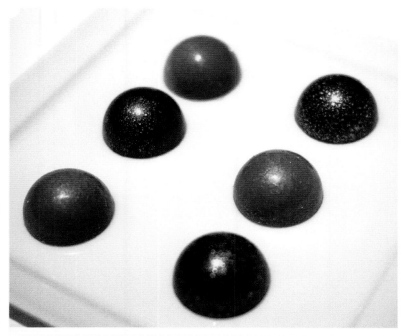

TY LETTAU
USA

0850

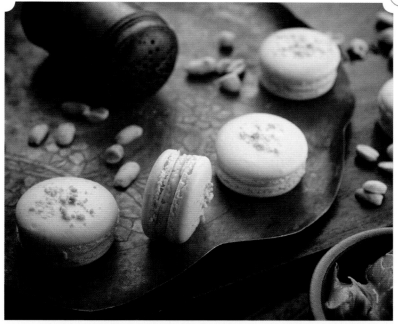

HEATHER VAN GAALE
USA

0851

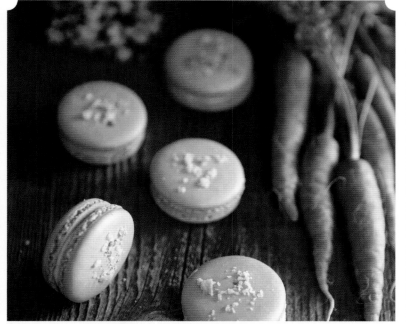

HEATHER VAN GAALE
USA

0852

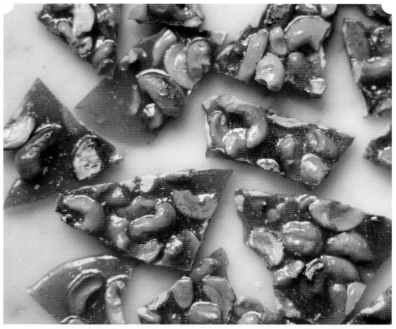

SHERI SILVER
USA

0853

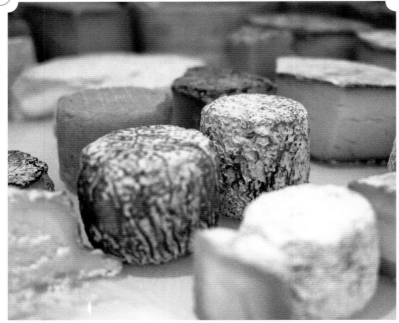

TY LETTAU
USA

0854

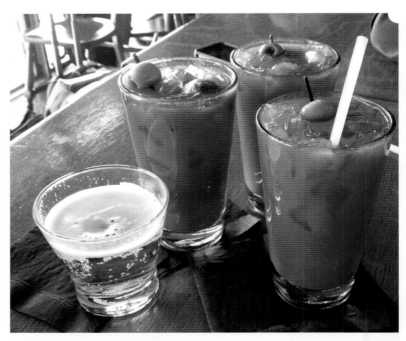

ARI BENDERSKY
USA

0855

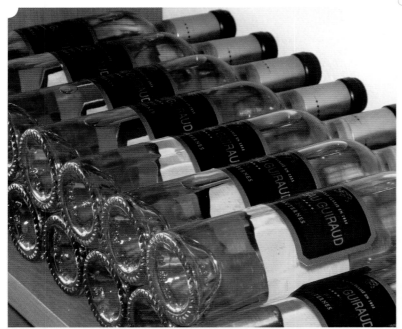

ARI BENDERSKY
USA

0856

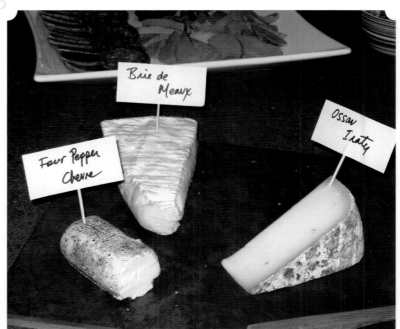

ARI BENDERSKY
USA

0857

LUKASZ FUKS
POLAND
0858

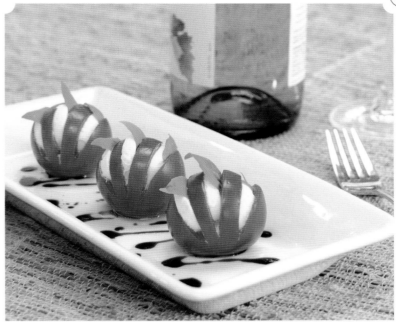

RONNIE SAINI
USA
0859

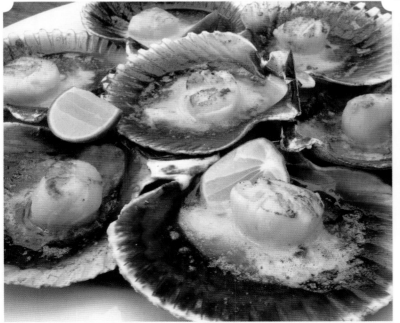

KATE RIESENBERG
USA
0860

HEATHER SPERLING
USA
0861

SEA

DELICATE / POACHED / WILD-CAUGHT / SMOKED

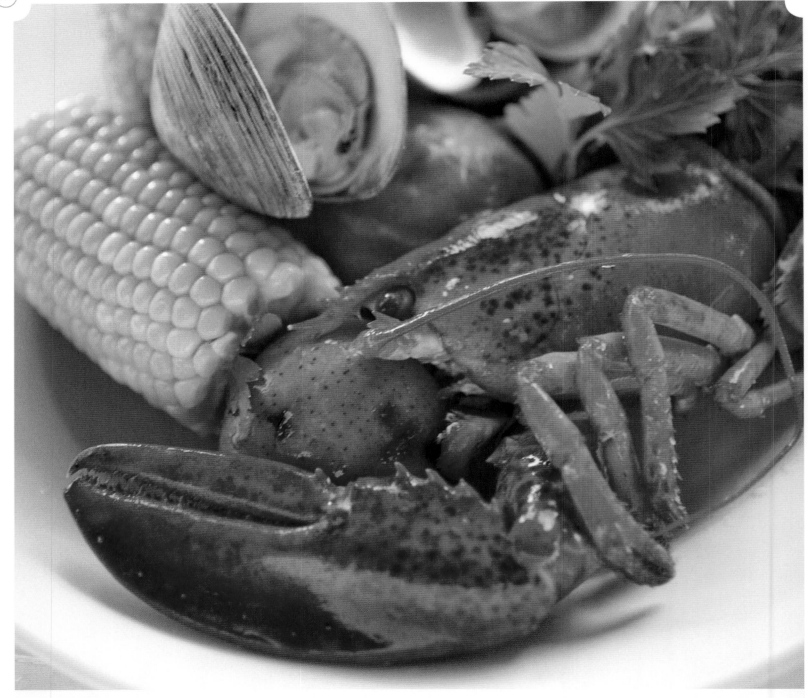

SCOTT ERB AND DONNA DUFAULT
USA

0862

ARI BENDERSKY
USA

0863

KARI SKAFLEN
USA

0864

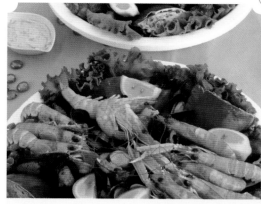

ARI BENDERSKY
USA

0865

ANDREW HICKEY
USA

0866

KATE RIESENBERG
USA

0867

SCOTT ERB AND DONNA
DUFAULT USA

0868

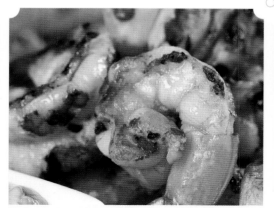

PARAGON MARKETING
COMMUNICATIONS KUWAIT

0869

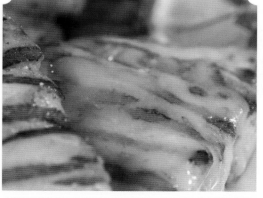

PARAGON MARKETING
COMMUNICATIONS KUWAIT

0870

ALLAN PENN
USA

0871

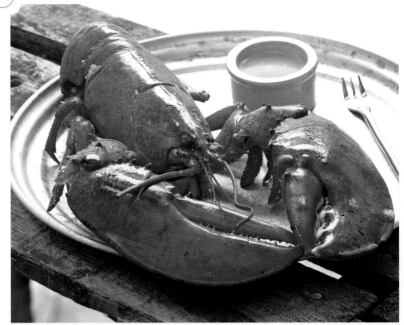

GLENN SCOTT
USA

0872

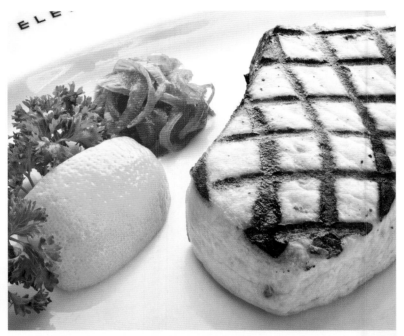

SCOTT ERB AND DONNA DUFAULT
USA

0873

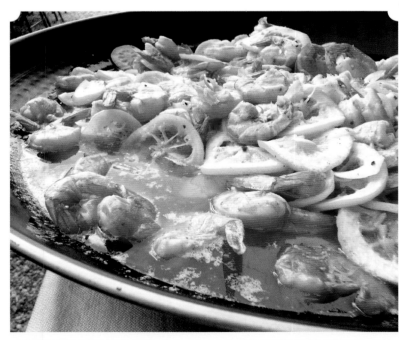

ELLIE MEYER
USA

0874

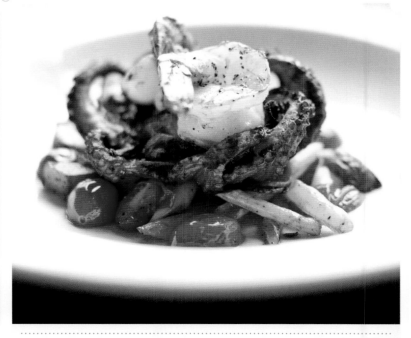

TUAN H. BUI
USA

0875

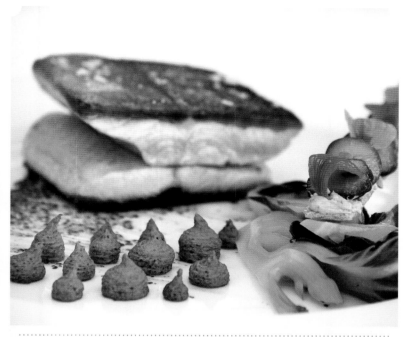

KATE RIESENBERG
USA

0876

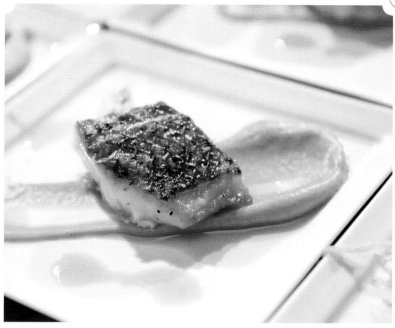

CARA AND SCOTT NAVA
USA

0877

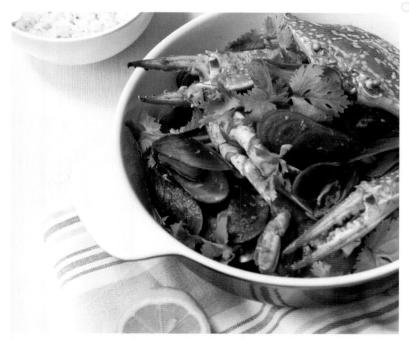

THAIN LIN TAY
SINGAPORE

0878

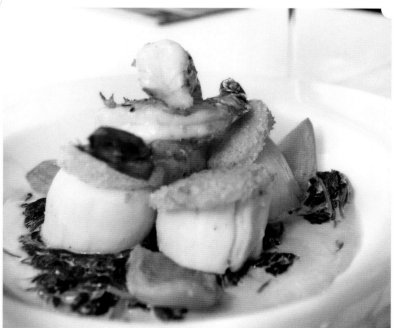

CARA AND SCOTT NAVA
USA

0879

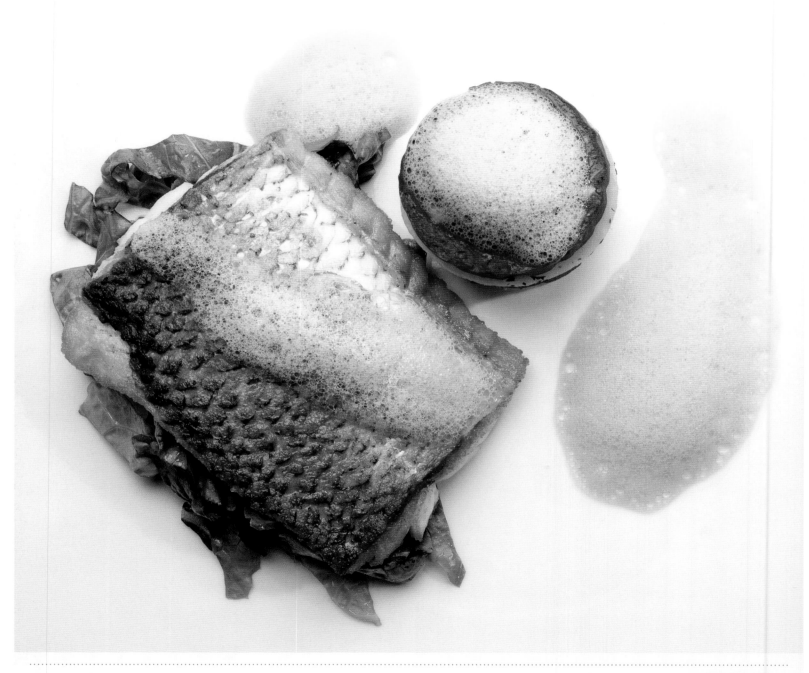

TUAN H. BUI
USA

0880

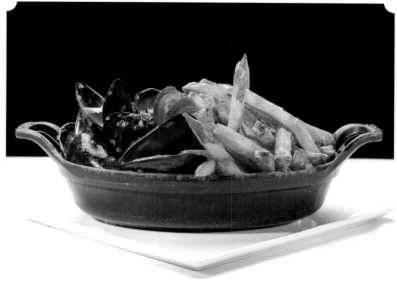

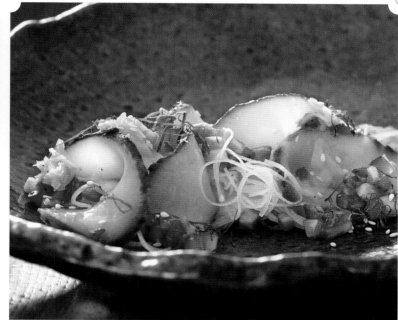

TUAN H. BUI
USA
0881

ERIC KLEINBERG
USA
0882

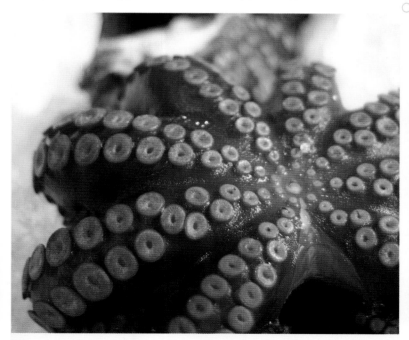

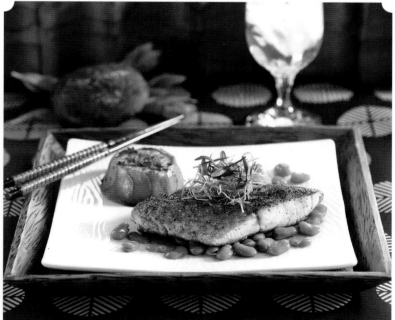

HEATHER SPERLING
USA
0883

RACHEL DE MARTE
USA
0884

PARAGON MARKETING COMMUNICATIONS
KUWAIT
0885

PARAGON MARKETING COMMUNICATIONS
KUWAIT
0886

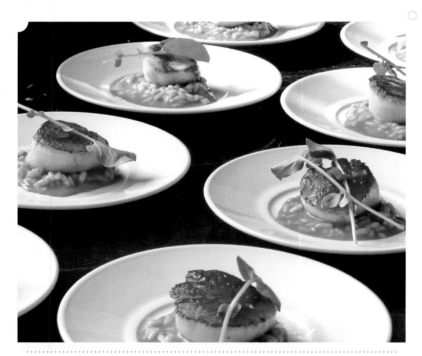

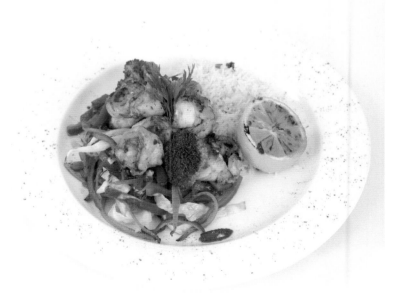

CARA AND SCOTT NAVA
USA
0887

PARAGON MARKETING COMMUNICATIONS
KUWAIT
0888

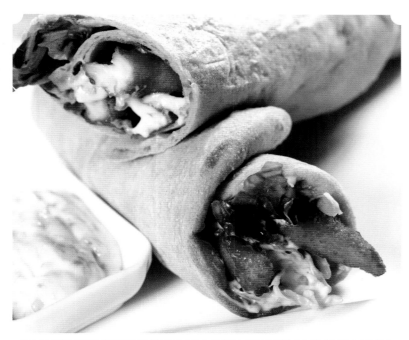

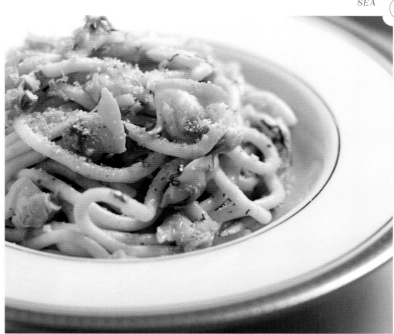

PARAGON MARKETING COMMUNICATIONS
KUWAIT

0889

ERIC KLEINBERG
USA

0890

PARAGON MARKETING COMMUNICATIONS
KUWAIT

0891

HEATHER SPERLING
USA

0892

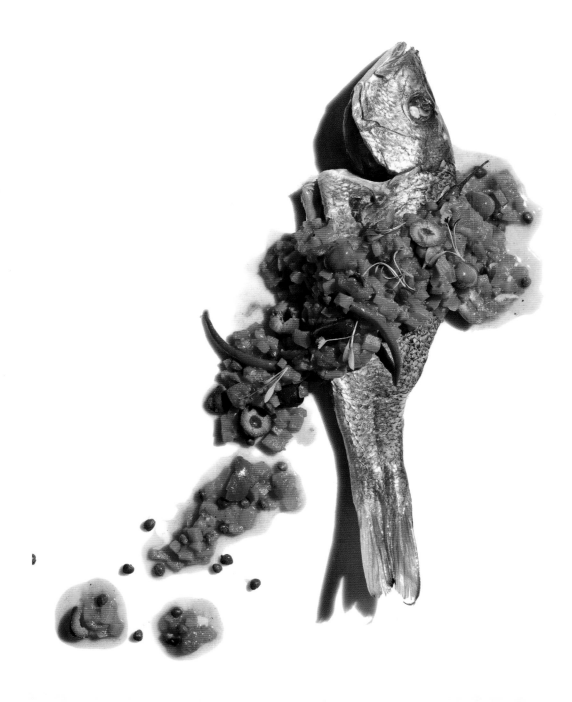

DAVE BRADLEY
USA

0893

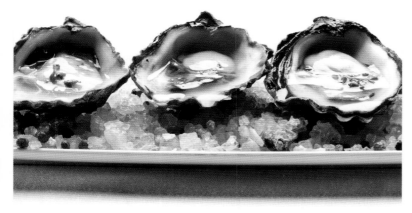

TUAN H. BUI
USA

0894

GALDONES PHOTOGRAPHY
USA

0895

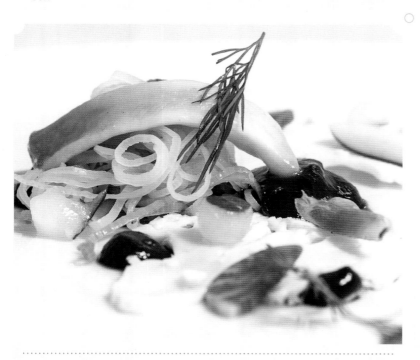

GALDONES PHOTOGRAPHY
USA

0896

SCOTT ERB AND DONNA DUFAULT
USA

0897

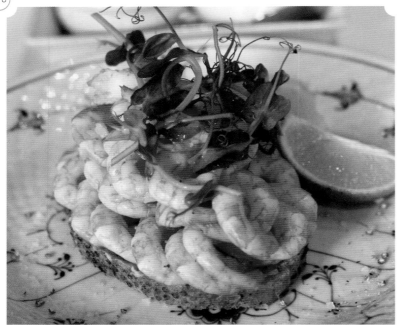

0898

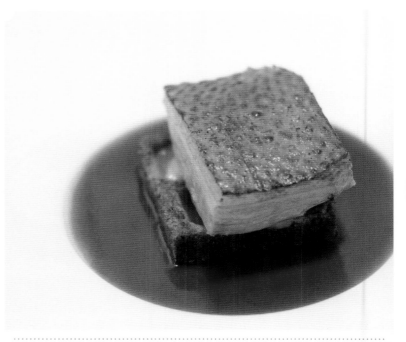

0899

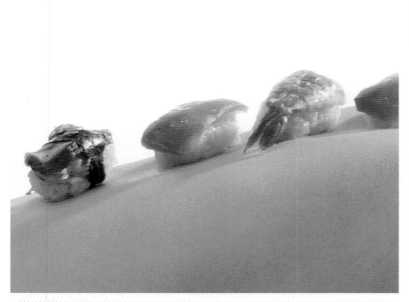

0900

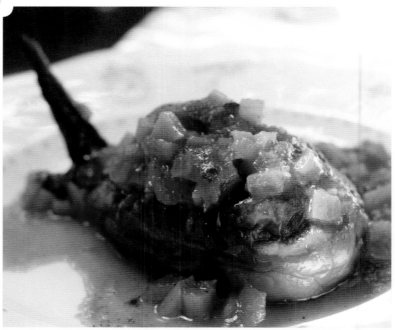

0901

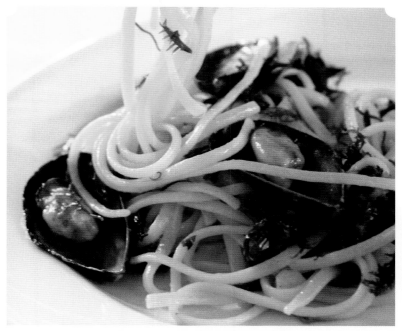

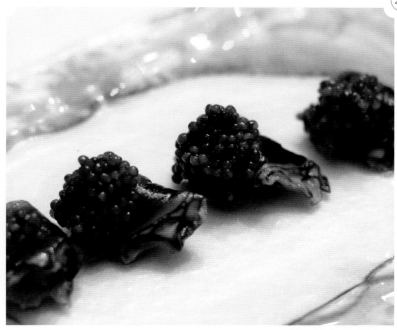

HEATHER SPERLING
USA
0902

HEATHER SPERLING
USA
0903

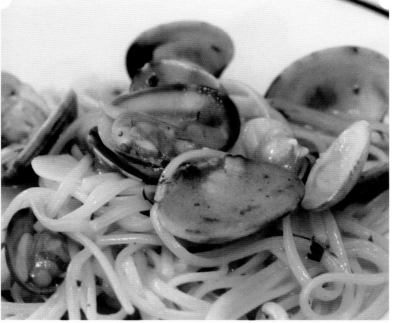

HEATHER SPERLING
USA
0904

HEATHER SPERLING
USA
0905

ANDRES DANGOND
USA
0906

SHERI SILVER
USA
0907

HEATHER SPERLING
USA
0908

ANDRES DANGOND
USA
0909

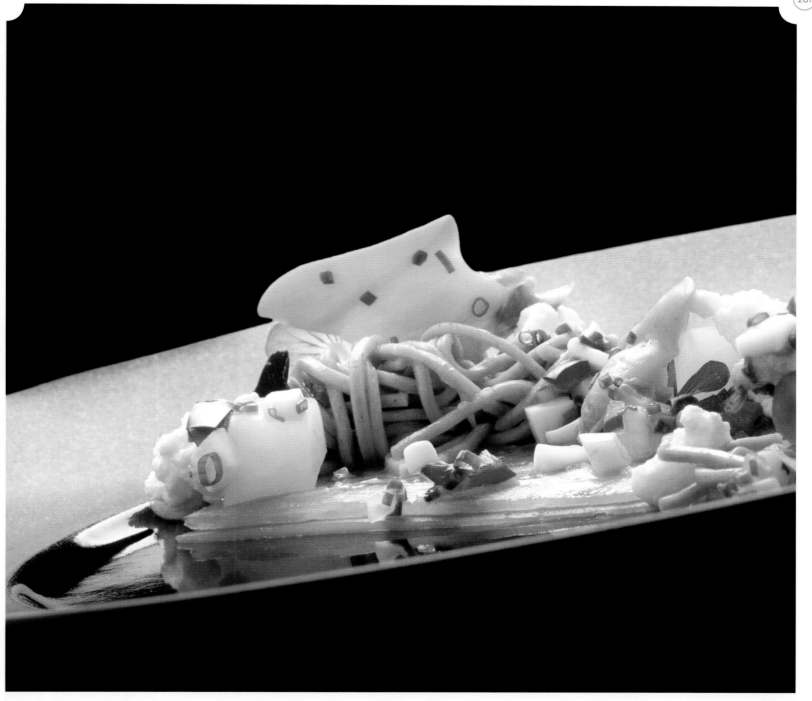

ERIC KLEINBERG
USA

0910

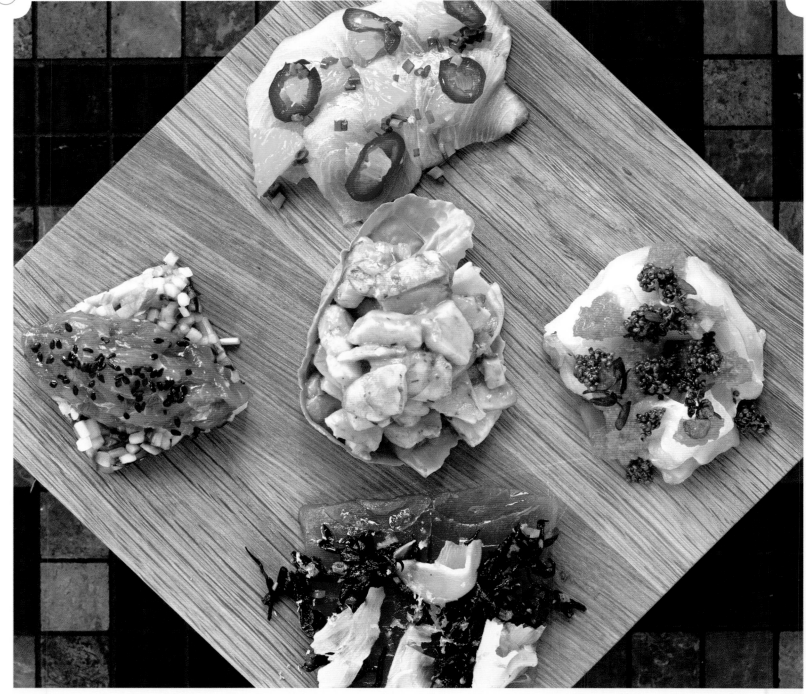

ERIC KLEINBERG
USA

0911

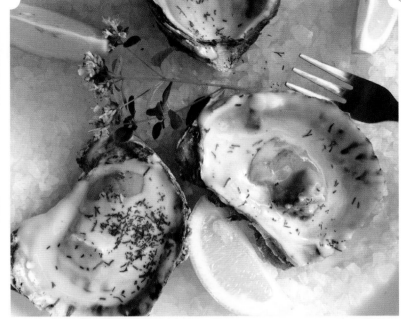

RACHEL DE MARTE
USA

0912

REGAN BARONI
USA

0913

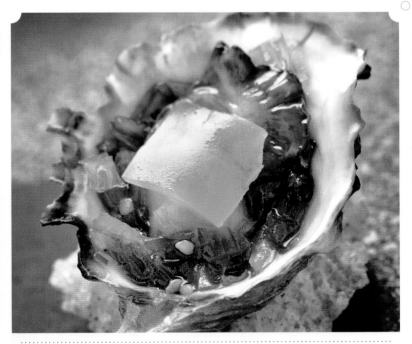

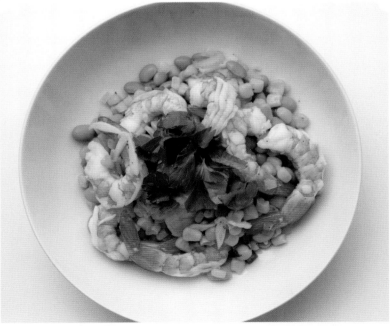

ERIC KLEINBERG
USA

0914

MOLLY MCMAHON
USA

0915

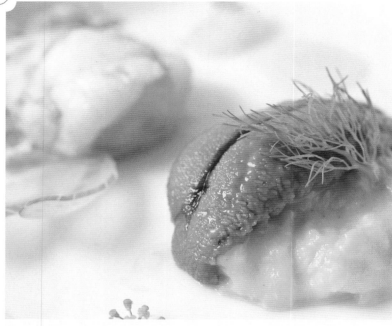

GALDONES PHOTOGRAPHY
USA

0916

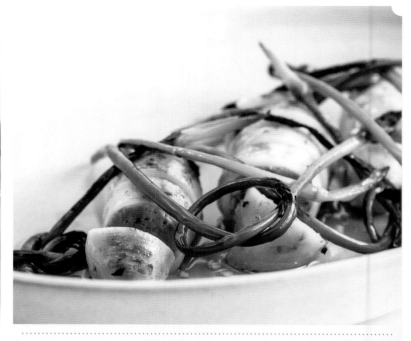

GALDONES PHOTOGRAPHY
USA

0917

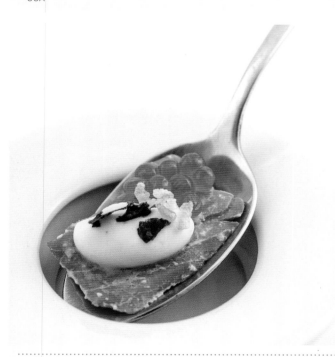

GALDONES PHOTOGRAPHY
USA

0918

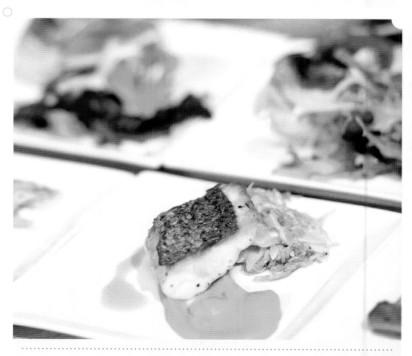

CARA AND SCOTT NAVA
USA

0919

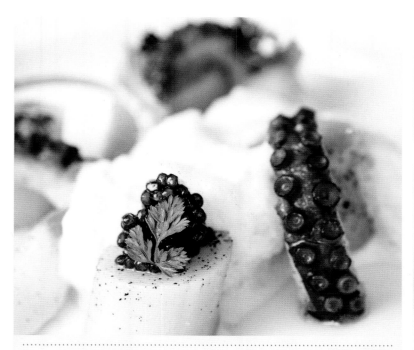

GALDONES PHOTOGRAPHY
USA

0920

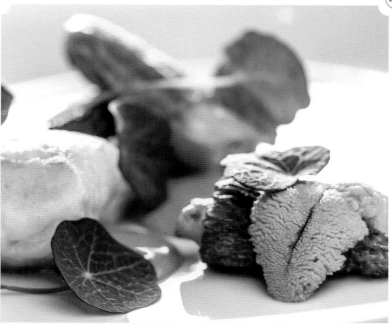

GALDONES PHOTOGRAPHY
USA

0921

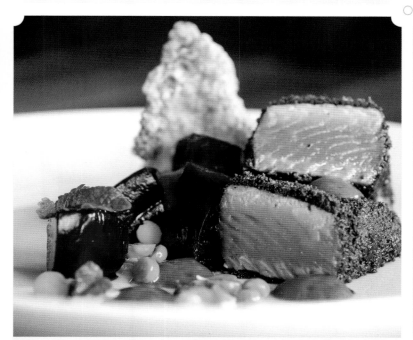

GALDONES PHOTOGRAPHY
USA

0922

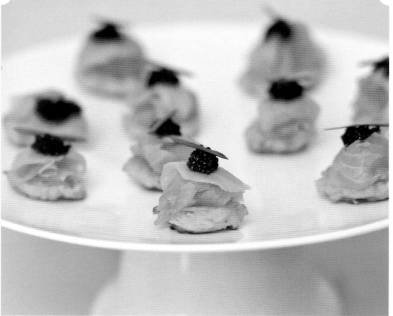

CARA AND SCOTT NAVA
USA

0923

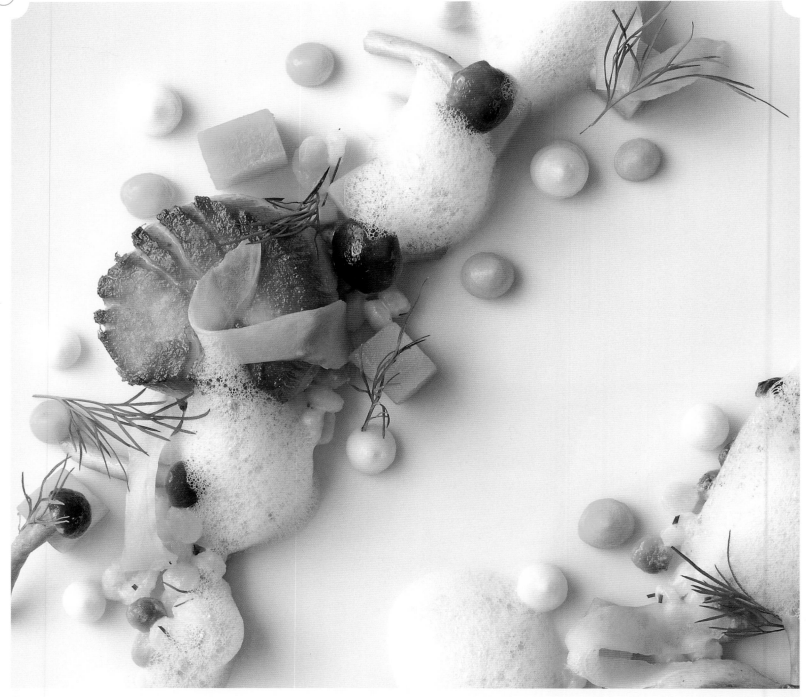

ANTHONY TAHLIER
USA

0924

HEATHER SPERLING
USA
0925

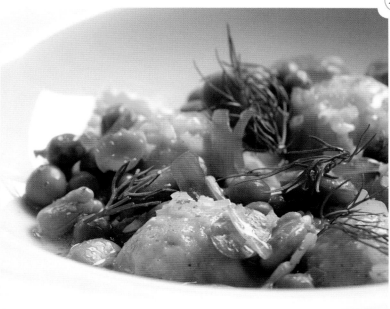

ERIC KLEINBERG
USA
0926

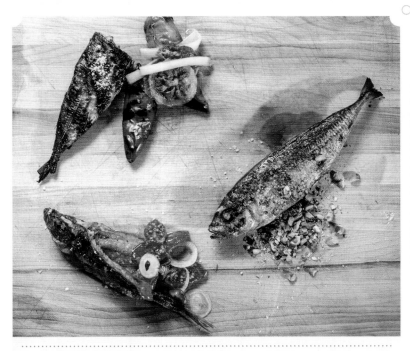

GALDONES PHOTOGRAPHY
USA
0927

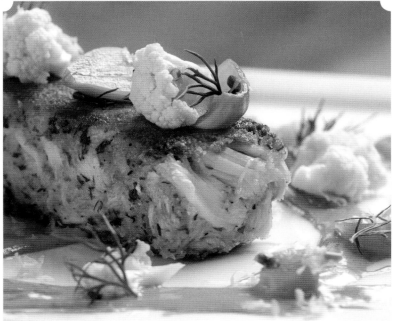

ERIC KLEINBERG
USA
0928

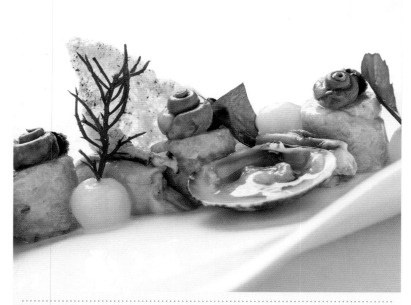

ERIC KLEINBERG
USA

0929

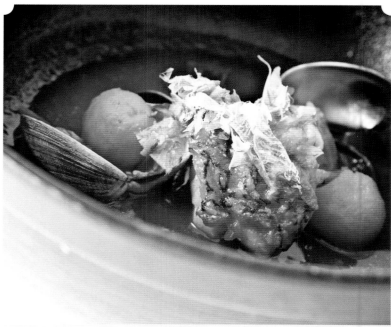

GALDONES PHOTOGRAPHY
USA

0930

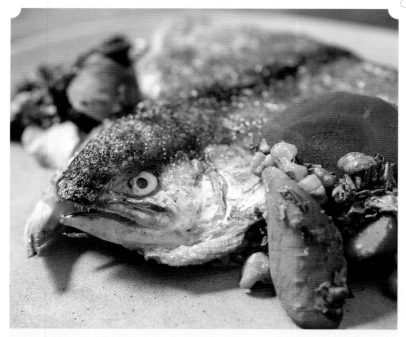

GRIP
USA

0931

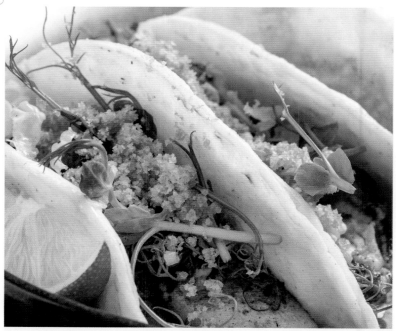

ERIC KLEINBERG
USA

0932

GALDONES PHOTOGRAPHY
USA

0933

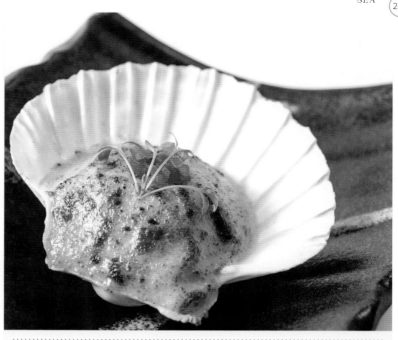

GALDONES PHOTOGRAPHY
USA

0934

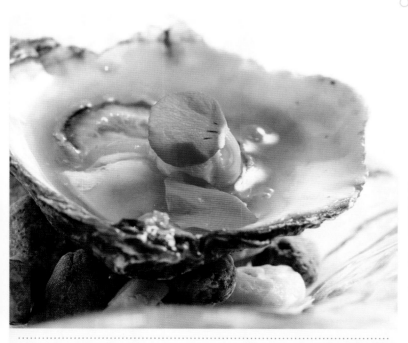

ERIC KLEINBERG
USA

0935

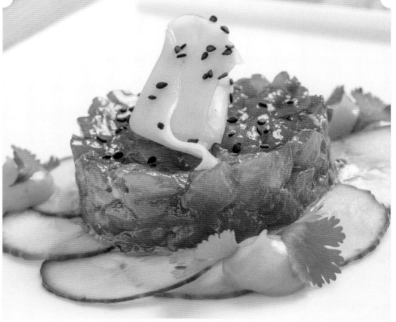

ERIC KLEINBERG
USA

0936

LAND

GRILLED / CURED / SEARED / ROASTED

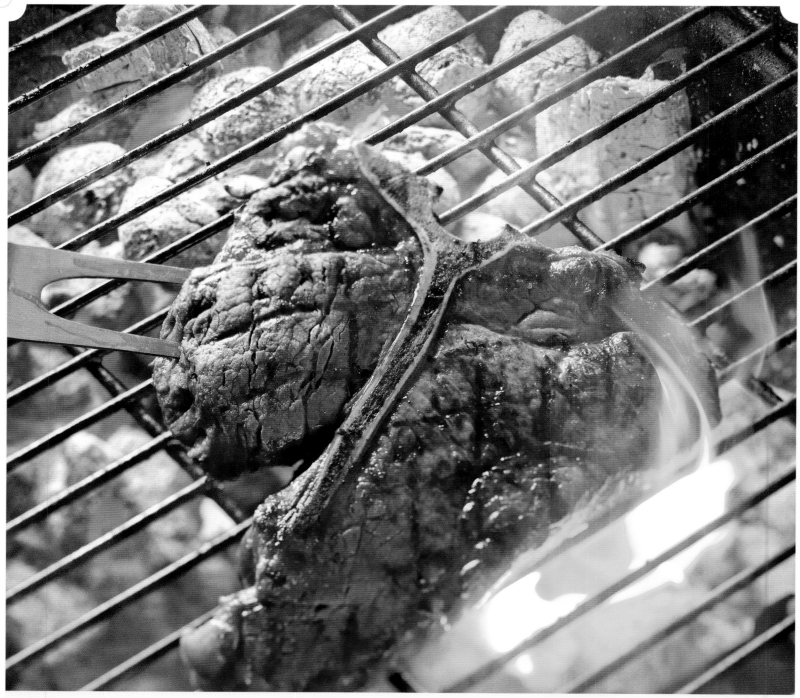

GLENN SCOTT
USA

0937

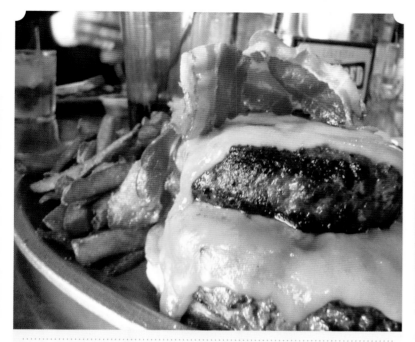

ELLIE MEYER
USA

0938

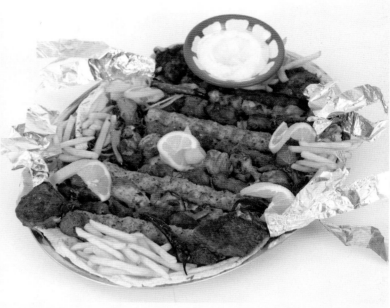

PARAGON MARKETING COMMUNICATIONS
KUWAIT

0939

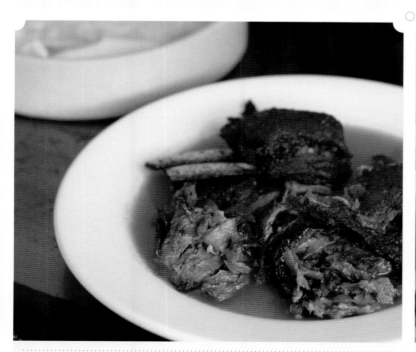

HEATHER SPERLING
USA

0940

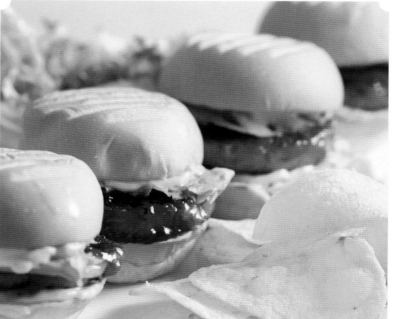

PARAGON MARKETING COMMUNICATIONS
KUWAIT

0941

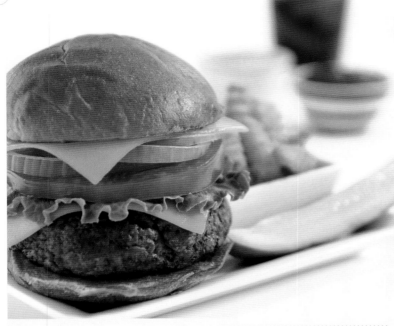

GRIP
USA

0942

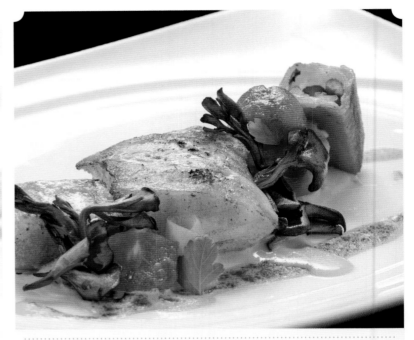

ERIC KLEINBERG
USA

0943

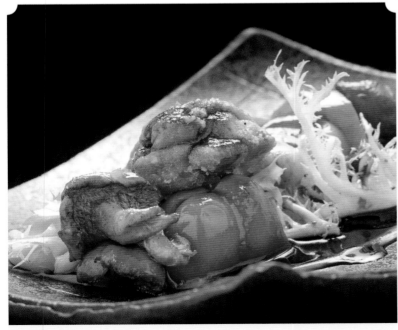

ERIC KLEINBERG
USA

0944

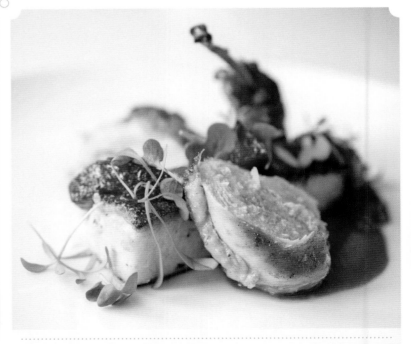

GALDONES PHOTOGRAPHY
USA

0945

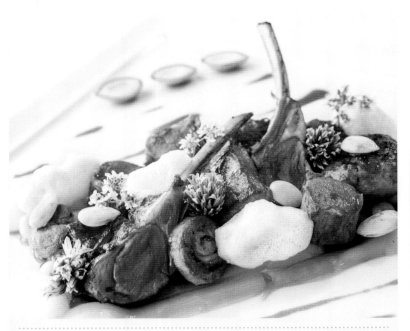

GALDONES PHOTOGRAPHY
USA

0946

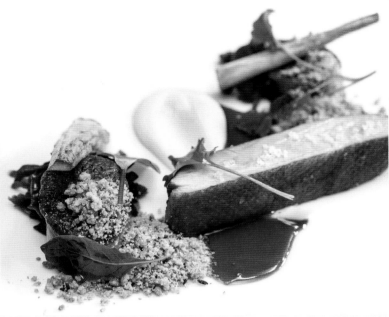

GALDONES PHOTOGRAPHY
USA

0947

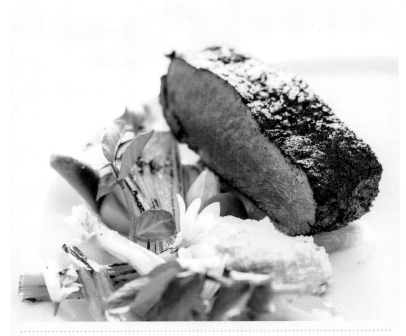

GALDONES PHOTOGRAPHY

0948

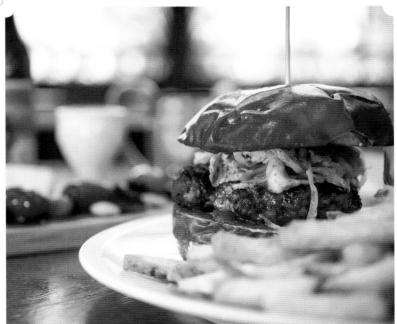

GALDONES PHOTOGRAPHY
USA

0949

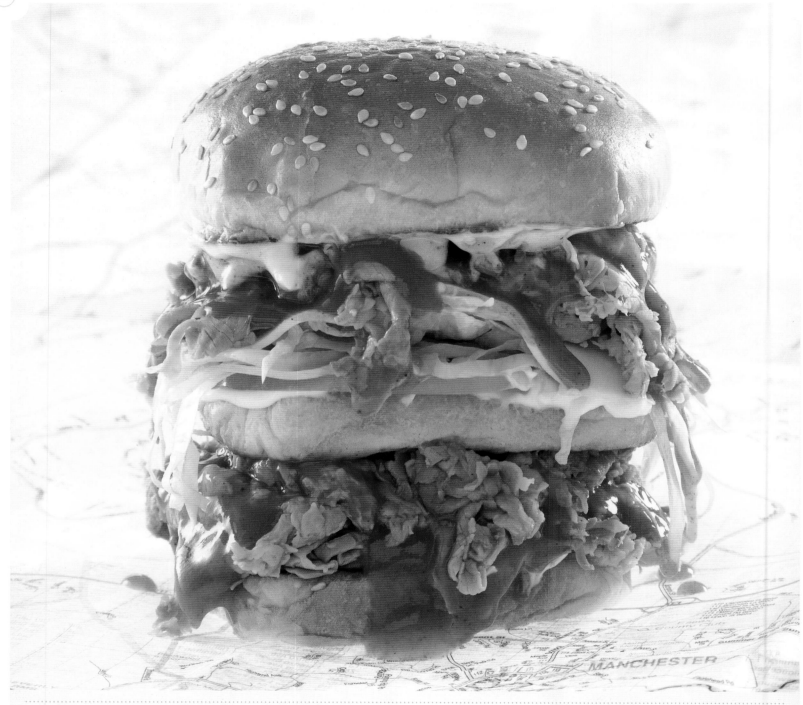

GLENN SCOTT
USA

0950

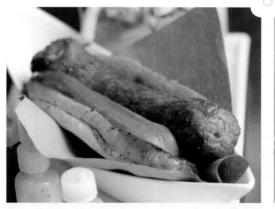

PARAGON MARKETING COMMUNICATIONS KUWAIT **0951**

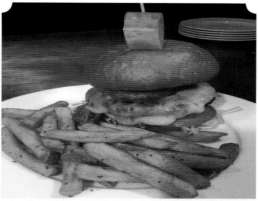

JACQUI WEDEWER
USA **0952**

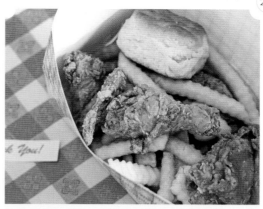

HEATHER SPERLING
USA **0953**

HEATHER SPERLING
USA **0954**

ANDREW HICKEY
USA **0955**

RACHEL DE MARTE
USA **0956**

ANDREW HICKEY
USA **0957**

RACHEL DE MARTE
USA **0958**

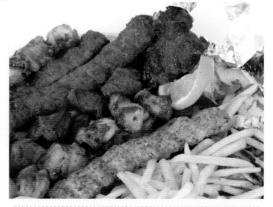

PARAGON MARKETING COMMUNICATIONS KUWAIT **0959**

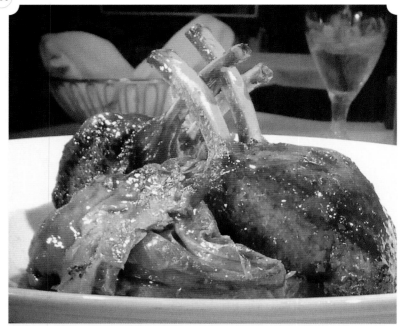

JACQUI WEDEWER
USA
0960

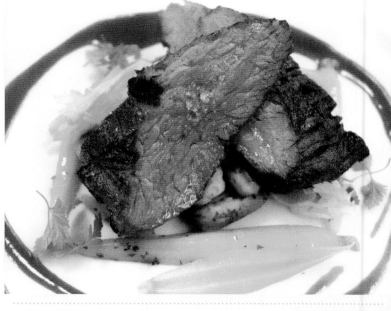

TY LETTAU
USA
0961

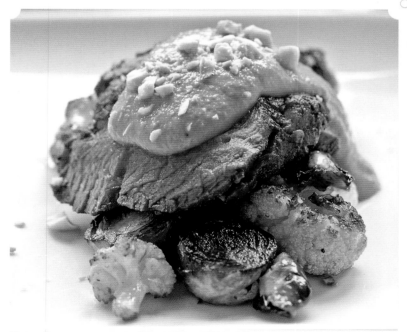

ANTHONY TAHLIER
USA
0962

HEATHER SPERLING
USA
0963

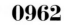

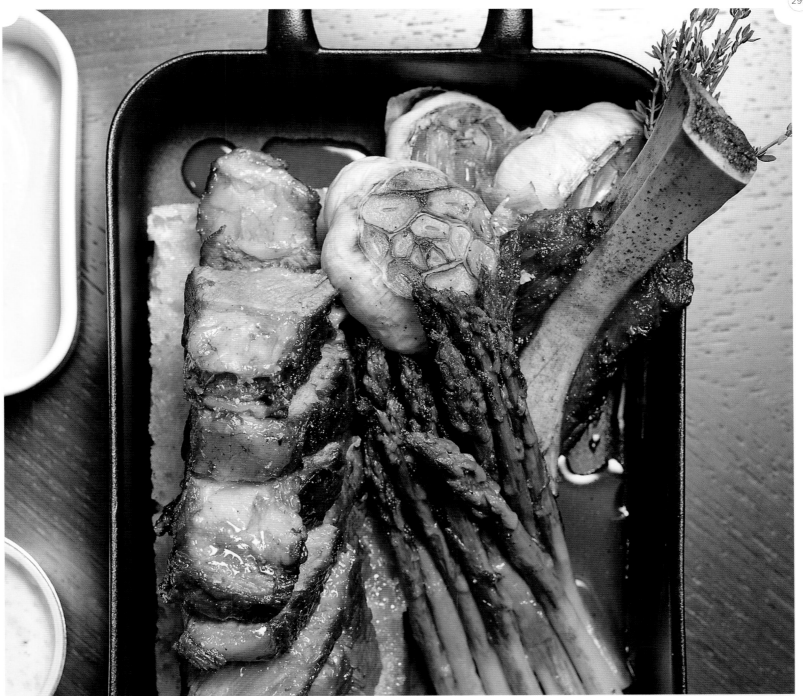

GALDONES PHOTOGRAPHY
USA

0964

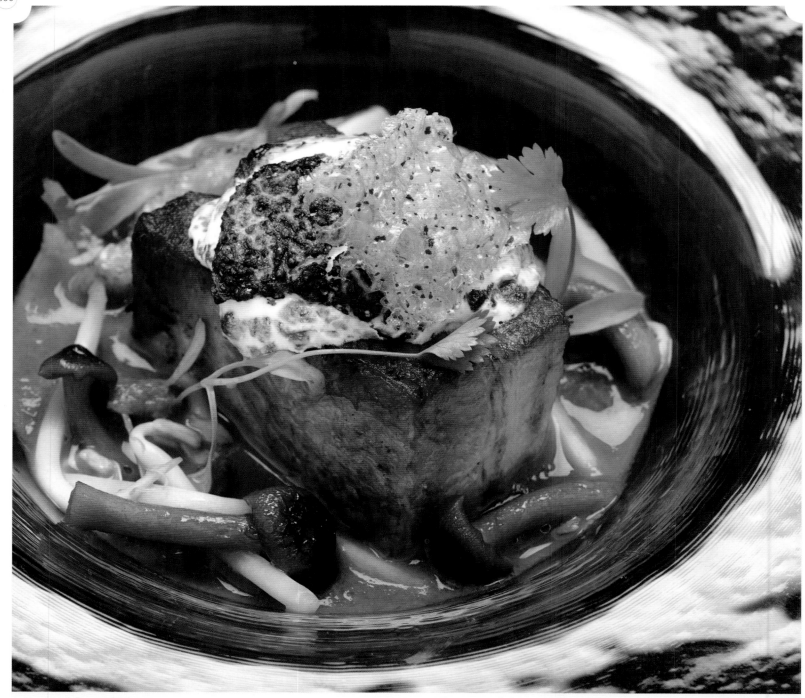

ERIC KLEINBERG
USA

0965

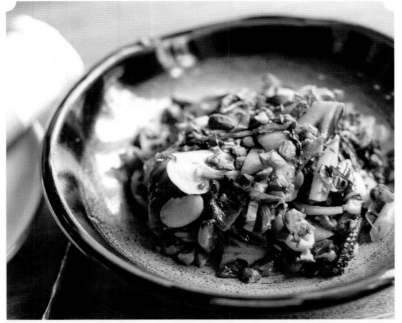

GALDONES PHOTOGRAPHY
USA

0966

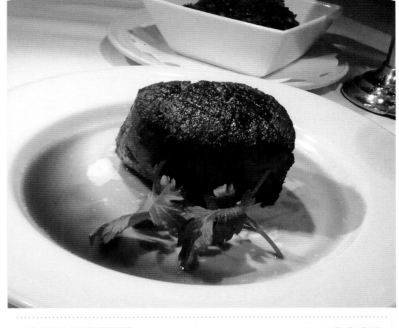

JACQUI WEDEWER
USA

0967

TY LETTAU
USA

0968

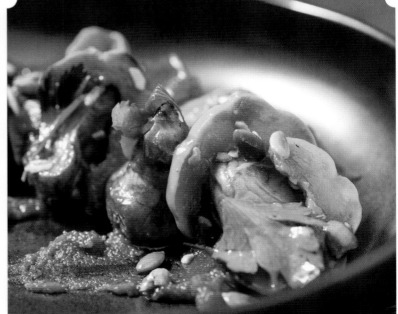

GALDONES PHOTOGRAPHY
USA

0969

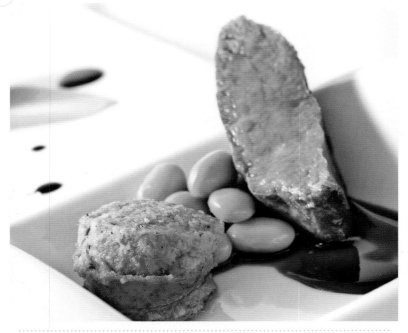

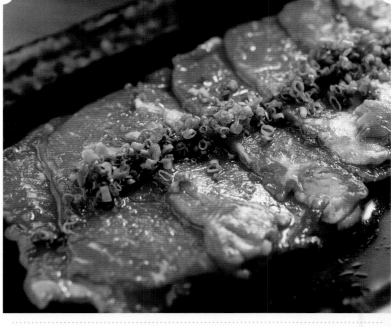

GALDONES PHOTOGRAPHY
USA
0970

GALDONES PHOTOGRAPHY
USA
0971

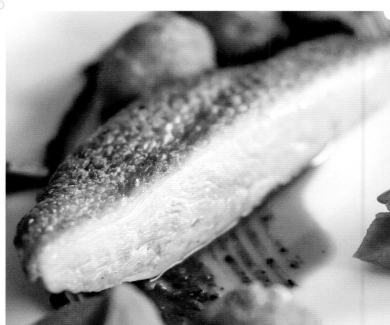

GALDONES PHOTOGRAPHY
USA
0972

GALDONES PHOTOGRAPHY
USA
0973

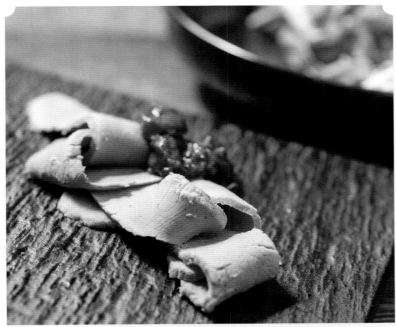

0974

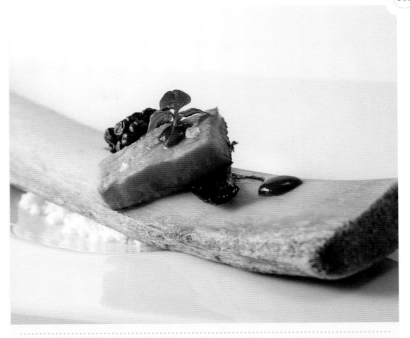

0975

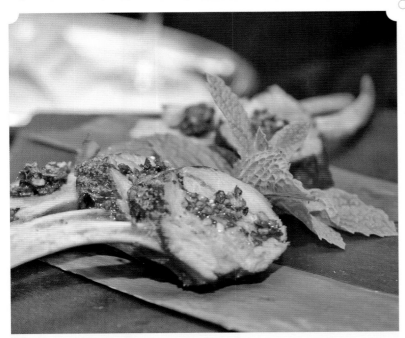

0976

0977

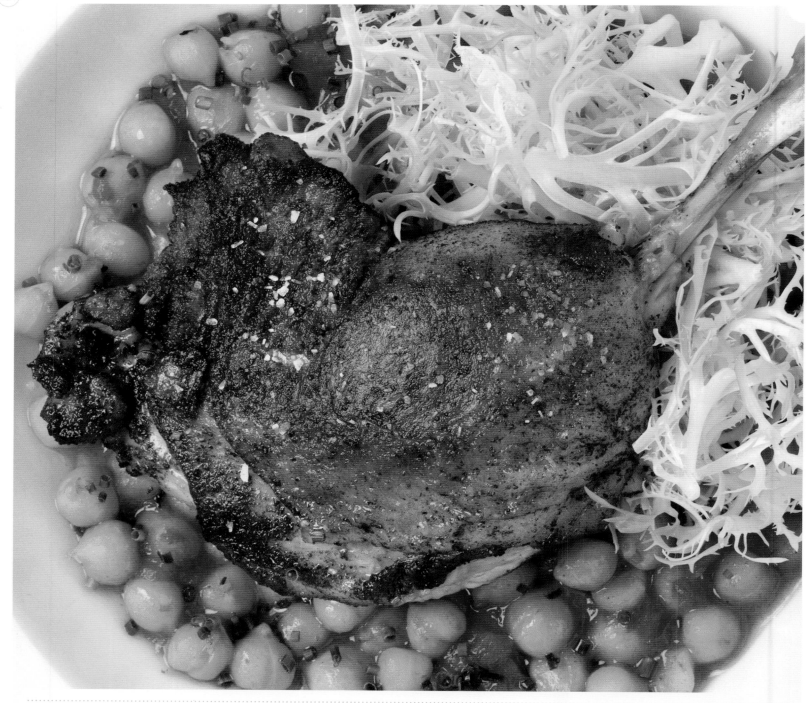

ERIC KLEINBERG
USA

0978

GALDONES PHOTOGRAPHY
USA
0979

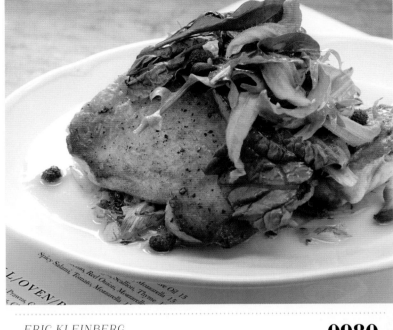

ERIC KLEINBERG
USA
0980

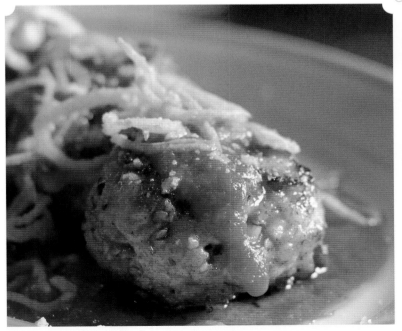

HEATHER SPERLING
USA
0981

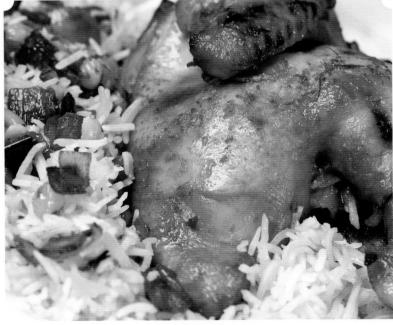

PARAGON MARKETING COMMUNICATIONS
KUWAIT
0982

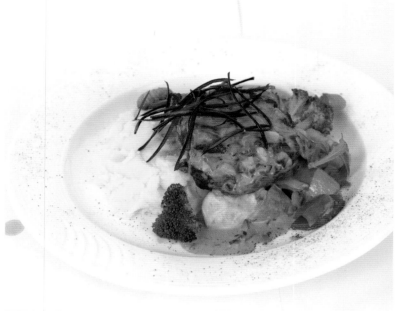

PARAGON MARKETING COMMUNICATIONS
KUWAIT

0983

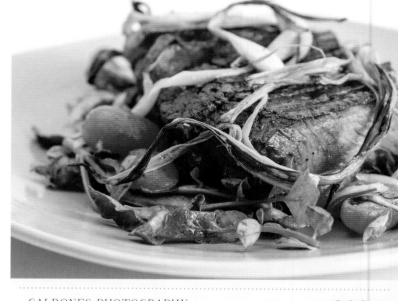

GALDONES PHOTOGRAPHY
USA

0984

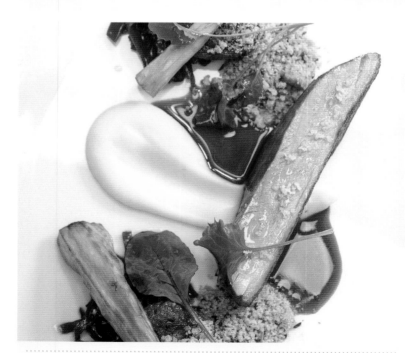

GALDONES PHOTOGRAPHY
USA

0985

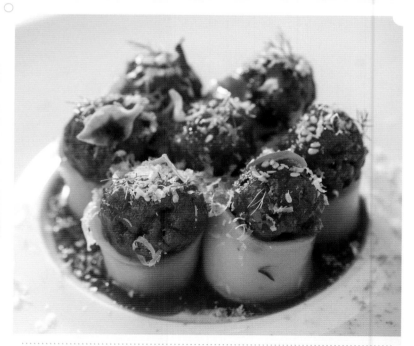

GALDONES PHOTOGRAPHY
USA

0986

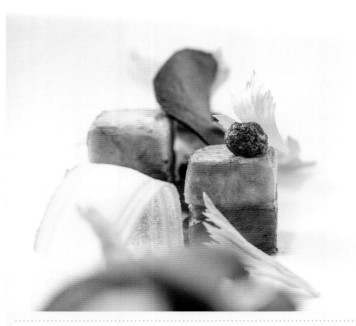

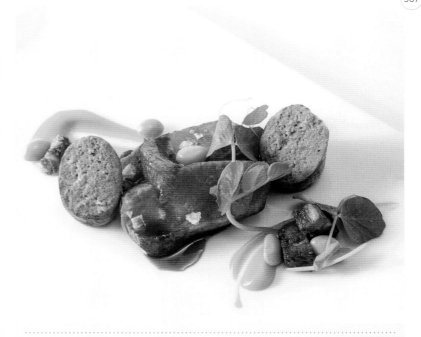

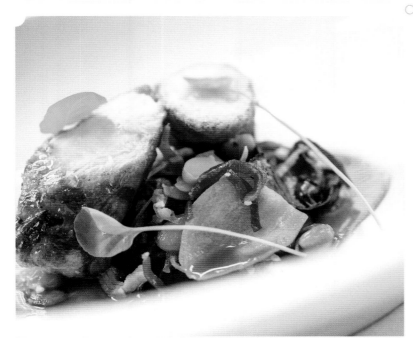

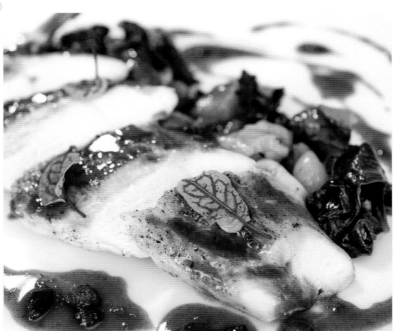

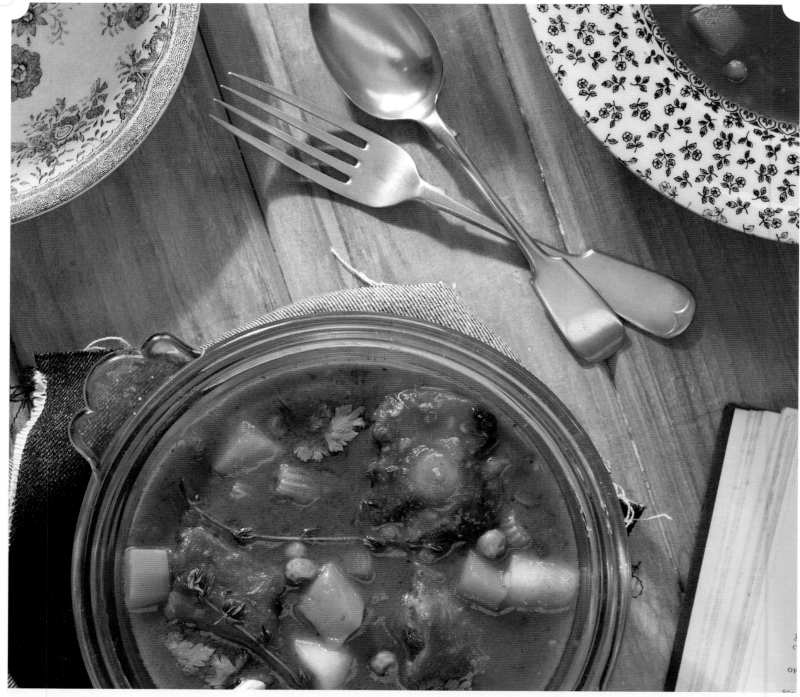

NADINE SHAW
AUSTRALIA

0991

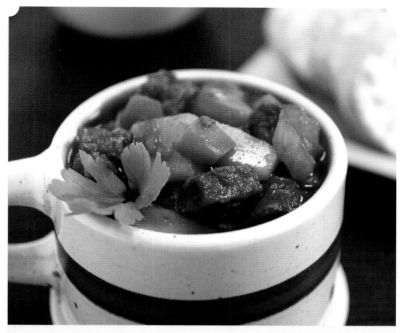

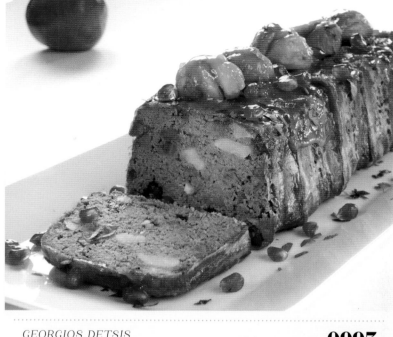

GRIP
USA
0992

GEORGIOS DETSIS
GREECE
0993

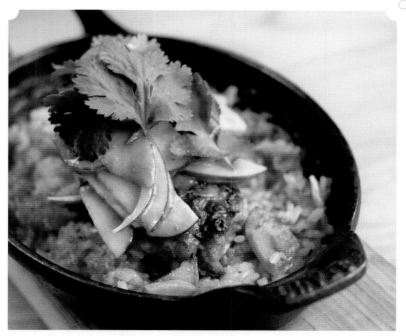

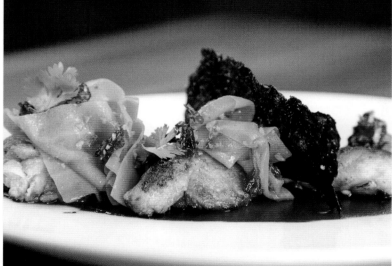

HEATHER SPERLING
USA
0994

GALDONES PHOTOGRAPHY
USA
0995

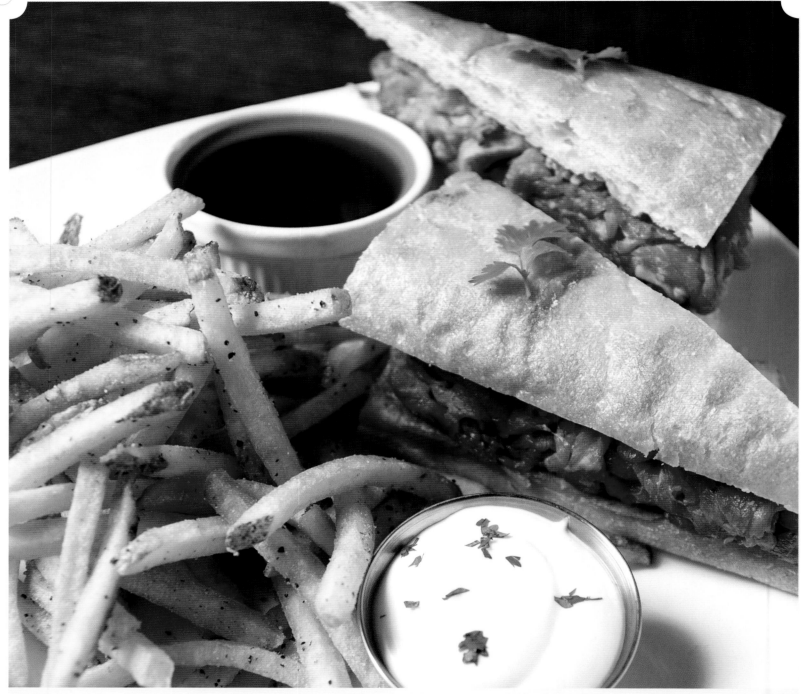

GRIP
USA

0996

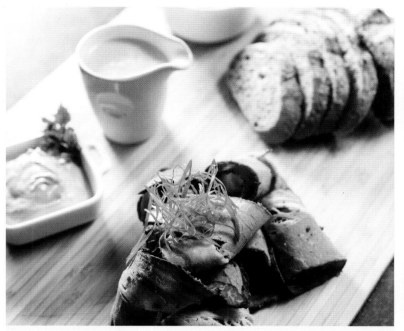

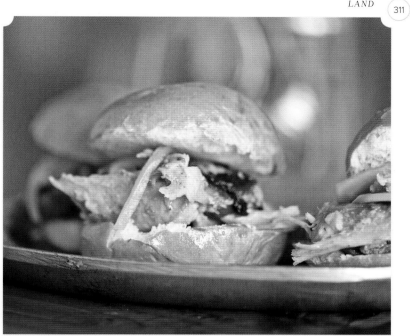

GALDONES PHOTOGRAPHY
USA
0997

ANTHONY TAHLIER
USA
0998

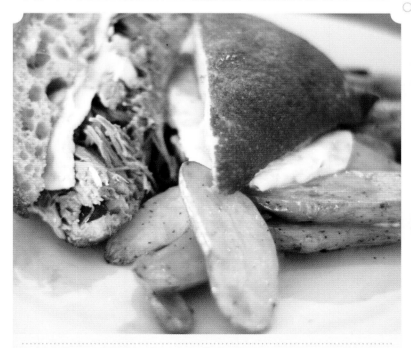

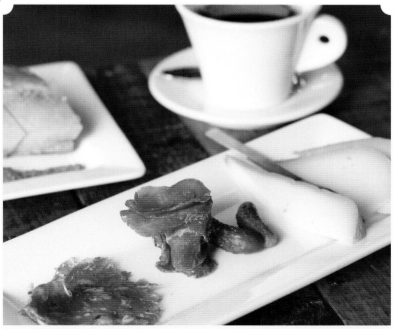

ANDREW HICKEY
USA
0999

HEATHER SPERLING
USA
1000

INDEX

REFERENCE / QUICK-FIND / LOOK-UP / SOURCES / CREDITS

B

REGAN BARONI
2432 W. Haddon
Chicago, IL, 60622
612.396.2303
www.reganbaroni.com
reganbaroni@gmail.com

0061, 0209, 0470, 0913

EZEQUIEL BECERRA
Negrafix
Curridabat
San José
506.8813.6847
almakzumi@gmail.com

0014, 0332

ARI BENDERSKY
ari@ariwrites.com

0609, 0676, 0677, 0720, 0729, 0855, 0856, 0857, 0863, 0865

DAVE BRADLEY
Dave Bradley Photography
840 Summer St
Boston, MA, 02127
617.268.6644
www.davebradleyphoto.com
dave@davebradleyphoto.com

0001, 0308, 0893

TUAN H. BUI
1100 W. Cermak #B413
Oak Park, IL 60608
217.721.4455
http://tuanhbui.com
tuan@tuanhbui.com

0022, 0027, 0028, 0033, 0035, 0038, 0039, 0155, 0222, 0224,
0242, 0274, 0275, 0347, 0375, 0377, 0464, 0524, 0528–0534,
0579, 0584, 0595, 0597, 0599, 0657, 0659, 0660, 0666, 0687,
0734, 0758–0760, 0767, 0875, 0880, 0881, 0894

C

HEATHER CROSBY
YumUniverse.com
P.O. Box 3344
Shepherdstown, WV
773.220.2980
www.yumuniverse.com
yumuniverse@gmail.com

0203, 0278

D

ANDRES DANGOND
2615 W Berwyn St.
Lake Forest, CA, 92630
773.980.0106
www.andresdangond.com
andres@andresdangond.com

0145, 0185, 0488, 0521, 0906, 0909

MICHELLE DEITER
223 Thatcher Ave
River Forest, IL, 60305
708.969.0708
michelle@mbj3.com
michelledeiter@gmail.com

0068, 0073, 0129, 0205, 0253, 0306, 0381, 0419, 0437, 0513,
0541, 0802, 0803

RACHEL DE MARTE
2 S Leavitt, #206
Chicago, IL, 60612
773.963.5144
www.racheldemarte.com
rachel@racheldemarte.com

0132, 0481, 0678, 0688, 0814, 0884, 0912, 0956, 0958

GEORGIOS DETSIS
50 Chris Smirnis St.
Athens 15342
30.693740036
www.flickr/photos/giomio
georgios@detsis.net

0070, 0091, 0094, 0148, 0156, 0159, 0163, 0168, 0186, 0188,
1093, 0245–0247, 0329, 0351, 0450, 0501, 0503, 0507, 0508,
0661–0663, 0668, 0681, 0764, 0774, 0779, 0993

DAVID ROBERT ELLIOTT
John Coyle Steinbrunner Creatives, LLC
3828 N. Wilton
Chicago, IL, 60613
773.529.6880
www.jcsteinbrunner.com
jc@jcsteinbrunner.com

0689–0692

SCOTT ERB AND DONNA DUFAULT
Erb Photography
380 Bridle Path
Worcester, MA, 01604
508.421.3912
www.erbphoto.com
scott@erbphoto.com

0006, 0054, 0089, 0090, 0218, 0414, 0467, 0471, 0542, 0623, 0757, 0770, 0862, 0868, 0873, 0897

F

BRANDON FREITAS DESIGN
124 Potomska St.
New Bedford, MA, 02740
508.728.7994
www.BrandonFreitas.com
brandonfreitasdesign@gmail.com

0353, 0355, 0356, 0364, 0439, 0441, 0442, 0620, 0705

LUKASZ FUKS
Poludniowa 15/4
Pabianice
48.603.531.626
www.lukaszfuks.pl
lukasz.fuks@gmail.com

0497, 0627, 0740–0742, 0858

G

GALDONES PHOTOGRAPHY
720 N Larrabee St, #1410
Chicago, IL, 60654
617.922.4363
www.galdones.com
huge@galdones.com

0011, 0096, 0133, 0134, 0162, 0172, 0252, 0257, 0272, 0276, 0282, 0283, 0286, 0287, 0289, 0318, 0319, 0358, 0371, 0397, 0403, 0405, 0444, 0445, 0452–0459, 0463, 0484, 0487, 0490–0494, 0509, 0518, 0543–0545, 0547–0550, 0560, 0561, 0563, 0565–0567, 0569–0576, 0598, 0612, 0613, 0644, 0645, 0647–0651, 0656, 0670, 0684, 0701, 0702, 0754–0756, 0763, 0771, 0772, 0775, 0778, 0780, 0804, 0895, 0896, 0916–0918, 0920–0922, 0927, 0930, 0933, 0934, 0945–0949, 0964, 0966, 0969–0975, 0977, 0979, 0984–0990, 0995, 0997

GRIP
1128 N. Ashland Ave.
Chicago, IL 60622
312.906.8020
www.gripdesign.com
info@gripdesign.com

0016, 0053, 0207, 0228, 0305, 0310–0311, 0314, 0342–0346, 0348, 0350, 0443, 0446–0449, 0472–0449, 0551, 0605, 0671, 0685, 0686, 0704, 0727, 0728, 0752, 0762, 0792, 0931, 0942, 0992, 0996

H

ANDREW HICKEY
4512 N. Malden St.
Chicago, IL, 60640
773.944.5121
drewinchicago@gmail.com

0116, 0120, 0123, 0124, 0153, 0248, 0249, 0250, 0334, 0349, 0354, 0421, 0466, 0554, 0709, 0711, 0713, 0800, 0805, 0807, 0808, 0809, 0811, 0824, 0866, 0955, 0957, 0999

AZITA HOUSHIAR
917.379.8857
www.figandquince.com
fig@figandquince.com

0030, 0057, 0059, 0137, 0144, 0157, 0582, 0588, 0679, 0783, 0788

N

CARA AND SCOTT NAVA
Carasco Photography
1750 W 35th St.
Chicago, IL, 60609
773.383.4112
www.carascophoto.com
caranava@photocarasco.com

0015, 0192, 0264, 0330, 0331, 0352, 0374, 0420, 0511, 0522, 0535, 0669, 0672, 0784, 0790, 0810, 0877, 0879, 0887, 0919, 0923, 0976

P

PARAGON MARKETING COMMUNICATIONS
Al Hamad Tower A, 3rd Floor, Jibla, Behind Sheraton
PO Box 6097, Salmiya, 22071
965.2297440 / 22974388
www.paragonmc.com
info@paragonmc.com

0026, 0031, 0043, 0048, 0092, 0097, 0103, 0104, 0110, 0111, 0113–0115, 0122, 0125–0128, 0130 0138, 0149–0151, 0169, 0173, 0210, 0213–0215, 0217, 0235–0237, 0260–0263, 0285, 0288, 0290–0304, 0312, 0317, 0320–0328, 0361, 0363, 0365, 0367, 0369, 0384, 0386-0391, 0395, 0398–0402, 0404, 0407, 0412, 0418, 0426, 0431, 0435, 0438, 0440, 0482, 0483, 0500, 0525–0527, 0539, 0555–0559, 0682, 0719, 0721–0726, 0731, 0733, 0736, 0739, 0789, 0794, 0801, 0812, 0813, 0818–0819, 0822, 0823, 0825–836, 0838, 0839, 0869, 0870, 0885, 0886, 0888, 0889, 0891, 0939, 0941, 0951, 0959, 0982, 0983

JUSTIN B. PARIS
Justin B. Paris Photography
905 Stonehurst Dr
Roselle, IL, 60172
630.270.9829
www.justinbparis.com
justin@justinbparis.com

0004, 0087, 0243, 0251, 0256, 0259, 0269, 0307, 0406, 0577, 0578, 0607, 0753

ALLAN PENN
Allan Penn Photography
33 Commercial St., Ste 3
Gloucester, MA 01930
978.283.7321
www.allanpenn.com
penn@allanpenn.com

0743–0747, 0871, 0900

LAUREN PODOLSKY
4907 Whitlock Ln
Mechanicsburg, PA, 17055
717.525.1320
www.saywhatyouneedtosayblog.com
Lpodolsky410@gmail.com

0198, 0199, 0212, 0232

BRIAN POREA
Brian Porea Photography
290 San Jose Avenue
San Francisco, CA, 94110
415.279.5478
bporea@gmail.com

0161, 0164, 0422, 0538, 0683, 0777, 0787, 0791

R

ELISABETTA REDAELLI
Photography by Elisabetta Redaelli
Via Alciato 21
Alzate Brianza (CO), Italy, 22040
3.9340226096e+011
www.flickr.com/photos/lillyred
elisabetta.redaelli1@gmail.com

0012, 0032, 0044, 0046, 0088, 0180, 0415, 0592, 0667, 0765, 0768, 0837

SARA REMINGTON
1660 N. La Salle, #809
Chicago, IL, 60614
312.643.5614
constancepik@gmail.com

0158, 0309, 0360

CARLOS RIBEIRO
Sevenfiles
Rua Senhora da Guia, n° 110
4785-122 Trofa
3.519162661e+011
www.sevenfiles.com
carlosribeiro@sevenfiles.com

0072, 0231, 0610

KATE RIESENBERG
178 Atlantic Ave, #2
Brooklyn, NY, 11201
973.609.2034
www.mycitybites.wordpress.com
kate.riese@gmail.com

0005, 0083, 0085, 0095, 0117, 0136, 0139–0141, 0146, 0166,
0194–0196, 0208, 0244, 0254, 0335, 0336, 0366, 0479, 0499,
0519, 0587, 0665, 0697, 0700, 0708, 0730, 0751, 0786, 0795–
0799, 0860, 0867, 0876

BERNADINE ROLNICKI
195 N Harbor Drive 3401
Chicago, IL, 60601
312.213.8508
bernadine1018@aol.com

0062, 0121, 0183, 0184, 0191, 0496, 0664, 0766

ROOT STUDIO
The Terrace, Grantham St
Lincoln, Lincolnshire, LN2 1BD
01522 . 528246
www.rootstudio.co.uk
tom@rootstudio.co.uk

0716–0718

S

RONNIE SAINI
Ronnie Saini Design
215 Arboretum Way
Burlington, MA
781.640.9375
www.ronniesainiphotography.com
ronnie@ronniesainidesign.com

0176, 0216, 0859

LAURA SANT
891 Bergen St., Apt 3R
Brooklyn, NY, 11238
804.350.6409
www.mizsant.net
mizsant@gmail.com

0230, 0516

MARTA SASINOWSKA
YumUniverse.com
P.O. Box 3344
Shepherdstown, WV
773.220.2980
www.yumuniverse.com
yumuniverse@gmail.com

0202, 0642, 0652–0654

GLENN SCOTT
GSP, INC.
228 Cabot St.
Beverly, MA, 01915
978.927.5522
www.glennscottphotography.com
gsphotography@comcast.net

0025, 0219, 0429, 0430, 0433, 0776, 0872, 0937, 0950

RENATO SEALY
Leinster Rd, Waterford
St. Michael
246.249.0202
www.renatosealy.com
ren23egade@gmail.com

0630

NADINE SHAW
Nadine Shaw Photography
P.O. Box 838
Spring Hill, QLD, 4004
0413 . 748132
www.feastphotography.com.au
dine@feastphotography.com.au

0009, 0023, 0052, 0055, 0084, 0206, 0229, 0277, 0424, 0514,
0553, 0580, 0589, 0594, 0603, 0628, 0675, 0714, 0715, 0806, 0991

SHERI SILVER
Donuts, Dresses and Dirt
3 Cedarlawn Road
Irvington, NY, 10533
914.591.2679
www.sherisilver.com
sheri@sherisilver.com

0041, 0101, 0227, 265, 0271, 0280, 0316, 0393, 0425, 0636,
0639, 0673, 0674, 0710, 0845, 0849, 0853, 0907

KARI SKAFLEN
2101 W. Rice St., #105
Chicago, IL, 60622
312.451.3588
kari.skaflen@gmail.com

0187, 0333, 0379, 0480, 0498, 0505, 0864

ALYSA SLAY
205 Barberry Rd
Highland Park, IL, 60035
312.215.1114
aslay@sbcglobal.net

0270, 0634

HEATHER SPERLING
2623 N. Emmett St., #1
Chicago, IL, 60647
301.706.2934
www.heathersperling.com
heathersperling@gmail.com

0002, 0024, 0037, 0050, 0056, 0063, 0064, 0067, 0071, 0086,
0098–0100, 0102, 0105, 0107, 0108, 0112, 0131, 0147, 0152,
0177–0179, 0190, 0201, 0220, 0221, 0223, 0225, 0226, 0233,
0338-00341, 0362, 0376, 0380, 0392, 0394, 0408–0410, 0428,
0465, 0489, 0495, 0502, 0515, 0536, 0546, 0562, 0600–0602,
0626, 0732, 0749, 0750, 0843, 0846–0848, 0861, 0883, 0892,
0898, 0899, 0901–0905, 0908, 0925, 0940, 0953, 0954, 0963,
0981, 0994, 1000

T

ANTHONY TAHLIER
Anthony Tahlier Photography, Inc
2021 West Fulton
Chicago, IL, 60612
312.927.8669
www.anthonytahlier.com
info@anthonytahlier.com

0337, 0370, 0378, 0383, 0385, 0411, 0413, 0436, 0486, 0564,
0593, 0621, 0622, 0624, 0632, 0633, 0635, 0698, 0735, 0841,
0844, 0924, 0962, 0998

THAIN LIN TAY
50 Bt Batok East Avenue 5 #23-08
Singapore
6597828618
www.flickr.com/photos/tiny_tots/
thainlin@gmail.com

0142, 0143, 0154, 0189, 0878

V

HEATHER VAN GAALE
The Confection Oven
12405 Conquistador Way
San Diego, CA 92128
858.945.4218
www.theconfectionoven.com
info@theconfectionoven.com

0003, 0042, 0047, 0631, 0637, 0638, 0748, 0840, 0851, 0852

NANDY VILLONGCO
50pov.com
27 Avignon Avenue
Foothill Ranch, CA, 92610
949.292.7170
www.50pov.com
nandyv@notebookdrives.com

0658, 0761

W

JACQUI WEDEWER
Check, Please!
848 W. Eastman, #205
Chicago, IL, 60642
312.804.5561
jacqui@checkplease.tv

0106, 0504, 0952, 0960, 0967

Z

NICOLE ZARATE
121 W. 17th St.
Lombard, IL, 60143
415.828.5861
www.nicolezaratephoto.com
nicole@nicolezaratephoto.com

0040, 0066, 0082, 0255, 0268, 0423, 0512, 0643

ABOUT

THE AUTHOR

Ari Bendersky, a longtime food and wine writer, is currently the director of content and editor in chief for AbesMarket.com, a mindful living destination for natural and organic products, news, and information. Prior to joining Abe's, Ari was the founding editor of Eater Chicago and built it into the No. 1 destination for restaurant news in Chicago. During the course of his lengthy career, Ari has also covered music, lifestyle, and travel, writing for the *New York Times*, Associated Press, RollingStone.com, *Chicago* magazine, Saveur.com, and more.